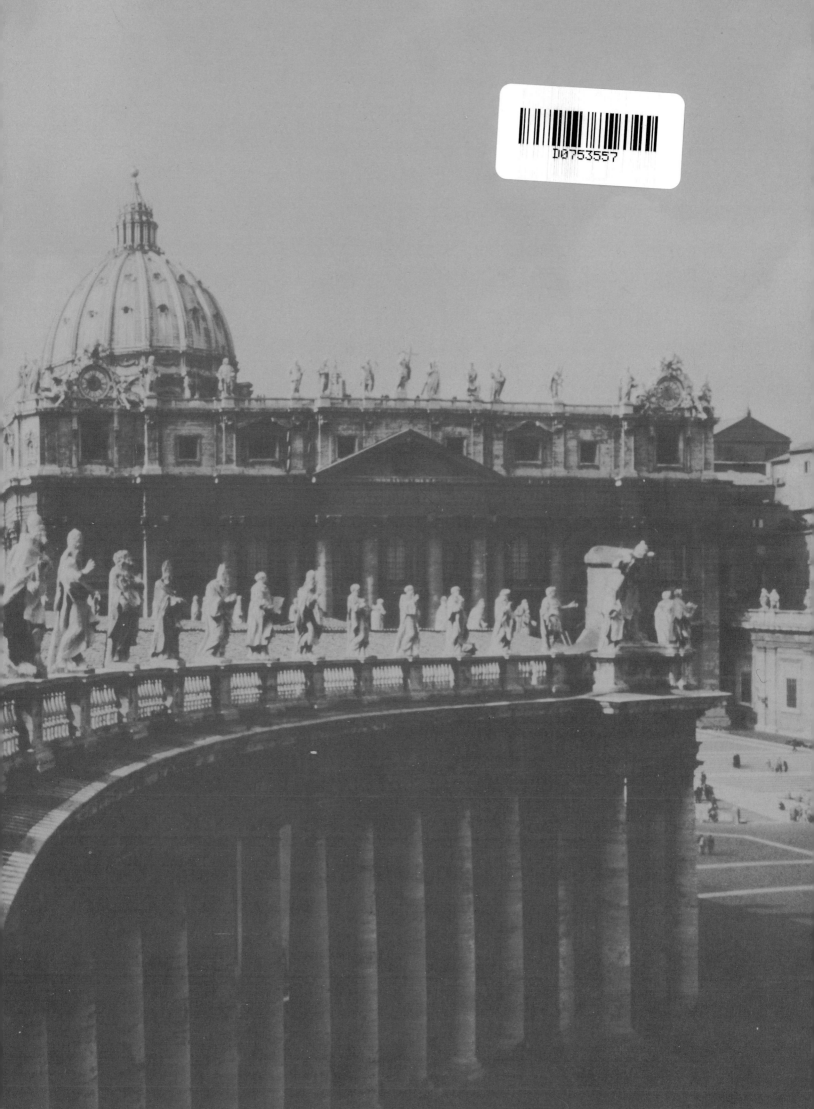

The World of
Bernini

TIME LIFE BOOKS ®

Other Publications:

THE CIVIL WAR

PLANET EARTH

COLLECTOR'S LIBRARY OF THE CIVIL WAR

LIBRARY OF HEALTH

CLASSICS OF THE OLD WEST

THE EPIC OF FLIGHT

THE GOOD COOK

THE SEAFARERS

THE ENCYCLOPEDIA OF COLLECTIBLES

THE GREAT CITIES

WORLD WAR II

HOME REPAIR AND IMPROVEMENT

THE WORLD'S WILD PLACES

THE TIME-LIFE LIBRARY OF BOATING

HUMAN BEHAVIOR

THE ART OF SEWING

THE OLD WEST

THE EMERGENCE OF MAN

THE AMERICAN WILDERNESS

THE TIME-LIFE ENCYCLOPEDIA OF GARDENING

LIFE LIBRARY OF PHOTOGRAPHY

THIS FABULOUS CENTURY

FOODS OF THE WORLD

TIME-LIFE LIBRARY OF AMERICA

GREAT AGES OF MAN

LIFE SCIENCE LIBRARY

THE LIFE HISTORY OF THE UNITED STATES

TIME READING PROGRAM

LIFE NATURE LIBRARY

LIFE WORLD LIBRARY

FAMILY LIBRARY:

 HOW THINGS WORK IN YOUR HOME

 THE TIME-LIFE BOOK OF THE FAMILY CAR

 THE TIME-LIFE FAMILY LEGAL GUIDE

 THE TIME-LIFE BOOK OF FAMILY FINANCE

This volume is one of a series that surveys Western painting and sculpture from the end of the Middle Ages to the present.

TIME-LIFE LIBRARY OF ART

The World of Bernini
1598 - 1680

by Robert Wallace
and
the Editors of Time-Life Books

Time-Life Books, Alexandria, Virginia

Time-Life Books Inc.
is a wholly owned subsidiary of
TIME INCORPORATED

FOUNDER: Henry R. Luce 1898-1967

Editor-in-Chief: Henry Anatole Grunwald
President: J. Richard Munro
Chairman of the Board: Ralph P. Davidson
Executive Vice President: Clifford J. Grum
Editorial Director: Ralph Graves
Group Vice President, Books: Joan D. Manley

TIME-LIFE BOOKS INC.
EDITOR: George Constable
Executive Editor: George Daniels
Director of Design: Louis Klein
Board of Editors: Dale M. Brown, Thomas A.
Lewis, Martin Mann, Robert G. Mason, Ellen
Phillips, Gerry Schremp, Gerald Simons,
Rosalind Stubenberg, Kit van Tulleken
Director of Administration: David L. Harrison
Director of Research: Carolyn L. Sackett
Director of Photography: John Conrad Weiser

President: Reginald K. Brack Jr.
Executive Vice President: John Steven Maxwell
Vice Presidents: George Artandi, Stephen L. Bair,
Peter G. Barnes, Nicholas Benton, John L.
Canova, Beatrice T. Dobie, Christopher T. Linen,
James L. Mercer, Paul R. Stewart

TIME-LIFE LIBRARY OF ART
EDITOR: Robert Morton
Designer: Leonard Wolfe
Chief Researcher: Martha T. Goolrick
Editorial Staff for The World of Bernini:
Text Editor: L. Robert Tschirky
Picture Editor: Adrian Allen
Staff Writers: Tony Chiu, Lee Greene,
Paula Pierce, Peter Yerkes
Researchers: Evelyn Constable, Margo Dryden,
Catherine Ireys, Susan Jonas, Lynda Kefauver
Design Assistant: Mervyn Clay
Copy Coordinator: Patricia Miller
Picture Coordinator: Elizabeth A. Dagenhardt

EDITORIAL OPERATIONS
Design: Arnold C. Holeywell (assistant director);
Anne B. Landry (art coordinator), James J. Cox
(quality control)
Research: Jane Edwin (assistant director),
Louise D. Forstall
Copy Room: Susan Galloway Goldberg (director),
Celia Beattie
Production: Feliciano Madrid (director),
Gordon E. Buck, Peter Inchauteguiz

About the Author

Robert Wallace, a former staff writer for TIME-LIFE BOOKS, has published more
than 100 nonfiction articles as well as numerous short stories and poems. He is the
author of *Rise of Russia* in the Great Ages of Man series and of three other Library of
Art volumes, *The World of Leonardo, The World of Rembrandt* and *The World of Van
Gogh.* The present book and its predecessors are the fruit of more than four years'
study in European and American museums and libraries.

The Consulting Editor

H. W. Janson was Professor of Fine Arts at New York University. Among his
many publications were *History of Art* and *The Sculpture of Donatello.*

On the Slipcase

Marble tears stain the cheek of the abducted Persephone in this detail from *Pluto
and Persephone,* an early Bernini masterpiece. A photograph of the entire statue may
be seen on pages 24 and 25.

End Papers

One of Bernini's greatest legacies is the colonnaded piazza of St. Peter's in Rome.
Front: Some of the 96 statues of saints and martyrs that line the top of the
colonnades. *Back:* A colonnade-top view across the piazza toward St. Peter's and
Vatican Palace *(right, rear).*

CORRESPONDENTS: Elisabeth Kraemer (Bonn); Margot Hapgood, Dorothy Bacon
(London); Lucy T. Voulgaris (New York); Maria Vincenza Aloisi, Josephine
du Brusle (Paris); Ann Natanson (Rome). Valuable assistance was also provided
by: Carolyn T. Chubet (New York); Mary Johnson (Stockholm); Traudl
Lessing (Vienna).

For information about any Time-Life book,
please write:
Reader Information
Time-Life Books
541 North Fairbanks Court
Chicago, Illinois 60611

Library of Congress Cataloguing in Publication Data
Wallace, Robert, 1919-
 The world of Bernini, 1598-1680, by Robert Wallace
and the editors of Time-Life Books.
 New York, Time-Life Books [c1970]
 192 p. illus. (part col.) 31 cm.
 (Time-Life library of art)
 Bibliography: p. 185.
 1. Bernini, Giovanni Lorenzo, 1598-1680.
 I. Time-Life Books. II. Title.
 NB623.B5W3 1970 730'.924 70-122329
ISBN 0-8094-0227-0
ISBN 0-8094-0286-6 lib. bdg.
ISBN 0-8094-0257-2 retail ed.

Contents

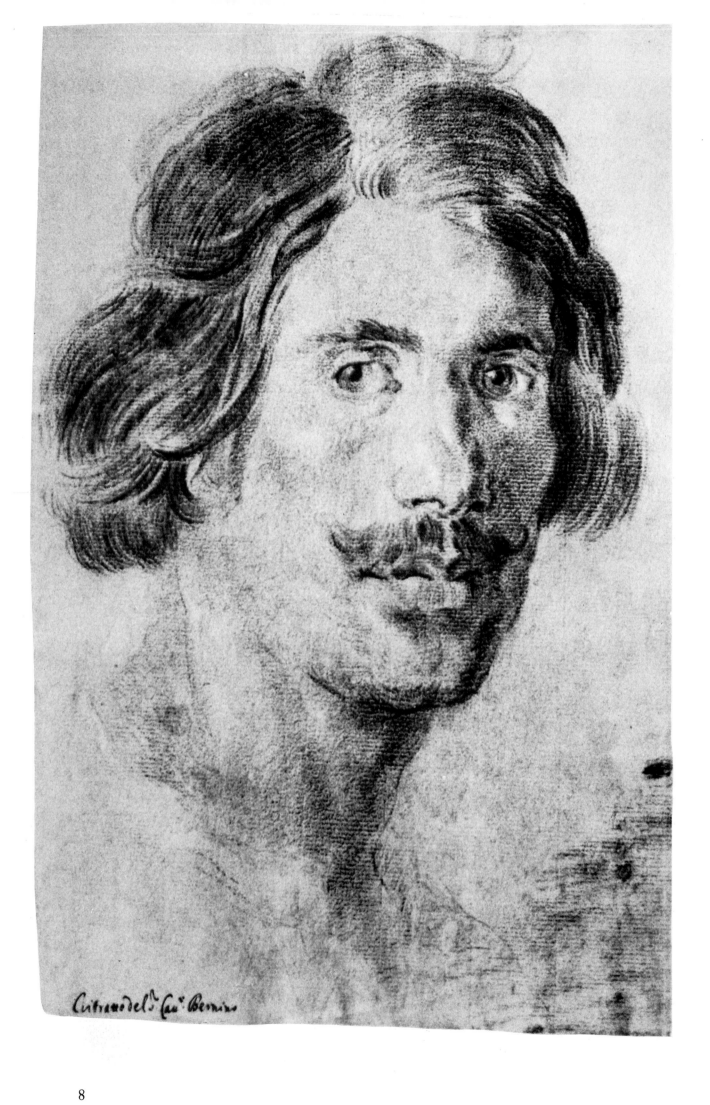

Ritratto del Cav.r Bernino

8

I

Art and Faith

At one glorious time in the 17th Century all of these artists were at work: Rembrandt, Hals, Vermeer, Poussin, Rubens, Van Dyck and Velázquez. But if a 17th Century connoisseur had been asked which of that illustrious company was held in the highest esteem, he would probably not have selected any of them. The likeliest choice would have been the Italian sculptor-architect Gianlorenzo Bernini, then widely regarded as not only the best artist of his era but the greatest man.

Bernini, who was born in 1598 and died a few days short of his 82nd birthday, in 1680, was the last in the line of the brilliant, many-sided artists who made Italy for three centuries the light of the Western world. Although the period in which he lived represents the sunset of the Renaissance, Bernini possessed a virtuosity comparable to that of Leonardo or Michelangelo. Whatever an artist may do, Bernini did superlatively. The English traveler and journalist John Evelyn, who toured widely throughout Italy in 1644, noted that Bernini "gave a public opera wherein he painted the scenes, cut the statues, invented the engines, composed the music, writ the comedy and built the theatre." To this, Evelyn might well have added that Bernini was an artist whose influence on his time is without parallel in history.

In succeeding generations, however, Bernini's fame was eclipsed by others, and only within recent years has it begun to regain its luster. Bernini himself predicted that his reputation would diminish after his death; his art is much concerned with emotion and faith, and very likely he sensed that these qualities would not be the most admired in the age of reason that was settling upon the world. He must have looked forward to an eventual restoration of his fame, although doubtless he hoped it would take less than 300 years. But he cannot have foreseen the depth to which his reputation would sink. For example, John Ruskin, the most formidable of British critics in the Victorian era, dismissed Bernini's art with what may have been the ultimate put-down: it was, Ruskin said contemptuously,

Bernini was a handsome and confident young man of 25, enjoying the rewards of his recently earned reputation as Rome's foremost sculptor, when he sketched this thoughtful self-portrait.

Self-portrait, 1624
CORSINI COLLECTION, GABINETTO NAZIONALE DELLE STAMPE, ROME

"impossible for false taste and base feeling to sink lower."

There are several reasons for today's revival of interest in Bernini. The first is that he was a fascinating and astonishingly gifted artist. Neither the neglect of time nor a platoon of Ruskins can forever obscure that fact. The second is that citizens of the late 20th Century, having seen what a botch men of reason have made of the world, are increasingly open-minded toward men of feeling. Another explanation stems from today's travel boom: as international airlines compete with one another to fetch customers to Rome, more and more people—millions each year—are meeting Bernini's work for the first time.

For Rome is Bernini's city. With the exception of a few years in his childhood and a six-month visit to France when he was 66, he lived and worked in Rome all his long life. For more than half a century he was sculptor-architect to eight popes, all of them dedicated to the glorification of the city and the Church, and all so respectful of Bernini's genius that they gave him the richest commissions any artist has ever received. As a result, a traveler today cannot walk for more than a few minutes in the old quarters of Rome without encountering a work by Bernini: the Fountain of the Four Rivers in the Piazza Navona, the Triton Fountain in the Piazza Barberini at the foot of the Via Veneto, the Barcaccia (The Old Boat), seeming to founder at the bottom of the Spanish Steps; the sculptures in the Villa Borghese or along the Ponte Sant' Angelo; the Church of Sant' Andrea al Quirinale and the Palazzo Montecitorio. Approaching St. Peter's the traveler is embraced by the arms of Bernini's vast colonnade, and within that greatest of all Christian churches he finds almost a dozen works by Bernini, among them the soaring bronze baldachin, or canopy, with its twisted columns above the tomb of St. Peter himself. Moreover, Rome contains scores of other monuments, churches, palaces and tombs that reflect Bernini's style although he did not personally design them —his influence was so powerful that he came close to being a dictator. "To work in Rome," as one of his disgruntled rivals remarked, "is to work for Bernini." And it is because of Bernini that Rome, for all its magnificent relics of other times, today presents to the world a face, a feeling, that is mainly 17th Century Baroque.

The word "Baroque," which comes to mind whenever Bernini is mentioned, calls for some explanation before his art is looked at. There are some old and wheezy jokes about the artist and the term: Bernini died at 81 after falling into the Baroque, or, While other men went mad, Bernini went Baroque. But the jokes offer little in the way of definition, and "Baroque" is by no means easy to define. Webster's Unabridged Dictionary makes a feeble one-inch stab at it and then abruptly switches to a discussion of "baroscope." Luigi Barzini, the brilliant Italian journalist, once attempted a definition on an American television program he produced and came up with this: "The Baroque is when you *can* draw a straight line but choose instead to draw a curve. The Baroque is when you

are bored with the melody and wish to listen to the variations."

In 1969 the newly appointed American Ambassador to England, Mr. Walter H. Annenberg, presented his credentials to Queen Elizabeth II. The Queen, hoping to lighten the ritual, engaged Mr. Annenberg in small talk. How, she asked, did he find the accommodations at the embassy? Mr. Annenberg said, "We are in the embassy residence subject, of course, to some of the discomfiture as a result of the need for elements of refurbishing and rehabilitation." The remark prompted a student of the scene to say that Mr. Annenberg was not speaking English or American; he was speaking Baroque.

It may appear from the foregoing that "Baroque" is not a term of unreserved praise. In fact it was intended as a derogatory word when it first came into widespread use in Europe about 200 years ago, meaning something that was bizarre, excessively ornate, distorted and possibly dishonest. Benedetto Croce, the revered 20th Century Italian philosopher, held that view. Baroque art, he wrote, is "the art of bad taste," and he suggested an interesting etymology for the word: possibly it derives from a synthetic word, "b-a-r-o-c-o," composed of the initial letters of six other words put together by inventive medieval monks as an aid in teaching dullards how to grapple with a complicated form of logic. Scholars other than Croce, however, hold that "Baroque" very likely stems from the Spanish word "*berrueco*" or the Portuguese "*barroco*," used to describe the irregularly shaped pearls that once were prized for making exotic jewelry in the forms of centaurs, dragons and other fabulous creatures. In Paris, dealers in secondhand bottles have long described the ordinary type as *normale;* those of odd size and shape —*apéritif* bottles, for example—as *baroque.*

Whatever its derivation and original meaning, "Baroque" has undergone a good deal of modification over the years and is now a perfectly respectable term. It is sometimes used as a period label, to designate the historical era that falls approximately between 1600 and 1750, and it is also a term that describes the dominant style in art (and music, drama, poetry, prose and life in general) of that time. In comparison with the art of the High Renaissance, Baroque art is a good deal more colorful, higher-pitched and "theatrical." Baroque art makes a direct appeal to the emotions of the viewer: a close look at Bernini's *Pluto and Persephone (pages 24-25)* will reveal exquisitely carved marble tears rolling down Persephone's cheeks. In Baroque paintings it is not uncommon to find a figure in the foreground staring straight at the observer, seeming to lock eyes with him as though trying to involve him in the action of the picture. Baroque gestures in painting and sculpture are vividly dramatic, as in Bernini's *St. Longinus* or his *Constantine (page 180).* Facial expressions of rage, pain, piety or ecstasy are so explicitly rendered that they verge on caricature. Indeed, Bernini was one of the first great caricaturists.

Baroque "exaggeration" jostles the staid Anglo-Saxon idea that

understatement in esthetic matters is best. To some, like Ruskin and Croce, the Baroque seems insincere or even hypocritical, and to others it seems hackneyed. Could not Bernini have thought of any more original means of expressing piety, for example, than to show a man (*Gabriele Fonseca, page 149*) with his eyes raised heavenward and his hand clutching his garments in the vicinity of his heart? But the fact is that it *was* original in Bernini's time.

It is a pity to look at Bernini's art without some sense of its context and purpose. His world was one of religious fervor and he was a very pious Catholic; for much of his life he attended Mass every morning, took Communion twice a week, went on an annual religious retreat and daily read passages from his favorite book, *The Imitation of Christ* by the German monk Thomas à Kempis. More significantly, Bernini and his contemporaries were employed principally by a line of popes and other wealthy churchmen who, like their Renaissance predecessors, were bent on making Rome Christendom's most splendid city, befitting the traditional seat of the Catholic Church. Moreover, these artists saw their mission as one of religious persuasion as well as beautification. It was their goal above all else to convince viewers of the true teaching of the Church. It was their task to convince men that the Resurrection was real, that the visions and sufferings of the saints were real and may be shared by the faithful, and that religious miracles have not only taken place in the past but are taking place before our eyes.

To be properly persuasive it was necessary for Baroque artists to speak in terms that were used and understood by ordinary men. It was also necessary to touch their emotions—it is only through emotion, not dry reason, that most men can be persuaded. (One of the classical works that had strong influence on Baroque thought was Aristotle's *Rhetoric*. In it Aristotle devoted many pages to the effectiveness of the emotions as a fundamental element in the art of persuasion.) Bernini was addressing his fellow countrymen, and he was using gestures and images that his countrymen themselves used. If the expressions seem exaggerated, it must be remembered that they were in no way exaggerated in 17th Century Italy. To this day Italians use gestures far more abundantly than other people, and with more effect and wit. The American actor and film director Orson Welles once noted that Italy is crowded with actors, about 50 million of them, and that almost all of them are good —the only bad ones are on the stage or in films. But it is unwise to suppose that Italians are insincere merely because of their vividness and mobility of expression, just as it is unwise to imagine (as many Italians do) that Anglo-Saxons do not use vivid gestures because they have no emotions to express.

A good deal is known about Bernini's art, but far less about the man. He did not feel obliged to write explanatory treatises nor did he engage in voluminous correspondence. Even at the darkest moment of his career, a period when he was briefly and unjustly pilloried by his enemies, he said very little. Instead he commenced

to carve a marble group, *Truth Revealed by Time,* which he intended to speak for him. Thus it is not in anecdotes but in stone that he must be discovered.

Gianlorenzo Bernini was born on December 7, 1598, in Naples. His father, Pietro, also a sculptor, had gone there from his native Florence to work for the Neapolitan court and had married a local girl, Angelica Galante. Whether or not there is any truth in the traditional characterization of Florentines as precise and Neapolitans as temperamental, Gianlorenzo's son, Domenico, many years later seemed to detect that combination in his father, writing that he was "*aspro di natura, fisso nelle operazioni, ardente nell'ira*" (stern by nature, steady in his work, passionate in his wrath).

Were it not for his remarkable son, Pietro Bernini's name would be little noted now. Nevertheless, he was among the best sculptors of his generation, and although present-day critics downgrade him as being superficial, it seems likely that in time he and several of his contemporaries will be recognized as the extraordinarily creative men they were. Pietro's great sculptural skill was transmitted to his son at a very early age. The boy was a prodigy, perhaps the most precocious in art history; others have produced fine drawings or even paintings when they were children, but Bernini seems to have been the youngest to have worked successfully with chisel and stone. The first biography of him, published only two years after his death by the Florentine historian Filippo Baldinucci, notes that "he was so extraordinarily pleasing, that at the age of eight he made a small marble head of a child that was the marvel of everyone." Bernini himself later recalled that when he was eight his father was smilingly warned by a cardinal, "Watch out, he will surpass his master," to which Pietro replied, "It doesn't bother me, for as you know, in that case the loser wins."

In 1605 or 1606 Pietro left Naples for Rome, where an energetic young cardinal, Camillo Borghese, had lately assumed the papacy as Paul V. The new Pope had a number of artistic projects in mind and during his 16-year pontificate was able to carry out several of them. These included the completion of St. Peter's (begun in 1506 to replace an earlier Christian basilica), the building of smaller churches, palaces and fountains, and in particular the creation of a splendid funeral chapel for himself in the venerable Church of Santa Maria Maggiore. Pietro Bernini was employed there. Evidently he made a favorable impression on Paul V, for young Gianlorenzo was soon allowed to have the run of the Vatican's art treasures. According to Baldinucci the boy "spent three continuous years from dawn until the sounding of the Ave Maria" studying and copying antique and Hellenistic works and the paintings of Raphael and Michelangelo.

At about the age of 11 Bernini carved a portrait bust *(Monsignor Giovanni Battista Santoni)* that aroused such acclaim in Rome that the Pope asked to have the boy brought before him. On command Gianlorenzo sketched a head of St. Paul "with free bold

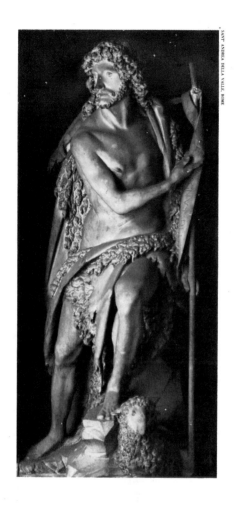

This strange and sensitive representation of St. John the Baptist epitomizes the work of Pietro Bernini, father of Gianlorenzo Bernini. Although the elder Bernini was a sculptor of considerable ability, his crowning contribution to art was not his work; it was the childhood encouragement and training he gave his immensely talented son.

13

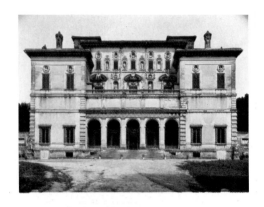

The Galleria Borghese *(above)* stands in Rome's Villa Borghese—a rolling expanse of gardens and parks nearly four miles around. Designed by the Dutch architect Vasanzio in 1613 for Cardinal Scipione Borghese, the building was a rural retreat. Originally covered with many niches, reliefs and classical statuary, the Galleria was partly restored in the 19th Century when much exterior decoration was removed. The photograph below shows in detail a portion of the central façade that remains much as it was in the 17th Century.

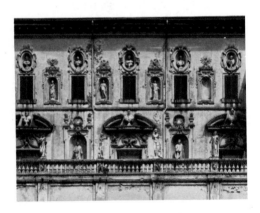

strokes in half an hour to the keen delight and marvel of the Pope," who immediately concluded that Bernini's further education was a matter of importance to the papacy. "Therefore he entrusted Bernini to Cardinal Maffeo Barberini, a great devotee and patron of the noblest arts, who fortunately happened to be present," wrote Baldinucci. "He strictly enjoined the Cardinal not only to attend with every care to Bernini's studies but also to give them fire and enthusiasm. He told him that he stood as the guarantor of the brilliant result that was expected of Bernini. And then the Pope, after encouraging the boy with kind words to continue the career he had begun with good heart, gave him 12 gold medals, which were as many as he could hold in his hands, and turning to the Cardinal, said prophetically, 'We hope that this youth will become the Michelangelo of his century.' "

The introduction of Bernini to Maffeo Barberini could scarcely have been more fortunate—in 1623 the cardinal would ascend the papal throne as Urban VIII, the greatest patron of sculpture in the history of the Church, with a high regard for Bernini both as artist and friend. But in the intervening years Bernini would remain at the service of the Borghese family, making a portrait bust of Pope Paul V and carving several major pieces for the Pope's wealthy and influential nephew, Cardinal Scipione Borghese. The latter had a large villa near the Pincian Gate in Rome, so adorned with bas-reliefs and statue-filled niches that it appeared to have been designed by a confectioner. (The villa, somewhat the worse for wear after more than 350 years, survives as a museum.) Among his accumulation of statuary, Cardinal Borghese maintained a superb collection of antique sculpture; he also had one of the finest picture galleries of his time. Some of the paintings, it is true, were not precisely his property. As nephew of the Pope, who was not only the spiritual ruler of Rome but its autocratic temporal ruler as well, the cardinal was able to pursue his love of art without the problems that often inconvenience other collectors. Fond of Raphael's *Deposition from the Cross*, which was located in a chapel in Perugia, he ordered it stolen and delivered at night to his collection. When the painter Cesari d'Arpino fell afoul of the papal tax officials, Cardinal Borghese arranged to have d'Arpino's personal possessions confiscated and turned over to him. Among them were a number of works by Rome's greatest painter of the time, Caravaggio.

Bernini spent much of his adolescence working for Cardinal Borghese and evidently got along well with him; the pair of almost identical marble busts of the prelate *(page 132)* that he made in later years indicate that he saw the cardinal as an amicable, lively man. Bernini also made a friendly pen-and-ink caricature of Borghese, copies of which were widely circulated in Rome without arousing the cardinal's displeasure.

The first of Bernini's works in marble for Borghese, made when the artist was 10, is *The Goat Amalthea (page 21)*. This small group, illustrating a scene from classical mythology, was iden-

tified as Bernini's only about 30 years ago. Previously, because of its classical subject and its realistic treatment, resembling that of Hellenistic sculpture, it was thought to be an antique, perhaps 1,800 years old. There is no indication that Bernini intended it as a fake —he had simply studied Cardinal Borghese's collection of ancient works so well and had developed such skill that the piece invited misattribution, even by experts. Soon after *Amalthea* he produced a second small work with a classical theme, *Boy with a Dragon*, which is evidently based on the legend of the infant Hercules strangling two snakes that had invaded his cradle. This piece, too, has confused experts in the past. There are records of its existence in Rome until 1702, when it was presented to King Philip V of Spain, but at some time thereafter it vanished from the Spanish royal collection. It surfaced 200 years later in a private collection in Paris, described as "French, anonymous, 18th century." By 1961 it had found its way back to Italy, where a scholar came very close to identifying it, attributing it not to Gianlorenzo Bernini but to his father, Pietro. Recently, however, documents have been found in the Vatican Library that establish it conclusively as Gianlorenzo's.

The first religious sculptures by Bernini, statues of St. Lawrence (his patron saint) and St. Sebastian, reveal that he was as much involved in studying the Renaissance as antiquity. In its pose and precise anatomy, his *St. Sebastian* shows the influence of Michelangelo and may derive from the Christ in Michelangelo's *Pietà* in St. Peter's, which Bernini must have known very well. But the statues of the two martyred saints also contain some foreshadowing of the sculptor Bernini was soon to become—unlike Michelangelo and, for that matter, unlike any sculptor the world had yet seen.

The legends on which he based these works were popular subjects among Italian artists from the beginning of the Renaissance onward. The story of St. Sebastian tells that he was an officer in the Imperial Guard in Rome under Diocletian and was secretly a Christian. When his faith was discovered he was sentenced to be shot to death by archers, who completed their work and left him for dead. However, he was revived by a Christian woman; then Diocletian ordered him killed by beating with cudgels, and this time the executioners made no mistake.

St. Lawrence, one of the Christian deacons of Rome, was martyred in 258 A.D. and buried at the spot where the Church of San Lorenzo Fuori le Mura (St. Lawrence Outside the Walls) now stands. According to tradition, he had been ordered by a pagan city official to surrender the treasures of his church, whereupon he gestured toward a group of the poor and the sick and said, "There is the church's treasure." For this defiance St. Lawrence was roasted to death on a gridiron.

Both St. Lawrence and St. Sebastian were far easier subjects for painters than for sculptors. With tempera or oil an artist could make the most of the dramatic possibilities—the flames and smoke around St. Lawrence and the shafts of arrows protruding from the

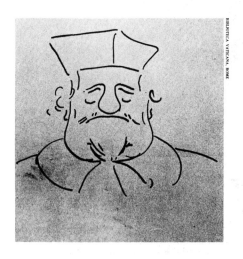

Cardinal Scipione Borghese, who spent much of his personal fortune subsidizing artists, is the subject of a warm caricature by Bernini. A pudgy and jovial man, the cardinal was famed for his lavish banquets and entertainments, many of which were held at the Villa Borghese.

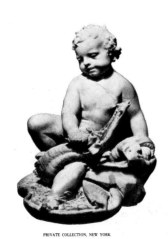

The youthful Bernini's precocious mastery of sculpture is evident in these two small but expressive statues. In *Boy with a Dragon (above)*, executed when he was about 16, Bernini made a charming adaptation of a classical motif—the baby Hercules killing snakes. It was originally used in a fountain decoration. *Boy Bitten by a Dolphin (below)*, probably finished a few years later, seems like the alter ego of the earlier work.

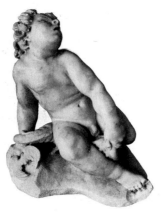

body of St. Sebastian. Sebastiano Zuccato, the Venetian artist who was the teacher of the great Titian, kept on painting arrows until he had them sticking out of the saint's thigh, abdomen, hip, breast and neck. Other painters have represented St. Lawrence in the midst of a leaping conflagration. But since long, thin, unsupported arrow shafts or soaring flames are not easily executed in marble, it might be supposed that Bernini would have ignored St. Sebastian and St. Lawrence in favor of saints whose martyrdoms lent themselves more readily to portrayal in stone. Nevertheless, these were the first he chose. His arrows and flames are necessarily limited, to be sure, but it is remarkable (and typical of Bernini) that at the age of 18 he attempted to represent them. No less remarkable were the extremes to which he is said to have gone to achieve fidelity of emotional expression. According to his son, Domenico, when the young sculptor was carving St. Lawrence on the gridiron he thrust his own leg into a fire in order to note, in a mirror, the tortured look on his face.

Both *St. Lawrence* and *St. Sebastian* are about three-quarters life size. Bernini soon turned to full-scale and over-life-size figures, and within a short time—before he was 25—developed some ideas and techniques that were to change the course of European sculpture. These were set forth in a series of remarkable pieces made for Cardinal Borghese and still on exhibit in the cardinal's villa. In part the ideas were brilliantly new, in part old, and it is intriguing to see where Bernini agreed with the past and where he broke with it.

For one thing, more than any artist who had gone before, Bernini brought a new dimension, a sense of time, to sculpture. Classical and Renaissance sculptors had often carved figures of athletes or warriors in action. By the very nature of sculpture the action was frozen, but not necessarily frozen at the most dramatic point in time. The famous *Laocoön* group of the Second Century B.C. in which a father and his two sons struggle with a couple of enormous snakes, is a fair example. If the group were suddenly to come alive, the struggle would immediately resume, but for an indefinite period. Nothing in the sculpture suggests that a climax is about to occur right now, at once. Similarly, the Greek *Discus Thrower* is shown gracefully winding up, but he is not about to throw the discus in the next split second; perhaps he will take another half minute, or he may even balk and not throw the thing at all. The same timelessness—the lack of a feeling of imminence—can be felt in most classical or Renaissance sculptures of great men. Moses and St. Paul, for example, are usually shown in powerful but passive attitudes, not at the overwhelming instant when they realize that the voice they hear is God's. But in Bernini's view it was precisely such instants that the artist must capture because in them the truth is revealed.

Later in his career Bernini would use his conception of the transitory, climactic moment in the service of his Church, and would

employ it in his figures to make visible the arrival of intuitions, revelations and divine messages. However, his first spectacular use of it was far removed from that, involving not a religious event but a wild physical one. *Apollo and Daphne (pages 28-29)*, made in the early 1620s, illustrates a story in the *Metamorphoses* of the First Century Latin poet Ovid. At the beginning of Ovid's tale the young, conceited god Apollo makes fun of the child Cupid, saying that Cupid has no business playing with such manly weapons as bows and arrows. Annoyed, Cupid shoots Apollo with a golden arrow that causes him to fall in love with the beautiful maiden Daphne, daughter of a river god, and then shoots Daphne with a blunt arrow tipped with lead that makes her detest him. Apollo woos her but she dashes away in terror. When the pursuing god, borne on the swift wings of love, is about to overtake her, Daphne implores the river deities to save her. In the translation of Ovid by the American poet Rolfe Humphries:

> *. . . hardly had she finished,*
> *When her limbs grew numb and heavy, her soft breasts*
> *Were closed with delicate bark, her hair was leaves,*
> *Her arms were branches, and her speedy feet*
> *Rooted and held, and her head became a tree top,*
> *Everything gone except her grace, her shining.*

The instant of Daphne's metamorphosis is so much a painter's subject that it is almost inconceivable that anyone would attempt to show it in stone. Yet that is the instant Bernini selected, carving a sheath of bark materializing around her legs, leaves exploding from her flying hair and outstretched fingers, and her feet literally taking root in the ground. The work is a tour de force in stonecutting that may have no equal in European art. The sculptor himself, long afterward, remarked that he had never surpassed its lightness. But it was not only the physical transformation that concerned him; he also caught the momentary psychological states of the pursuer and the pursued—Apollo's expression changing from triumph to amazement and Daphne's from terror to numbness.

It may appear puzzling that young Bernini, while working for Cardinal Scipione Borghese and under the avuncular supervision of Cardinal Maffeo Barberini, should have produced a major work with so pagan a theme. However, the two cardinals were broadminded men. Cardinal Borghese, in addition to his galleries of sculpture and painting, had the best collection of antique pornography in Rome. Although not so well equipped in that regard, Cardinal Barberini, the future pope, still had a keen eye for liveliness in whatever form. In order to rationalize the pagan subject it was only necessary, in accordance with a long tradition of artistic license, to point a proper Christian moral. This Barberini did by composing a Latin verse that was engraved on a plaque set on the base of the *Apollo and Daphne: "Quisquis amans sequitur fugitivae gaudia formae fronde manus implet baccas sev carpit amaras"*

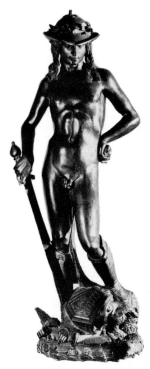

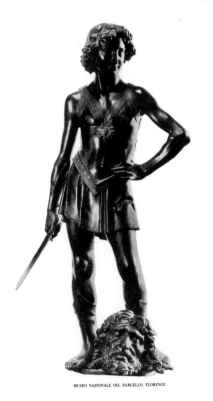

Renaissance sculptors usually portrayed Goliath's slayer, David, as a boyish figure, emphasizing his youthful grace. Both Donatello *(above)* and Verrocchio *(below)* stressed David's litheness by showing at his feet the massive severed head of the giant. Each of these two statues stands less than five and a half feet high.

(Whoever, loving, pursues the joys of fleeting forms, fills his hands with sprays of leaves and seizes bitter fruits). As long as that lesson is borne in mind it is possible for an observer to enjoy the work without endangering his soul.

Another of the characteristics of the style evolved by Bernini is its intense realism. The rape of Persephone, a daughter of Zeus, by Pluto had long been a favorite subject of artists, but many of them seem not to have given much thought to the psychology of the act. Rape scenes before Bernini's time often showed ladies simply rolling their eyes heavenward and throwing up their arms to indicate the dreadful fate that was overtaking them. In the most celebrated rape sculpture of the preceding century, Giambologna's *Rape of a Sabine Woman,* the victim is not putting up much of a fight. Apparently Bernini thought such passivity improbable—would not a girl kick and scratch, try to escape and certainly howl? His dynamic version of *Pluto and Persephone* suggests his answer.

Psychological realism, an insistence on the credibility of the actions and emotions depicted, was only part of Bernini's conception of sculpture. Physical realism was equally important—if, for example, a man is carrying a naked girl, his fingers will not be merely resting against her flesh but pressing deeply into it, as they are in *Pluto and Persephone.* This detail *(page 25)* is one of the most remarkable in carved (as opposed to modeled) sculpture, indeed so striking that it draws attention from other and more astutely rendered elements of the work. Among these is one that is a trifle difficult to discuss without arousing the hilarity that often—and often rightly—greets specialized art criticism, but it is worth the risk. Take a look at Persephone's left big toe. Sculptors before Bernini's time would have carved it parallel with the other toes, but Bernini made it turn upward and outward because he had taken the trouble to consider what a naked, scared girl might do with her toes.

There is another aspect of Bernini's style that is best looked at in the light of earlier ideas. The sculptors of Michelangelo's day had invariably carved their works from single blocks of stone. Michelangelo himself had a mystical attitude toward that; he spoke of "liberating" figures that were imprisoned inside the marble. It was only necessary, he suggested, to cut away all the extraneous material that encrusted the hidden shape. The natural boundaries of the marble block were those of the trapped figure within, which might be pressing its head against the top, a knee against one side, an elbow against another and so on, as in Michelangelo's unfinished *St. Matthew* or his series of *Captives.* Accordingly, it was possible for a Renaissance thinker to advance the notion that a good piece of sculpture could safely be rolled downhill—if it was true to the block it would survive unbroken.

Most sculptured Renaissance figures were not only physically limited by their blocks of stone; they were spiritually bound as well. They made no effort to "communicate" with the spectator; they did not invite him to enter the space in which they were liv-

ing, nor did they presume to enter *his* space. They were insulated, withdrawn, objects on exhibition. The three famous *Davids* of Donatello, Verrocchio and Michelangelo are excellent examples of that self-containment. Bernini's *David* *(pages 26-27)*, which is often called the first truly Baroque statue, is far different.

The difference is not only in the realism of Bernini's work, although that is remarkable enough—David's body is that of a normally muscular young man and his determined and angry expression is the look of a back-country shepherd who really intends to kill his enemy right now, this minute. The varying textures of the statue—David's plaited leather sling, the course goatskin pouch for his slingstones, his smooth drapery and flesh, his tousled hair —are all cut with an eye to reinforcing the impression of reality. But what is most startling about the statue is its use of space: David is about to sling his stone past the spectator at an unseen Goliath looming *behind* the spectator. The segregation of spectator and statue is abolished; both now stand in the same space and the spectator is involved in the action. Indeed his inclination, if he is directly in front of the *David*, is to get out of the way. And Bernini, by involving the spectator, has also caused him to make his own contribution to the work. The spectator mentally creates Goliath behind him; observing the angle and direction of David's fierce glance, he even senses exactly how tall Goliath is and where and how close he is standing.

This is involvement to a degree rarely approached before Bernini, and it is characteristic of him. In his career as a religious sculptor, which began soon after he completed the *David*, Bernini did not merely portray saints who had glimpsed the supernatural or believed they had. He set out to involve the spectator so deeply that the spectator himself felt something akin to what the saints had experienced. To this end he used all his command of realism, his grasp of the crucial instant, his new conception of artistic space and assorted other ideas. Among them was the suggestion of different levels of reality. In the *David*, for instance, there appear to be three levels: the flesh-and-blood spectator exists on the first, the stone statue on the second and the imaginary Goliath on the third.

But perhaps there are still more levels. The reader of this book is imagining himself imagining Goliath. What level is that? Or since —as Bernini believed—all inspiration is heaven-sent, is there yet a higher level on which everything exists in the mind of God? This is not wholly a 17th Century notion. The American author Thornton Wilder touched it relatively recently when he caused a character in the play *Our Town* to address a letter to someone who lived in "Grover's Corners; Sutton County; New Hampshire; the United States of America; Continent of North America; Western Hemisphere; the Earth; the Solar System; the Universe; the Mind of God." Doubtless Bernini might have been a little less specific, but he would have relished Wilder's thought. Fired by his own piety, Bernini tried to involve everybody in the mind of God.

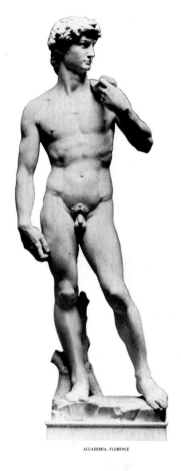

ACCADEMIA, FLORENCE

Michelangelo's *David* differed from earlier conceptions in being less boyish and in becoming a gigantic figure himself—the work is almost 17 feet high. But he is still inanimate. Bernini changed the entire conception by showing the figure in motion, in the act of slaying Goliath *(pages 26-27)*. This emphasis on drama is a characteristic of the Baroque art of Bernini and others.

Gianlorenzo Bernini liked to boast that even as a young boy he "devoured marble and never struck a false blow." His precocity was attested to by painter Annibale Carracci, who is said to have remarked that Bernini had reached a point in his childhood that others might glory to achieve in old age. The tribute is all the more impressive because Carracci uttered it when Bernini was no more than 10 years old. At that tender age the child prodigy was extremely adept at imitating the style of classical sculptors—as seen in the work opposite.

The awesome skills of young Bernini were not fully demonstrated until 1618, when he began a series of works commissioned for Cardinal Scipione Borghese. For sheer virtuosity in shaping marble so that every nuance of expression is captured, Bernini has never been surpassed. Before his 24th birthday these early works had established his reputation as the greatest sculptor of the era.

Today, these early works can be seen in Cardinal Borghese's Roman villa, now the Borghese Gallery. But they are not displayed as Bernini wanted them to be seen; they are freestanding. Bernini had designed them to be placed against a wall, so that a single point of view would dominate the viewer's attention. The photographs on the following pages recapture the views originally intended.

Myths in Marble

This cheerful group was carved by Bernini as a child, when he was mastering the techniques of marble carving in the classical style of ancient sculptors. Inspired by a legend from Greek mythology. it shows the infant god Zeus and a friendly faun being fed by the goat-nurse Amalthea.

The Goat Amalthea, 1609

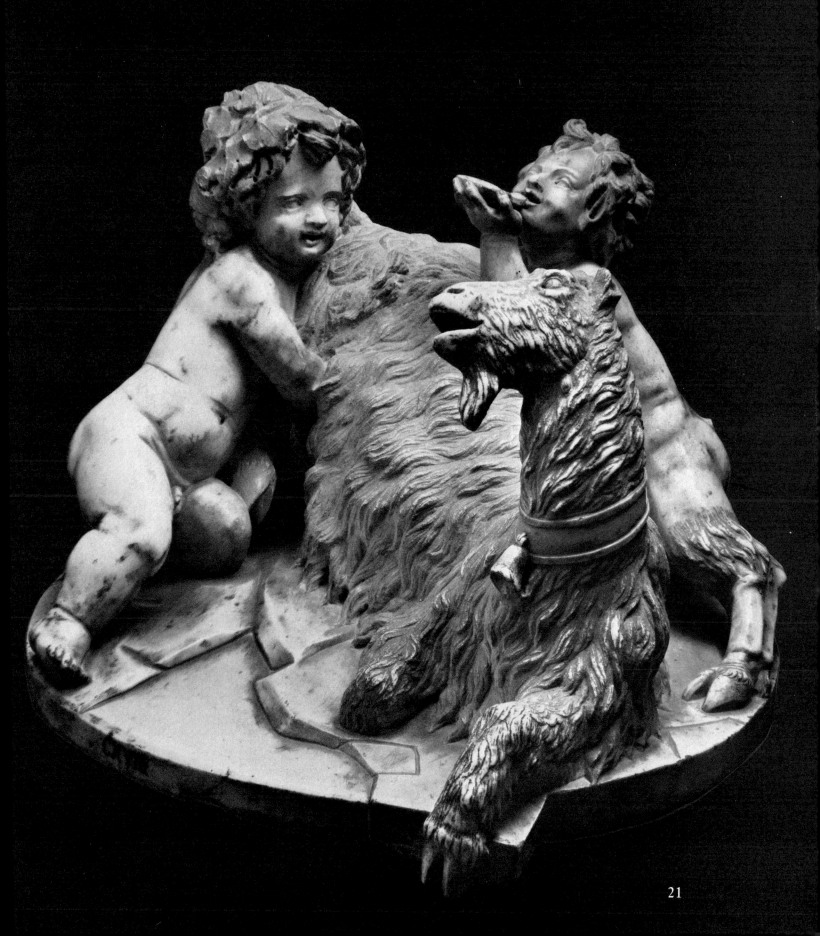

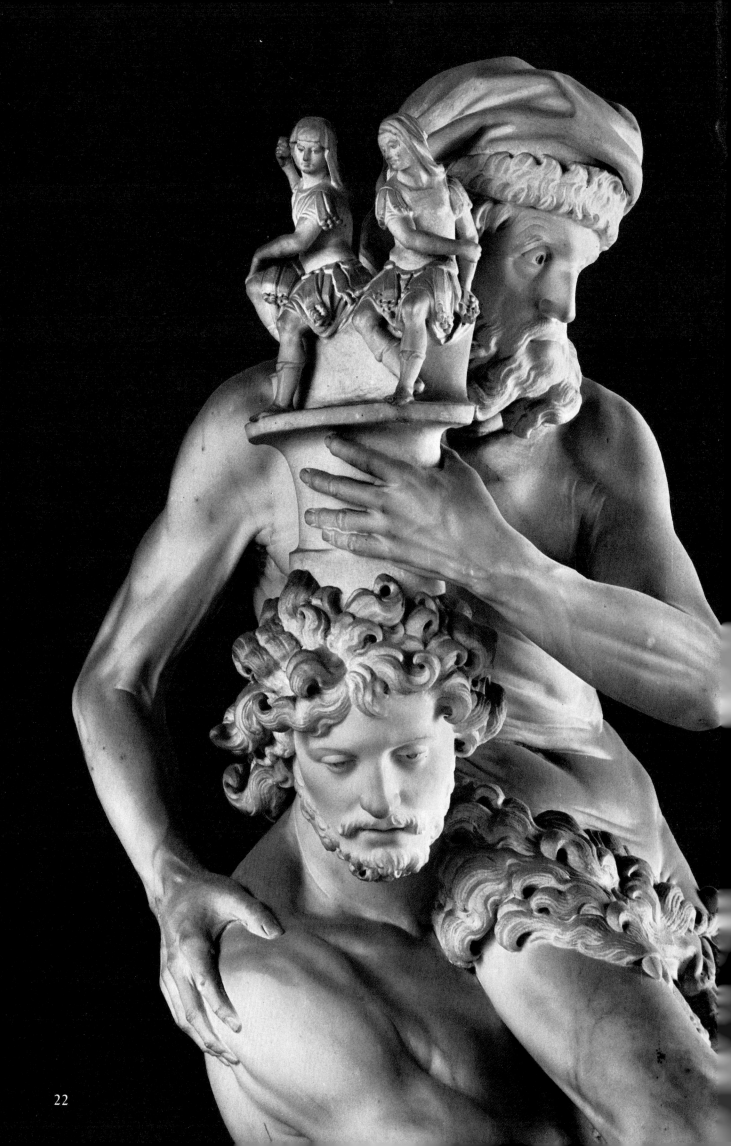

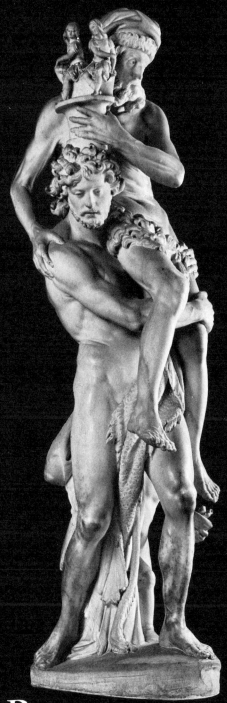

Bernini's first major work shows a muscular Aeneas, hero of Vergil's *Aeneid* carrying his father Anchises from burning Troy. The statue offers an unusual contrast between traditional style—exemplified by the idealized heroism expressed in the face of Aeneas —and an early example of Bernini realism: the wide-eyed horror of the dazed old man, who clutches a salvaged statuette of his household gods.

Flight from Troy, 1618-1619

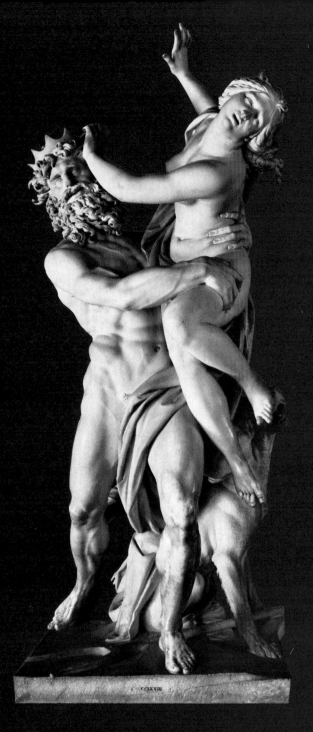

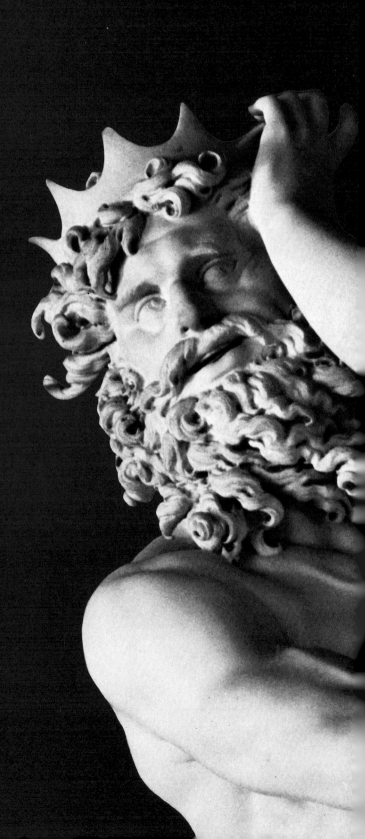

In *Pluto and Persephone* Bernini displayed for the first time the dazzling power of his emerging style, with its full-blown realism and dramatic visual impact. The work depicts the mythological moment when Pluto, the love-smitten god of the underworld, carries his still-struggling abducted bride across the threshold of his hellish kingdom. Carving marble as deftly as if he were modeling clay, Bernini portrayed the terrified girl's futile struggle in the firm grip of Pluto, whose fingers press deeply into her flesh.

Pluto and Persephone, 1621–1622

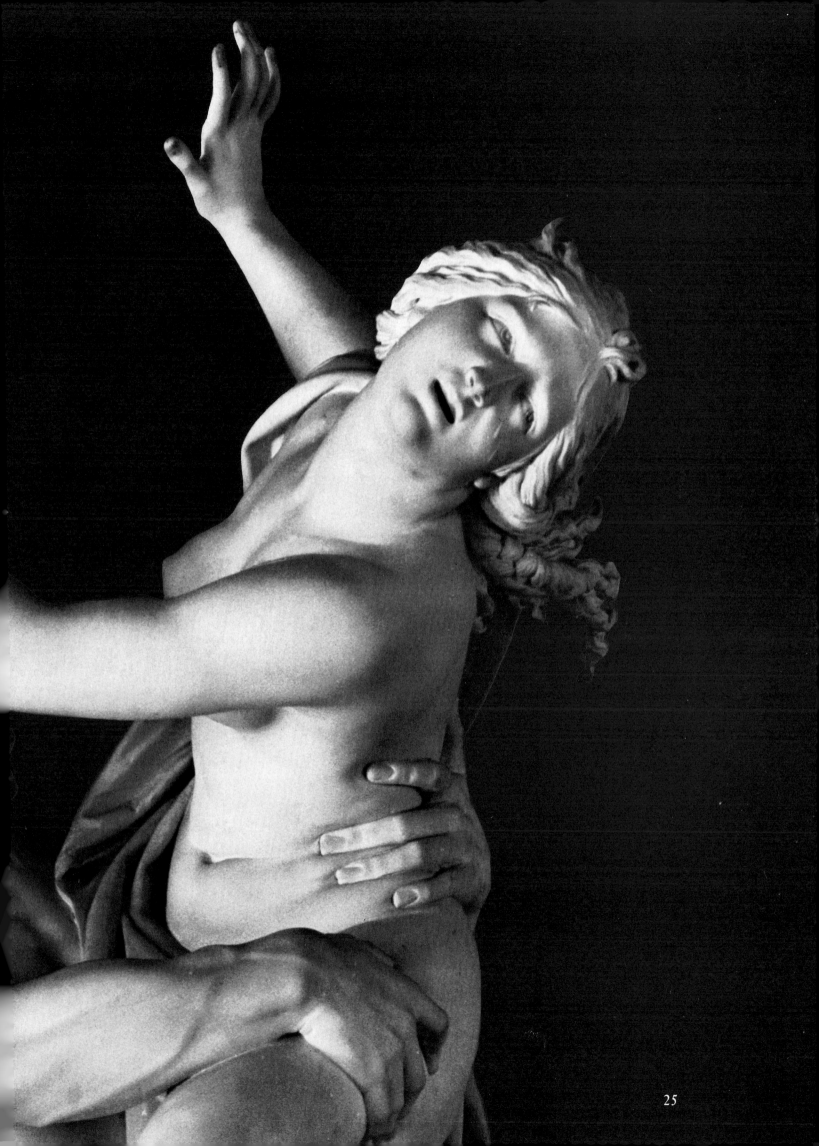

25

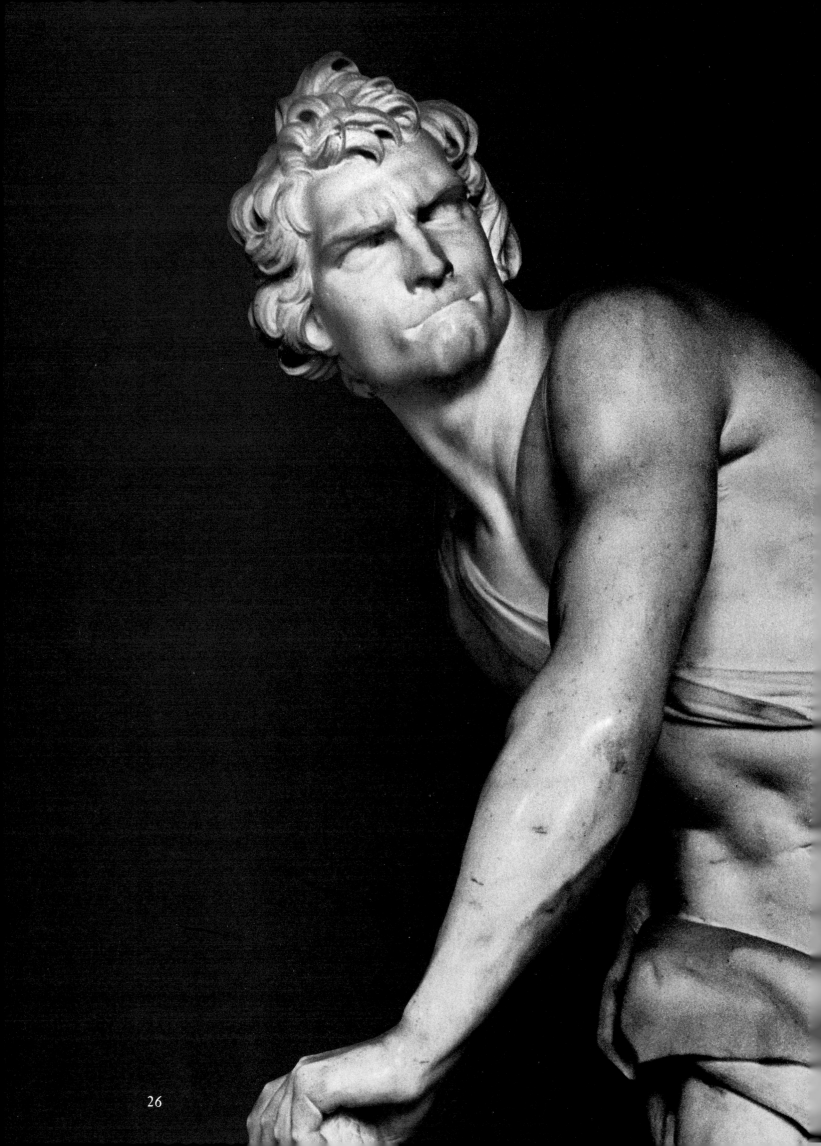

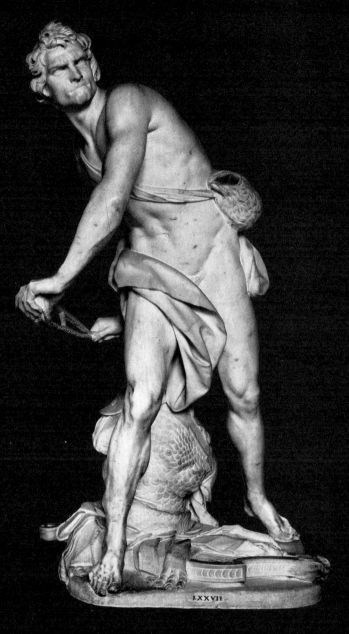

For his epic statue of the Biblical hero David, which he conceived and executed in just seven months, Bernini carved a youthful warrior, standing poised over his castoff harp and armor and grimacing with determination. David's every muscle is tensed at the instant before he flings the fatal stone at an unseen Goliath, whose presence Bernini effectively suggests somewhere behind and above the viewer. As a subtle extra touch of realism, Bernini shows David's muscular foot tensely gripping the base of his own statue. His tight-lipped facial expression is actually Bernini's own, copied in reflection from a mirror that was sometimes held by no less a personage than the artist's admiring friend Cardinal Maffeo Barberini.

David, 1623

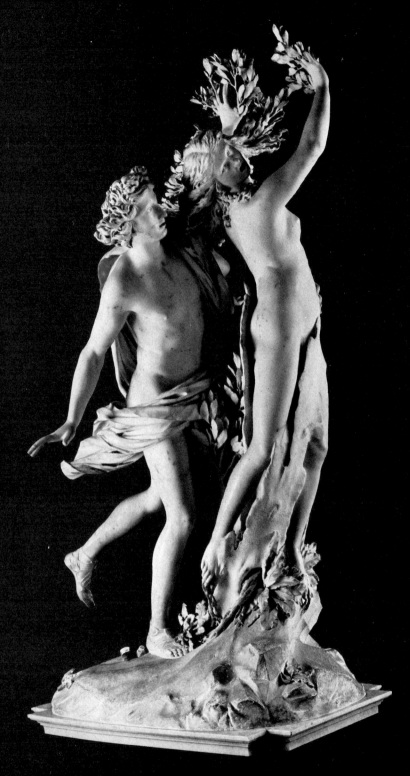

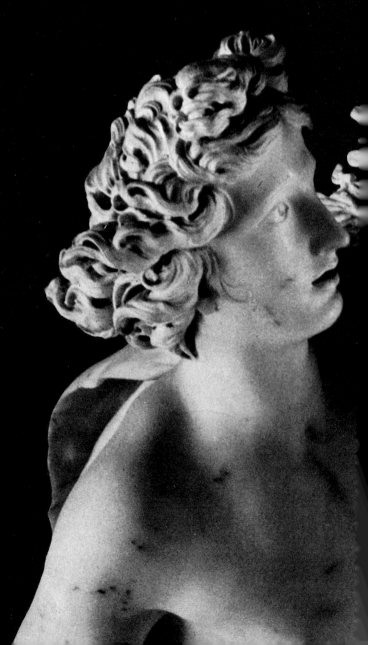

Bernini's virtuosity reached its zenith in his electrifying *Apollo and Daphne*. In re-creating the moment when the sun god catches the fleeing nymph, Bernini faced the formidable challenge of rendering the event in marble! Daphne, as in the legend, turns into a laurel tree before the viewer's eyes. His handling of the delicate marble leaves sprouting from her fingers and hair and the bark springing up around her body created a sensation. According to Bernini's biographer Filippo Baldinucci, "all Rome rushed to view it as though it were a miracle."

Apollo and Daphne, 1622-1624

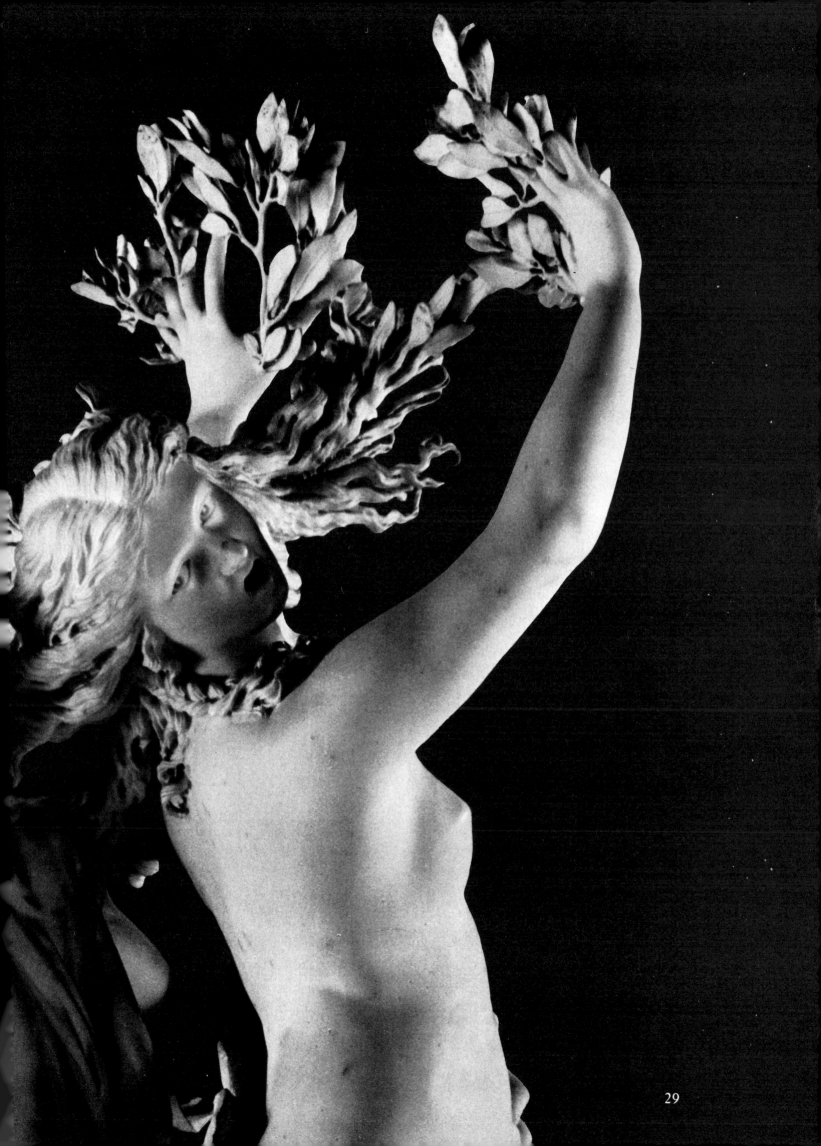

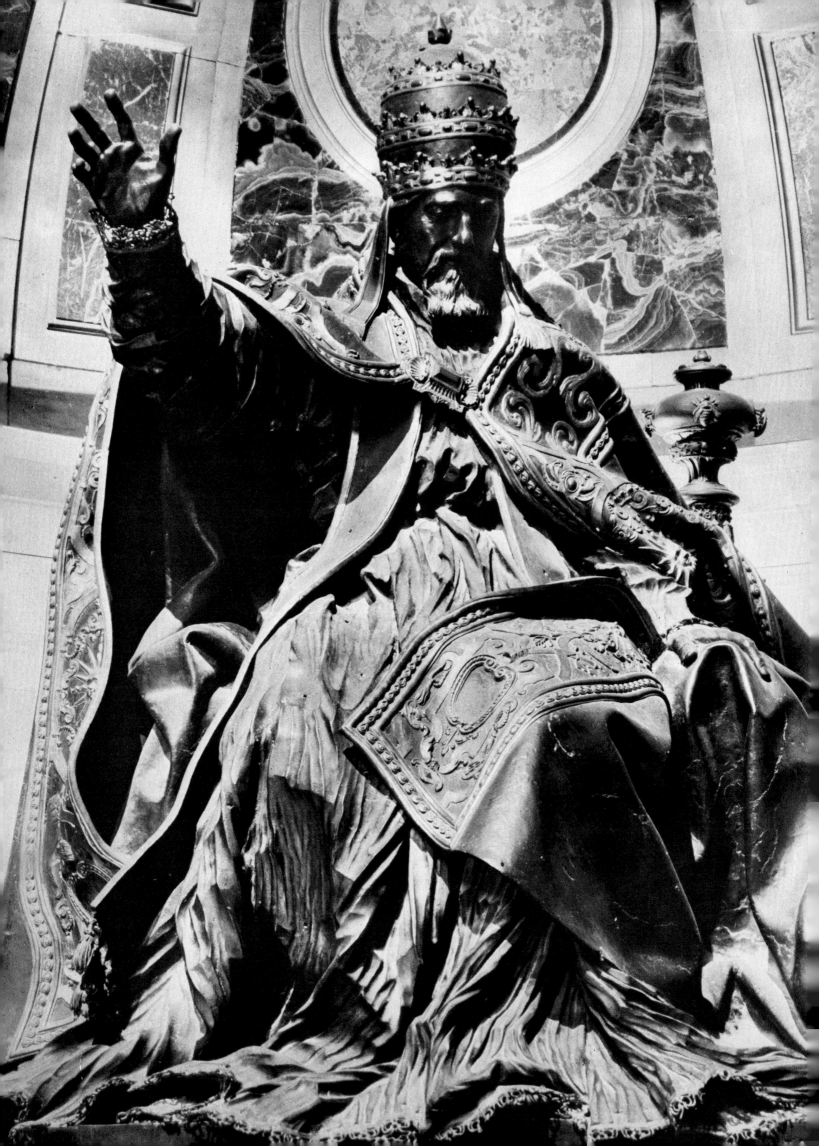

II

The Pope's Favorite

Hand raised vigorously in
benediction, Pope Urban
VIII epitomizes benign
power in this imposing statue
by Bernini, the prime
recipient of Urban's artistic
patronage. The statue is the
dominant feature of the
lavish tomb that Bernini
designed for Urban in St.
Peter's. Bernini began work
on the monument in 1627,
early in the Pope's reign; it
was completed in 1647,
almost three years after
Urban's death.

Soon after he assumed the papacy as Urban VIII in 1623, Maffeo
Barberini is reported to have summoned Gianlorenzo Bernini, then
24 years old. "It is your great fortune, Cavalier," he told his friend
and protégé, "to see Cardinal Maffeo Barberini Pope, but our for-
tune is far greater in that Cavalier Bernini lives during our pon-
tificate." Whether the Pope used precisely that Baroque prose is
of little consequence; what he was saying in effect was that a mo-
mentous day had arrived. The greatest art patron of the 17th
Century and its greatest sculptor now had the opportunity to join
forces to do the Lord's work.

Barberini was one of the most sophisticated men ever to be elect-
ed pope. Born in Florence in 1568 to a wealthy and long-established
merchant family, he had delayed entering the priesthood until he
had taken a degree in law, but once in the Church he rose with re-
markable speed. At 24 he became governor of Fano, an Italian
seaport city under papal jurisdiction; at 35 he was an archbishop,
at 36 Apostolic Nuncio (Ambassador) to France and two years
later a cardinal. When he became pope he was only 55.

The intellectual community of Rome rejoiced at Barberini's
election and saw in the name he chose—Urban VIII—a sign that
his heart was in the great cosmopolitan city. Encouraging, too, was
the fact that the new Pope had a broad but keen mind, was a friend
of writers, scholars and scientists—including Galileo—and had an
excellent eye for art. In his personal collection, in addition to sculp-
tures by Bernini, were paintings by such old masters as Raphael
and Correggio as well as recent works he had commissioned from
Guido Reni (*pages 52 and 53*) and Caravaggio. Urban's interests
and accomplishments also included—as a Venetian Ambassador to
the Vatican noted—"a special taste for the kind of studies that most
appeal to the French, such as polite letters, out of the way knowl-
edge, poetry, an aptitude for languages." And Urban did not
merely read poetry, he wrote it—in Italian, Latin and Greek.

In his personal life the Pope was almost ascetic. Ordinarily he

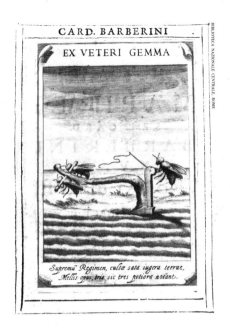

In 1631 Bernini drew the illustration above for a collection of Urban VIII's poems. Showing three bees—the Pope's family insignia—pushing a plow, the drawing hints that all will prosper under the pontiff's reign. Urban VIII was an enthusiastic poet both before and after his election to the papacy in 1623. The love poem below was written before he entered the service of the Church.

The Favors of a Beautiful Lady at the Ball

To please, my Goddess offered
Her shining hand in the dance;
Alas, in that moment I suddenly felt
My right hand taken and my heart
 enchained.

At the sound of the music of trumpets
 and song
Her feet flash in the gallant battle,
And with the bow of her sublime and
 shining eye
She excels Cupid himself in shooting.

Her loving darts rendered me
 defenseless
But she turned away her face,
Dusky visage with two white snows.

O faithless Warrior, untrue Amazon,
Making war with her cruel and
 piercing eyes,
Why did she offer her hand, a pledge
 of Peace?

arose at dawn to read his breviary or to hear or say Mass. He ate sparingly, with one chief meal in the evening. A vigorous and handsome man, he would exercise by riding horses for hours in the Vatican grounds. In the many portrait busts that Bernini made of him he emerges as thoughtful and sensitive. With all of his qualifications, Urban should have been one of the most successful and popular of popes. And yet, despite the papal commissions executed by Bernini and such outstanding Roman painters as Domenichino, Lanfranco and Pietro da Cortona (*pages 48-51 and 56-59*), his reign was a disappointing one in some respects.

One reason for Urban's difficulties is suggested by his full papal name, Urban VIII Barberini. All popes use that style, to be sure, although today it is not common to speak of Paul VI Montini or John XXIII Roncalli. However, in the 17th Century the family names—and the families—of popes were of great importance. It was customary for newly elected Vicars of Christ to shower their relatives with titles, rich salaries, pensions and presents, dispensing the most succulent patronage to their nephews. With the election of each new pope—every seven years on the average—there was an upheaval in Rome, with former favorites cast down and new ones elevated; old scores were continually being settled, sometimes even in blood. "There is no situation more difficult or more dangerous," said Gregory XV Ludovisi, Urban's predecessor, "than that of a Pope's nephew after the death of his uncle."

So enormous were the worldly benefits to be extracted from the papacy that there were occasional plots to do away with a reigning pope and install another. Urban himself was the intended victim of one of these. It happened that an ambitious young man named Giacinto Centini had an uncle, Felice, Cardinal of Ascoli, who was one of the *papabili*—cardinals who were thought to be papal material and whose chances of election had to be taken seriously. But the *papabile* cardinal was growing old, 60, while Urban showed no signs of poor health. Hoping to speed up the course of events, the nephew conspired with two friars and a Sicilian hermit to eliminate the Pope by sorcery and astrology—at that time astrologers claimed not only to know the future but to be able to put secret forces into motion to bring about desired results. The conspirators made various futile attempts for two years, and then one of the friars panicked and betrayed the others to the Inquisition in exchange for his own life. The cardinal's nephew was beheaded, while the hermit and the remaining friar, after publicly recanting in St. Peter's, were hanged. Their fate was in accordance with a bull issued earlier by Urban that directed that anyone who practiced bad magic against a pope and any members of his family was to be excommunicated, deprived of all property and put to death.

The practice of nepotism by popes, if kept within reasonable bounds, was routine and even respectable. There were only muted outcries in Rome when Urban made cardinals of his nephews, aged 26 and 19, of his brother Antonio and of another brother's brother-

in-law. What the Romans found appalling was the virtual surrender of the papal treasury to the Barberini family. Urban, who drew little distinction between his personal income and that of the Church, handed over such huge sums to his relatives that they were able to purchase great estates and, six years after he took the throne, the principality of Palestrina. Most of the Barberini were patrons of the arts, and thus some of the money was used for purposes for which posterity may be grateful, but the ordinary citizens of Rome were not so philosophical about that.

In addition to his functions as earthly head of the Church and of the Barberini family, Urban had still a third: he was temporal ruler of the Papal States, which then shared the Italian peninsula with the Kingdom of Naples, the Republic of Venice and several smaller territories. The States, with Rome as their capital, occupied a central region roughly half the size of Maine and contained about 1.5 million people. In 17th Century fashion, Urban tended to rule them as an absolute monarch. The old Roman Senate still existed, although it had long since abandoned real power. Under Urban the members of that once-august body were further reduced to debating where commemorative statues of the various Barberini should be placed. Urban was also an autocrat in Church affairs. "The only use of Cardinals these days," said a contemporary observer, "is to act as a grandiose crown for the Pope." Even in household matters Urban was a hard man. When he retired at night he insisted on absolute silence; the birds in the Vatican garden had to be killed because their chirping disturbed him.

But while Urban wielded enormous temporal power within the Papal States, this authority was sharply curtailed beyond their borders. At the time of his election the once-considerable political and military strength of the papal domain had shrunk to insignificance. In earlier centuries the popes had dictated to the sovereigns of Europe, with the power to give and take away crowns; they negotiated treaties, exacted tribute from kings and mustered armies to deal with those who disputed Church authority. However, as the rulers of France, Germany and other developing European nation-states became conscious of their own strength, the Church's temporal dominion had gradually dwindled.

Now it was overshadowed by the great power of Spain, which in addition to its home territories and its rich colonies in the New World held much of southern Italy and what is today Belgium, and through Hapsburg family connections had great influence in Austria. A second great power was France, with its foreign policy ably conducted by Cardinal Richelieu, who loomed behind the throne of Louis XIII. Pope Urban, who had a wistful inclination to rattle the Vatican sword, was not quite content to regard himself as of no consequence in big-power Europe. Fascinated by weapons, he expanded the papal gun foundry and built up an arsenal in the Vatican cellars that could equip 28,000 men. At one time he even toyed with the notion of sending papal warships and

troops to help liberate Catholic Ireland from Protestant England. But the most prudent course open to him, and the one he generally followed, was to encourage a balance of power between France and Spain—meanwhile attempting to assert the spiritual authority of Rome over both.

In eliciting awe from foreigners Rome had an obvious advantage. The city was, and for centuries had been, the religious and cultural center of Europe, or as one ambassador put it, "a sort of emporium of the Universe. To Rome people come from every country as they have done at all times to see her splendours; and it would scarcely be an exaggeration to say that they come to pay her tribute, as she is as much the motherland of foreigners as of her own citizens." Because the prestige of Rome no longer depended on her legions but on her "splendours," it was both duty and wisdom for the Pope to beautify the city with churches and fountains, piazzas, palaces, paintings and sculpture. This was *ad majorem Dei et Ecclesiae gloriam* (to the greater glory of God and the Church). Coincidentally it was also to the greater glory of Maffeo Barberini and his family, but it is only fair to say that his beautification program was undertaken with the loftiest of motives.

Urban's vision of a more beautiful Rome and his choice of Bernini to give it reality came at a fortunate time. The mood of the Catholic Church had only recently changed from one of austerity and gloomy introspection to one of relief, even of triumph. During most of the preceding century, from 1517 when Martin Luther nailed his 95 theses to the door of the Wittenberg church in protest against what he considered abuses and deceptions in Church practices and teachings, Rome had been under the attack of the Protestant Reformation. Much of Europe had broken with Catholicism, and in the darkest hours there had been pessimists who feared that the Church might not even survive. But by 1623, when Urban took the throne, the danger had passed. The Counter Reformation, a dynamic movement of self-renewal within the Church, led by such famous reforming saints as Ignatius Loyola, Francis Xavier, Philip Neri and Teresa of Ávila, had accomplished its work. England, Scotland, Holland and the Scandinavian nations remained lost to Catholicism, but the tide of Protestantism had been contained or rolled back in Poland, southern Germany, France, Austria and parts of Switzerland. After a grim time Rome was relaxed and in a mood to welcome the exuberant, extrovert art of the High Baroque—Bernini's art.

Another serious threat to Catholic authority was checked, at least temporarily, by Urban himself. The story of Galileo's struggle with the Church, which led to his trial for heresy, has been so often condensed that to many it now seems only an argument over whether the earth revolves around the sun or vice versa. In 1968, when the Church got around to reconsidering Galileo's case 326 years after his death, newspaper accounts generally stressed that point without going deeper into the matter.

Galileo did indeed believe that the earth rotates daily on its axis and that it revolves around the sun. These, of course, were not his own deductions; they had been expounded by the Polish scientist Copernicus a century before him. Galileo fell into trouble not for originating the ideas but for advocating them. His own contributions lay elsewhere, in mechanics, the study of motion, astronomy, and above all in the rigorous system of experimentation and observation upon which modern science depends.

Although he was convinced that Copernicus was correct (as were other major scientists of the day), Galileo did not set out to force Copernicanism upon the Church or to provoke a confrontation. He was a devout Catholic who loved the Church, had many highly placed friends in it and was always willing to submit to its discipline. The tragedy occurred because Galileo tried to bring about a reconciliation, not a rupture, between science and religion.

The problem that faced Galileo—and other scientists who were not willing to deal with it—was the inflexible attitude that the Church had adopted toward the interpretation of Scripture. The words of the Bible, in the Catholic view, were written by men at the direction of God and consequently were open to only one interpretation. God meant precisely what He said. If, for example, He said, through the writer of the Book of Ecclesiastes, that "the sun also riseth, and the sun goeth down, and hasteth to his place where he arose," this was a very clear indication that the sun revolves around the earth. Men must believe this, and must not be allowed to interpret the words to mean anything else or to take them as figuratively rather than literally true. It was occasionally possible, because of the fallibility of man, that some ambiguity might have been injected into the Scriptures—but in that case the sole interpretation was to be made by a board of theologians at the request of the Holy Office.

The rigidity of the Church in interpreting the Bible is understandable in the light of the century of strife that had just ended. The Reformation had been spearheaded by men—Martin Luther and John Calvin among them—who had insisted that individuals may be their own interpreters. And if this were so, might not there soon be as many interpreters as there were men in the world? Where, then, would be the word of God? Thus the Church did not view unauthorized interpretation as a minor insult to its authority but as a threat to its very life, to be countered if need be by taking the life of the heretic who dared make it.

Galileo saw clearly that his beloved science and his Church were hastening toward a dreadful collision and that a way must be found to avoid it by enlisting the Church in the cause of science. As the vehicle for what he hoped would be the grand reconciliation he chose Copernicanism. In its simple but revolutionary ideas he saw the convergence of new research and sound method in mathematics, mechanics and astronomy; in short, the science of the future. If the Church could somehow accept Copernicanism, other differences

could surely be made up; but if not, all the old prejudices would prevail. Therefore the issue was far more important than the question of whether the earth moves around the sun.

In Galileo's campaign of friendly persuasion, which began in earnest in 1611, when he was 47 and acknowledged to be the foremost scientist in Italy, he tried to show that Church dogma and Copernicanism could be made compatible quite easily. It was only necessary, he suggested, to assume that God spoke in two languages, both of which revealed the truth but in different ways. In order to make the Bible clear to its audience of common men, God dictated the Scriptures in common language and used the only figures of speech that common men could understand—the sun goes around the earth. But when God was dictating the Great Book of Nature, not being particularly concerned with revealing Himself to men, He spoke in the purest, most rigorous scientific terms—the earth goes around the sun. As may be imagined, the Church hierarchy did not take kindly to Galileo's idea, although it is not too far removed from today's working agreement between religion and science—that is, some passages of Scripture may safely be regarded as symbolically true but need not be taken literally.

After trying the foregoing and various other arguments for several years, Galileo in 1616 was admonished by the Church. In that proceeding Pope Paul V instructed a cardinal who was friendly to Galileo to warn him to abandon the tenets of Copernicanism, which had been censured by the Holy Office. It appears that the Pope's intention was to moderate Galileo's tone but not to silence him: according to the letter-of-the-law readings that were placed upon such words as "abandon" in those days, it would still be possible for Galileo to talk about Copernicanism in hypothetical terms. He could, for example, write a book in which he condemned Copernicanism with tongue in cheek, in effect arguing for it.

After his admonishment Galileo remained silent and bided his time. He had reason to hope that the Church was changing its posture. In 1620 Maffeo Barberini, then a most *papabile* cardinal, wrote a poem in Galileo's honor titled "*Adulatio Perniciosa*" ("Dangerous Adulation"), which he sent to the scientist with a very warm note asking him to see in his composition "the affectionate intention that it shall shine from the mere presence of your name."

Galileo was filled with optimism after the election of Maffeo Barberini to the papacy in 1623. From his home in Florence he journeyed to Rome and was granted six audiences with the new Pope in six weeks, a remarkable number. But when he pleaded that he be allowed to speak out once more for Copernicanism the Pope offered a very shrewd answer that has entered history as "the argument of Urban VIII." It may be, said Urban, that God, for His own unfathomable reasons, made it *appear* that the earth revolves around the sun—but without its actually doing so. Urban did, however, leave the door ajar, allowing it to be leaked out that he was not unalterably opposed to a little more debate about the sun-cen-

tered theory. Therefore Galileo, still full of hope, was emboldened to write his *Reply* to critics of Copernicanism.

The *Reply* makes some delightful points. Critics of Copernicanism had given, as "proof" that the earth does *not* rotate, the observation that heavy objects dropped from a height fall perpendicularly to the surface of the earth, whereas if the earth *did* rotate, the objects would fall obliquely. That idea, which even to this day can sometimes be passed off as common sense to the slow-witted, was widely held among the "philosophers" who opposed Galileo, but it cannot stand up against his famous "principle of relativity" expounded in his *Reply*.

Galileo contended that it is impossible to tell from experiments performed within a system whether that system is moving in an undeviating way (as for all practical purposes the earth is moving) or is at rest. He challenged the critics to go into "the largest room of a great ship, and have there some flies, butterflies and similar small flying animals; take along also a large vessel of water with little fish in it; fit up also a tall vase that shall drip water into another narrow-necked receptacle below. Now, with the ship at rest, observe how those little flying animals go in all directions; you will see the fish wandering indifferently to every part of the vessel, and the falling drops will enter into the receptacle placed below. . . . When you have observed these things, set the ship moving with any speed you like (so long as the motion is uniform and not variable); you will perceive not the slightest change in any of the things named, nor will you be able to determine whether the ship moves or stands still by events pertaining to your person. . . . And if you should ask me the reason for all these effects, I shall tell you now: 'Because the general motion of the ship is communicated to the air and everything else contained in it, and is not contrary to their natural tendencies, but is indelibly conserved in them.'"

The scientific importance of Galileo's point, for all his successors from Isaac Newton to Albert Einstein, is plain enough. So too is his method; he had "tested this more than a hundred times, making the ship move and having it stand still," while his opponents had not even tested it once, relying on what seemed obviously true but was in fact false.

A few years after publishing the *Reply*, and without new censure by the Church, Galileo felt encouraged to publish another book, the *Dialogue on the Two Chief Systems of the World*. In it there is a scientific ignoramus named Simplicio who argues that the earth is the center of the universe. Simplicio also advances what sounds very much like "the argument of Urban VIII," in which he says that God acts "in many ways which are unthinkable to our minds. From this I forthwith conclude that this being so, it would be excessive boldness for anyone to limit and restrict the Divine power and wisdom to some particular fancy of his own."

Galileo knew Urban well and regarded him as an intelligent friend. It seems inconceivable that he should have *intended* to lam-

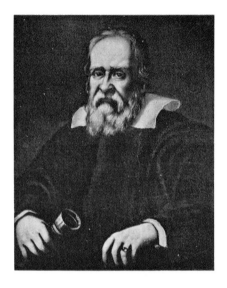

Galileo Galilei *(above)*, rebuffed in his efforts to get the Church to accept scientific discoveries, managed to mask many of his frustrations from the public. Shortly after he began astronomical observations with his telescope *(below)*, he complained in a letter to a friend: "In spite of my oft-repeated efforts and invitations, they have refused, with the obstinacy of a glutted adder, to look at the planets or the moon or my glass."

MUSEO DI STORIA DELLA SCIENZA, FLORENCE

poon the Pope through the character of Simplicio. Yet Galileo's enemies were able to convince Urban that this was the case. His pride wounded, the Pope raged at the scientist who had committed "an injury to religion as grievous as ever there was and of a perverseness as bad as could be encountered." And with that the wheels of the Inquisition began to turn.

At his trial in 1633 Galileo was confronted with the notes of his admonition of 1616—which now contained an unsigned statement that apparently had been added with the idea of trapping him. According to the statement, Galileo had not only been told to "abandon" Copernicanism but forbidden to talk about it in any way whatsoever. At that his defense collapsed, and the 70-year-old man was forced to fall on his knees before the Inquisition and renounced both Copernicanism and, indirectly, his vision of the future of science. When he arose he is said to have tapped the earth with his foot and murmured, "And yet, it does move!"

It is unfair to Urban VIII to suggest that his anger alone brought Galileo to humiliation—there were many others in the Church who considered the scientist dangerous. But the Pope felt genuinely insulted, and it is difficult to see exactly what Galileo intended when he put Urban's argument in Simplicio's mouth. Perhaps the only certainty that can be drawn from the affair is that men of principle can make a far grander mess than unprincipled ones.

Bernini stood close enough to the papal throne to observe Urban's anger at first hand as it was turned against Galileo. In the controversy between the scientist and the Church there can be no way of knowing where Bernini stood. He appears to have taken no interest in science and to have been an unquestioning follower of Church dogma and authority. It was his purpose, through his art, to try to reveal the established word and mind of God, and so it is hard to see how he could have had much sympathy for Galileo. Yet paradoxically the two had more than a little in common. Each was trying to persuade his fellow men to believe in something that cannot be seen.

Since his days as a cardinal, when Pope Paul V had entrusted him with young Bernini's education, Urban had recognized the artist's genius and its value to the Church. He extolled him as "rare man, sublime artificer, born by Divine Disposition for the glory of Rome to illuminate the century," and shortly after becoming Pope he urged Bernini to extend his talent as a sculptor to other fields. As the artist's biographer Baldinucci describes it, Urban "informed Bernini that it was his wish that he dedicate a large part of his time to the study of architecture and painting so that he could unite with distinction these disciplines to his other virtues."

Bernini mastered the new techniques quickly and brilliantly, and Urban engulfed him with commissions. During Urban's 21-year pontificate there were more than 30 of them—for fountains, tombs, portraits, figures, church decorations and architectural projects. The Pope also appointed Bernini to several posts that carried pres-

tige and good salary—Master of the Papal Foundry, Superintendent of the Acqua Felice and the Acqua Vergine, and in 1629, when Bernini was only 30, Architect of St. Peter's.

It was impossible for Bernini alone to perform all the work that was asked of him. He was obliged to set up a studio where he employed assistants, including his father. Soon his enterprise became so large that virtually every talented sculptor in Rome, at least for a time, worked under his direction. When other sculptors came to the city from northern Italy or from beyond the Alps, hoping for papal patronage, they found that almost all of it was in the hands of one man—and if they wanted to work it was necessary to squeeze into some corner of Bernini's organization.

Bernini was a superb administrator whose career belies the notion that artists are improvident bunglers in what nonartists like to call "real life." He was capable of organizing men and projects in a manner that would do credit to a modern management specialist, and evidently he had a keen financial sense as well—when he died he was the 17th Century equivalent of a millionaire. Moreover, Bernini's personality was so forceful and his style so impressive that most of the men who worked for him, or in some cases collaborated with him on a basis of equality, were deeply influenced. When they left his studio they took Bernini's style with them, carrying it through Italy and into Austria, Germany and Spain, whence it eventually reached Latin America.

Enthusiastic as his disciples may have been, however, there were still a good many artists in Rome who resented Bernini's dominance. Poems were written in his honor but there were also parodies, including one that ran, "That dragon who ceaselessly guarded the Orchards of the Hesperides made sure that no one else should snatch the golden apples of Papal favor. He spat poison everywhere, and was always planting ferocious spikes along the path that led to rich rewards." But as long as Urban VIII was alive Bernini's position was unassailable.

Among the many papal commissions given to Bernini were several for work in the interior of St. Peter's. The nave and façade of the great basilica had only recently been completed—Urban consecrated the church in 1626—and the largely unadorned interior was the richest of fields for patrons and artists. The most prominent of Bernini's works in St. Peter's, so large that it can be classed as architecture as well as sculpture, is the bronze canopy, or baldachin, beneath the dome. It rises above the tomb of St. Peter as high as an eight-story building and weighs 93 tons. The collection of so much metal was not easy; at Bernini's suggestion the Pope solved the problem in a way that won no friends for either man.

For his supply of metal Bernini cast his eye on the Pantheon, among the few buildings of Rome that had survived almost intact since the time of the Caesars. The Vandals and the Goths who invaded Rome in the Fifth and Sixth Centuries had not done much harm to the Pantheon, nor had it been torn apart for building ma-

terials during the Middle Ages. In the time of Urban VIII the ceiling of the portico still was as the Romans had built it, containing a great weight of cast bronze. Bernini pointed out to Urban that the bronze could be put to better use if it were removed and recast in the baldachin, which was done. So large was the harvest of metal (part of which also came from the seven bronze ribs in the dome of St. Peter's, which were removed and replaced with lead) that the Vatican's foundry was able to cast 80 cannons from the surplus.

Romans were furious at the despoiling of their ancient monument, although in fairness to Bernini it should be pointed out that much of the bronze removed from the Pantheon was in the form of girders that were not visible to the public. As was their custom —and almost their only recourse—in the days of papal absolutism, the people composed bitter epigrams and circulated them. The memorable gibe in this case was in Latin, written by the Pope's personal physician, who evidently was willing to risk his neck for his wit: "*Quod non fecerunt Barbari, fecerunt Barberini*" (What the Barbarians didn't do, the Barberini did).

After the removal of the bronze from the Pantheon Bernini further altered the venerable structure by mounting a pair of bell towers on the portico. These did so little to enhance its appearance that they became known as "asses' ears." They were pulled down in 1882. On another occasion, when he was hard-pressed to find a large quantity of marble suitable for one of his projects, Bernini proposed (and Urban agreed) to demolish the cylindrical tomb of Cecilia Metella on the Appian Way, one of Rome's best-known landmarks from old imperial days. The public reaction in this case was so genuinely outraged that the tomb was spared.

This battered Roman statue, called *Pasquino*, near the Piazza Navona, was long used as a repository for gibes at the Establishment; for three centuries biting comments were affixed to it for passersby to read. When Maffeo Barberini, Pope Urban VIII, ordered Bernini to remove girders from the Pantheon for use in St. Peter's, a Roman wit commented, probably via *Pasquino*: "What the Barbarians didn't do, the Barberini did."

Bernini's proposals, however scandalous they may seem today, were not so extraordinary in the 17th Century. The Pantheon, as its name indicates, was built as a temple to all the pagan gods. In the Seventh Century it had been rededicated as a Christian church but did not enjoy the same status as a church constructed mainly of "Christian" materials. The stone and bronze of the Pantheon still bore something of a taint and could be rifled without great spiritual guilt. Indeed, Urban was proud of having done so and placed an inscription in the Pantheon boasting of "having made use of a useless ornament for the decoration of St. Peter's and the defense of Rome." The use of "pagan" building materials and monuments for Christian purposes was long regarded as particularly apt symbolism, indicating the triumph of the Church over the forces of darkness. For example, the 10 large Egyptian obelisks in Rome, brought to the city by conquering generals in antique times, are now topped by Christian symbols; one of them, surmounted by a cross, adorns the square in front of St. Peter's itself. It must be added that the Barberini family was a little more rapacious than others in despoiling antiquities; their palace in Rome is made in part of stone taken from the Colosseum. But again, that was not thought very wicked. The Colosseum, which was often called

"Rome's rotten tooth," had been used as a quarry for centuries.

Throughout the years of their professional relations Urban and Bernini maintained the close personal friendship begun during the artist's youth. In the 1630s, after he had been laboring for the Pope for a decade, Bernini fell ill, quite possibly from overwork. While he was confined to his house—actually it was more than a house; by this time the Pope had made him rich enough to buy a palazzo which still stands near the Piazza di Spagna—Urban called on him twice a day to pray for his recovery. On one occasion, in what must have been a fairly spectacular sickbed visit, the Pope brought along 16 cardinals to lend weight to the prayers. During his calls Urban apparently urged Bernini to marry; he had a considerable investment in the sculptor and was anxious to see it protected by wifely care. Bernini seems not to have reacted enthusiastically to the thought of marriage; according to his biographer Baldinucci he "showed repugnance at the suggestion, saying that the statues he carved would be his children and that they would keep his memory alive in the world for many centuries." But "in the end he decided to give way to the Pope's counsel and to accommodate himself to the married state."

After this none-too-passionate beginning Bernini approached the married state, as he did everything else, with a vengeance. At 40 he took to wife Caterina Tezio, the young daughter of a lawyer who was said to be so poor he could not afford a dowry. Bernini, the story goes, furnished a large sum secretly himself. He lived happily with her for 30 years and fathered 11 children.

Bernini's "repugnance" at the suggestion of marriage, however rapidly it was overcome, may have had solid foundation. He had a mistress at the time, Costanza Bonarelli, whose portrait bust by him appears on page 131. Costanza, when Bernini met her, was the wife of one of his assistants, Matteo Bonarelli, who collaborated on at least three of Bernini's projects in St. Peter's. Bonarelli must have been a most complaisant man, as he continued to work for Bernini for several years after his wife became involved with the artist. The wife-mistress was a fiery girl and Bernini's passion for her was violent—a contemporary described it in two words that need no translation; he was *fieramente innamorato*. Nevertheless, when the Pope prevailed on him to marry, Bernini somehow managed to bridle his passion, disentangled himself from Costanza and gave away her portrait, which he had been keeping in his palazzo.

I n 1644 the Pope's death at the age of 76 brought an end to his long friendship with Bernini. When he was on his deathbed Urban became fearful that he might have given away too much of the Church's wealth to the Barberini family. He summoned a group of theologians to ask their opinion; somehow they calmed his conscience, but there is no record of what they said to him. The Church was almost bankrupt. Gianlorenzo Bernini, in bidding the Pope farewell, must have given urgent thought to his own situation. His enemies had been waiting for this moment for 21 years.

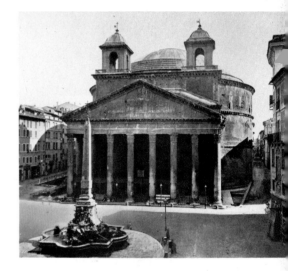

The twin bell towers that Bernini added to the Pantheon—they were quickly dubbed the "asses' ears"—are evident in this photograph made before they were finally removed from the ancient building in 1882. Bernini greatly admired the architecture of the building, which had survived since the days of the Caesars, and once drew elaborate plans for renovating the surrounding area.

A Papal Patron's Taste

For Italian artists during the papacy of Urban VIII, all roads did indeed lead to Rome. The Catholic Church, having recovered from the Reformation, was intent on rekindling the enthusiasm of its membership; Urban enlisted to this cause, through generous commissions, the leading artists of the era.

A private patron long before he assumed the papal throne, Urban dipped deep into the Vatican treasury to purchase for the Church a magnificent array of ecclesiastical art works. The principal beneficiary of his patronage was the emerging group of Baroque artists; yet the Pope was impressively eclectic in his tastes. While he favored the classical architecture of Bernini, he also supported the highly innovative designs of Francesco Borromini. Master Baroque painters such as Giovanni Lanfranco, Pietro da Cortona, and Domenico Zampieri, known as Domenichino, were given the opportunity to create dazzling ceiling frescoes; less flamboyant artists like Guido Reni and the French-born Nicolas Poussin found themselves equally endowed with papal encouragement and commissions.

These artists led a feverishly productive esthetic flowering that lasted for more than two decades. It was only after Urban's death, as succeeding pontiffs tightened the purse strings, that the remarkable period dwindled to an end.

Designed by Francesco Borromini, the dome of Sant' Ivo della Sapienza in Rome is radiant with cascading sunlight. The dome is decorated not with a fresco but with molded reliefs of stars, wreaths, papal insignia and winged angels.

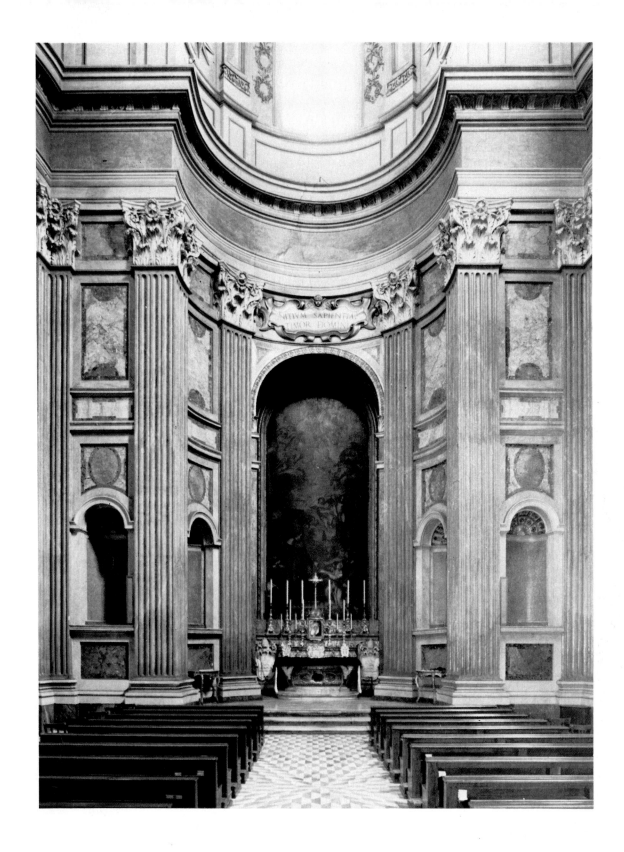

Francesco Borromini shunned gaudy decoration in his churches. His designs made no room for frescoes and paintings; instead, he teased the eye with intricate spaces and inventive architectural detail. Few of his structures survive; but those that do—especially Sant' Ivo della Sapienza—show that his genius was underrated in his own time.

In designing Sant' Ivo, Borromini had to work with an existing courtyard *(left)* and wall. Yet he blended his exterior with the old work so naturally that it was later believed he had conceived the entire structure. In the cramped interior of the church *(above)* he created a feeling of space and height with bold vertical lines.

The subtle complexities of Sant' Ivo are most evident in Borromini's unorthodox handling of the church's interior and dome.

Dusting off a design that architects had long discarded as too difficult, he based the floor plan of the church on a six-pointed star. Borromini solved the awkwardness of the six acutely angled nooks by transforming them into semicircles, then gently reversing the curve in alternate nooks *(below)*. The effect is a roughly circular panorama of a strongly undulating rhythm.

The exteriors of most church domes are simple hemispheres. For Sant' Ivo, Borromini concocted an unusual four-stage design *(page 44)*: a massive drum—echoing the interior shape—supports a stepped cupola, atop which sits a graceful lantern. At the apex is a spiral *(right)* that seems to have been inspired by a Babylonian ziggurat. Though disparate, the elements blend to achieve a singular effect, leading the eye constantly upward.

Borromini's Sant' Ivo stands as a masterpiece of dynamic Italian Baroque architecture.

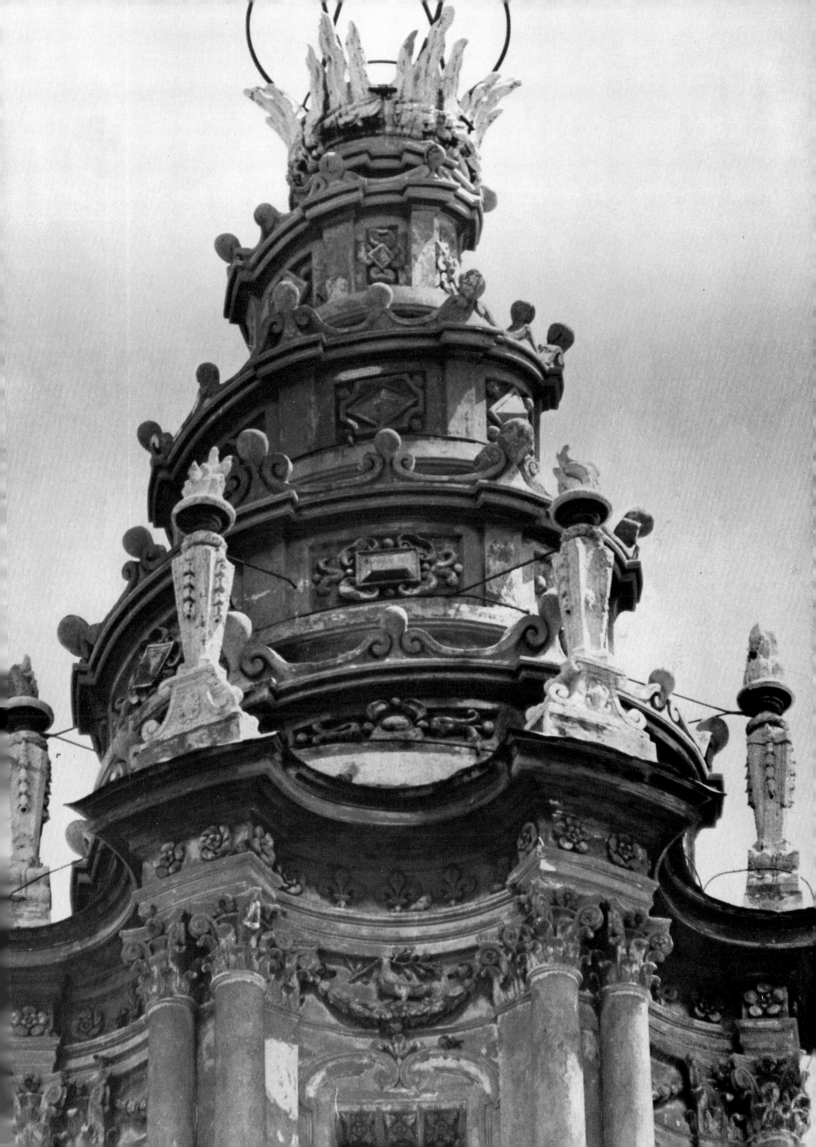

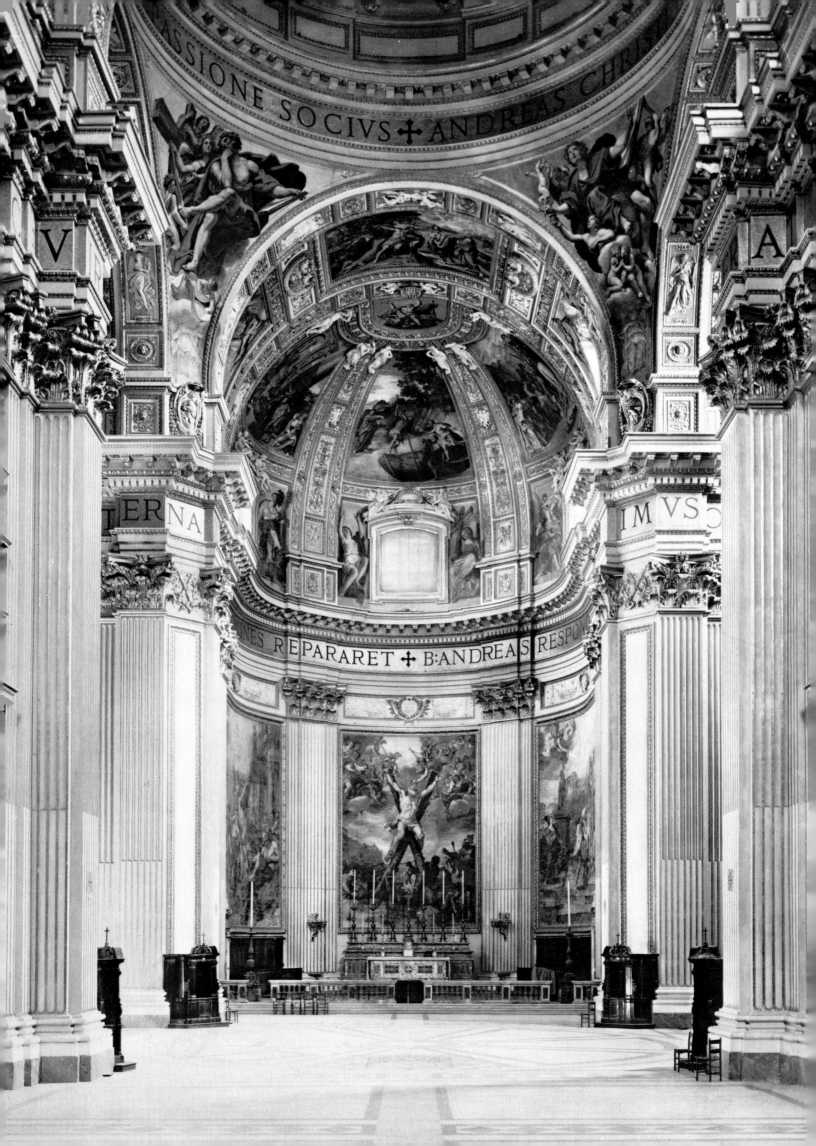

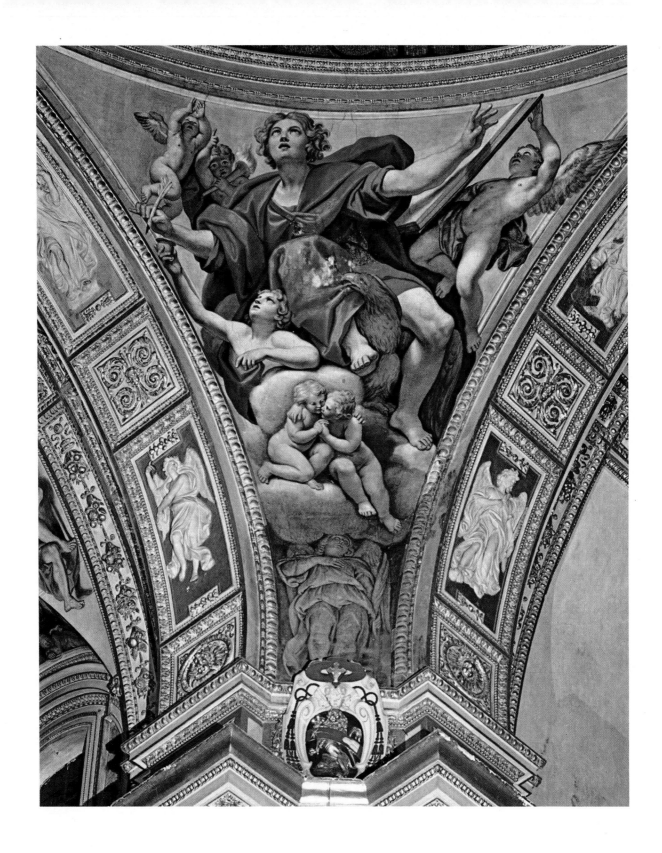

In sharp contrast to the subtle Sant' Ivo, Sant' Andrea della Valle *(left)* is a sumptuous church. Designed by several architects, it features a dome second in size only to St. Peter's; its frescoes and paintings are second to none.

When decoration of Sant' Andrea began in 1621, the dome fresco was assigned to Giovanni Lanfranco. His *Vision of Paradise (overleaf)* is a stirring work that uses scores of figures to guide the eye upward toward a centrally placed Christ.

Domenichino secured assignments for the apse and pendentives—the triangular junctures between the dome and its piers. He filled the spaces with robust figures of the Evangelists, including St. John *(above)*, along with scenes from the life of St. Andrew, to whom the church is dedicated.

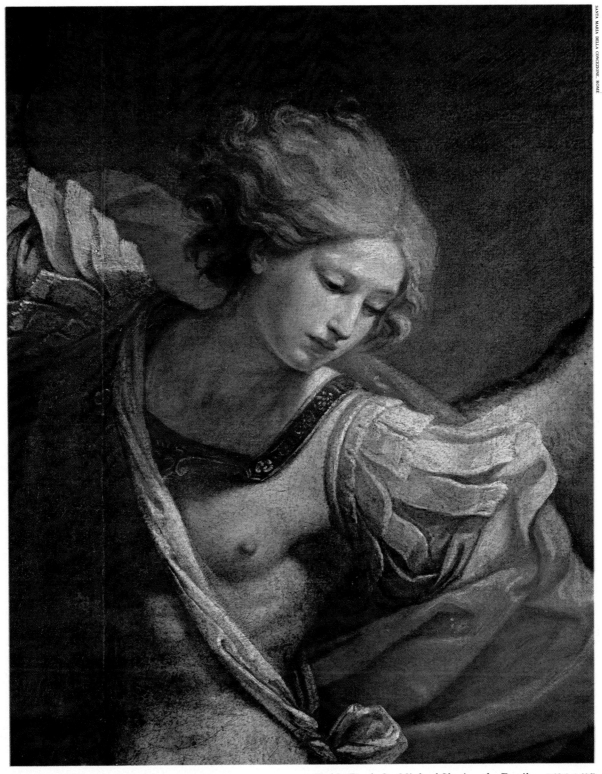

Guido Reni: *St. Michael Slaying the Devil*, c. 1626-1627

Urban VIII sponsored the decoration for the Capuchin Church of Santa Maria della Concezione, but out of respect for the austerity of the order he dropped plans for costly altars and bejeweled ornaments. Instead, he commissioned a number of paintings, among which was Guido Reni's *St. Michael Slaying the Devil (left)*.

A resident of Bologna, Reni was little influenced by the flamboyant Baroque style popular in Rome. Through muted colors and a composition involving only two figures, his *St. Michael* achieves a classical calm that is clearly evident in the detail above. Reni's works were popular, but not universally admired; commenting on this painting one critic snorted that for an archangel locked in holy combat Michael had "the air of a dancing master."

Among foreign artists patronized by the Pope was Nicolas Poussin, who was born in France but spent most of his life in Rome. Poussin was the master of a popular 17th Century painting form, the idealized landscape; an example is seen at the right in a painting representing St. John on the island of Patmos that was commissioned by the Barberini family (whose most famous member was Urban VIII).

Poussin's standard ingredients for an idealized landscape were a Biblical or mythological figure or group, usually placed in the foreground, a pervasive light in which all objects stood out with equal clarity, trees at both right and left borders, a glimpse of river or sea, and remnants of classical architecture, often in ruins. He was unrivaled at manipulating these elements. His works show an almost mathematical balance in their composition, along with exceptionally clean and dramatic lighting. This meticulousness seems to have been part of the artist's temperament. "My nature," he once wrote, "leads me to seek out and cherish things that are well-ordered, shunning confusion which is as contrary and menacing to me as dark shadows are to the light of day."

Nicolas Poussin: *St. John on Patmos*, c. 1644

Not all of Urban VIII's art commissions were for churches. The master fresco painter Pietro da Cortona's *Triumph of Divine Providence (right)* graces the ceiling of the *gran salone* of the Pope's family home, the Palazzo Barberini. It took the artist seven years to execute the tumultuous 79-by-46-foot painting, but the time was well spent. Based on a now-lost allegorical poem glorifying the mission and deeds of Urban VIII, the fresco is a Baroque tour de force.

Starting with a flat ceiling, the painter created an impression of a high vault by feigning an elaborate coved framework that divides the surface into five sections. He furthered the illusion of depth by superimposing various groups of figures over his simulated framework. The effect of this busy, well-populated work is much like that of grand opera. The side panels, which recount minor episodes from the poem, serve as the chorus while the central rectangle resounds with the solo voices. There, at the right in this view of the ceiling, Divine Providence sits triumphant over Time (with a scythe) and three Fates. Above them, three Muses and other female figures carry the tiara and papal keys. Within an immense wreath are three gigantic golden bees—the heraldic emblem of the Barberini family. *(See detail overleaf.)*

Not only is Pietro da Cortona's ceiling one of the most lavish of all Baroque frescoes, it is one of the most unabashed tributes to a patron in the history of painting.

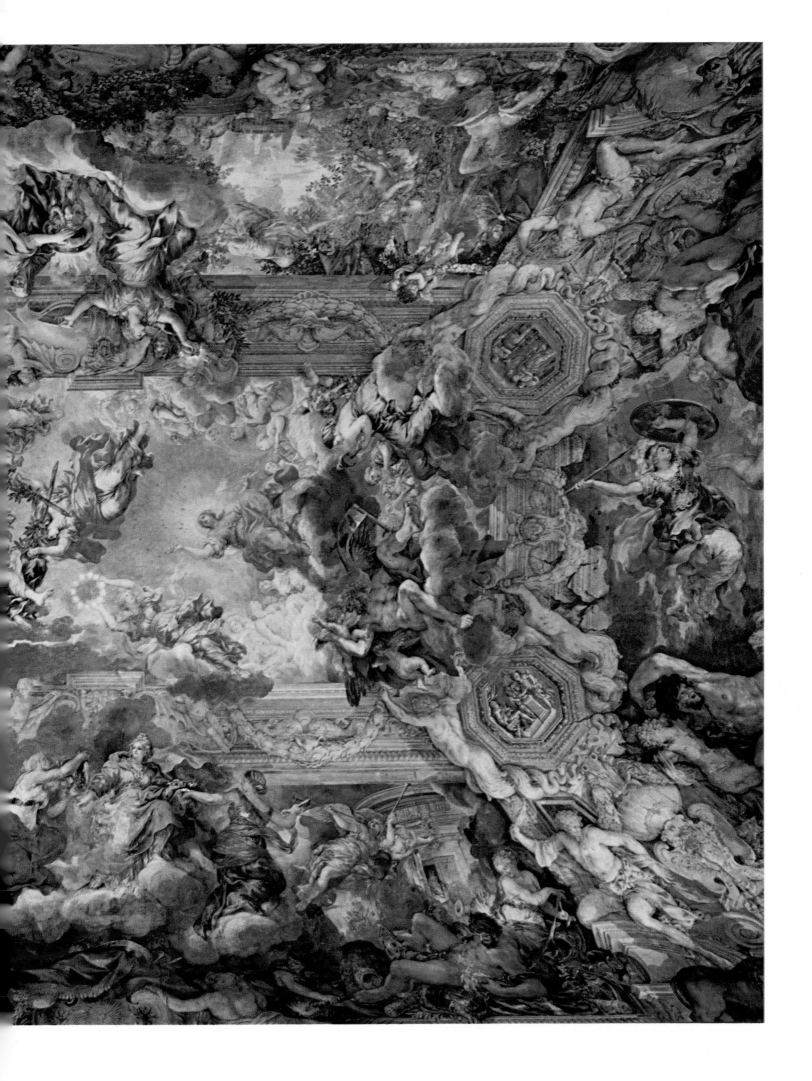

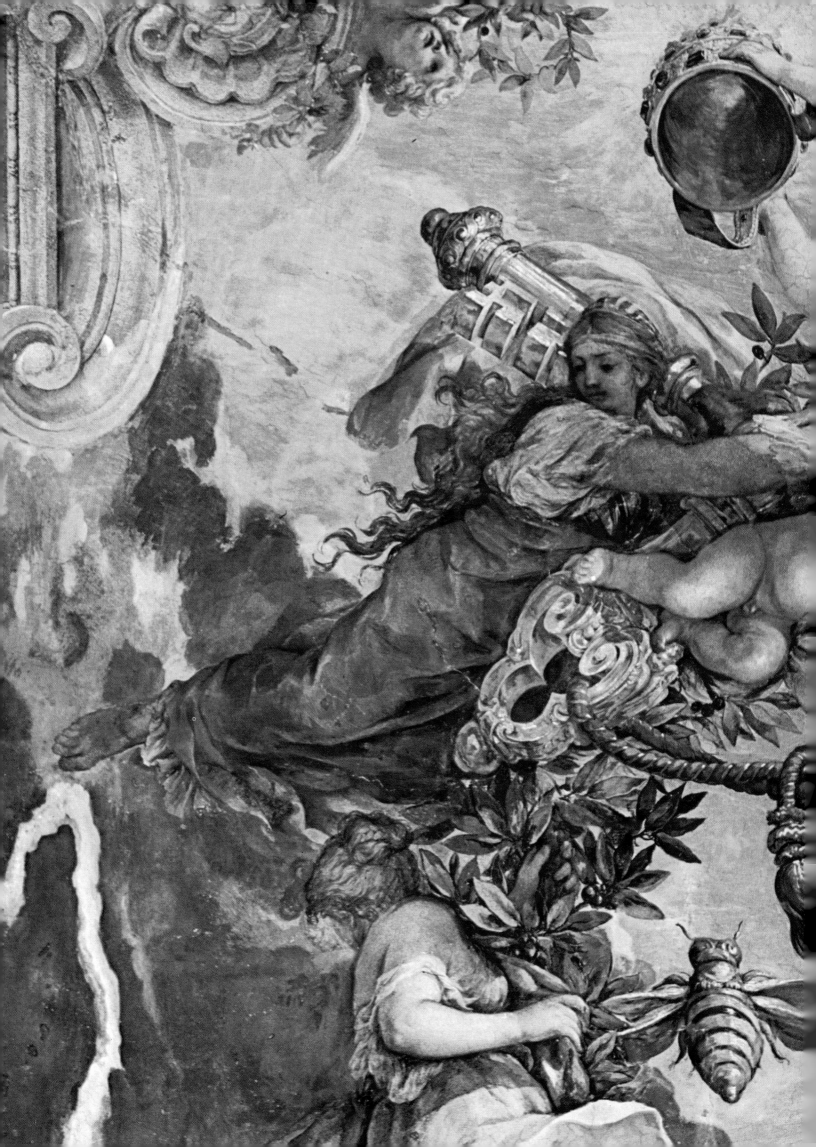

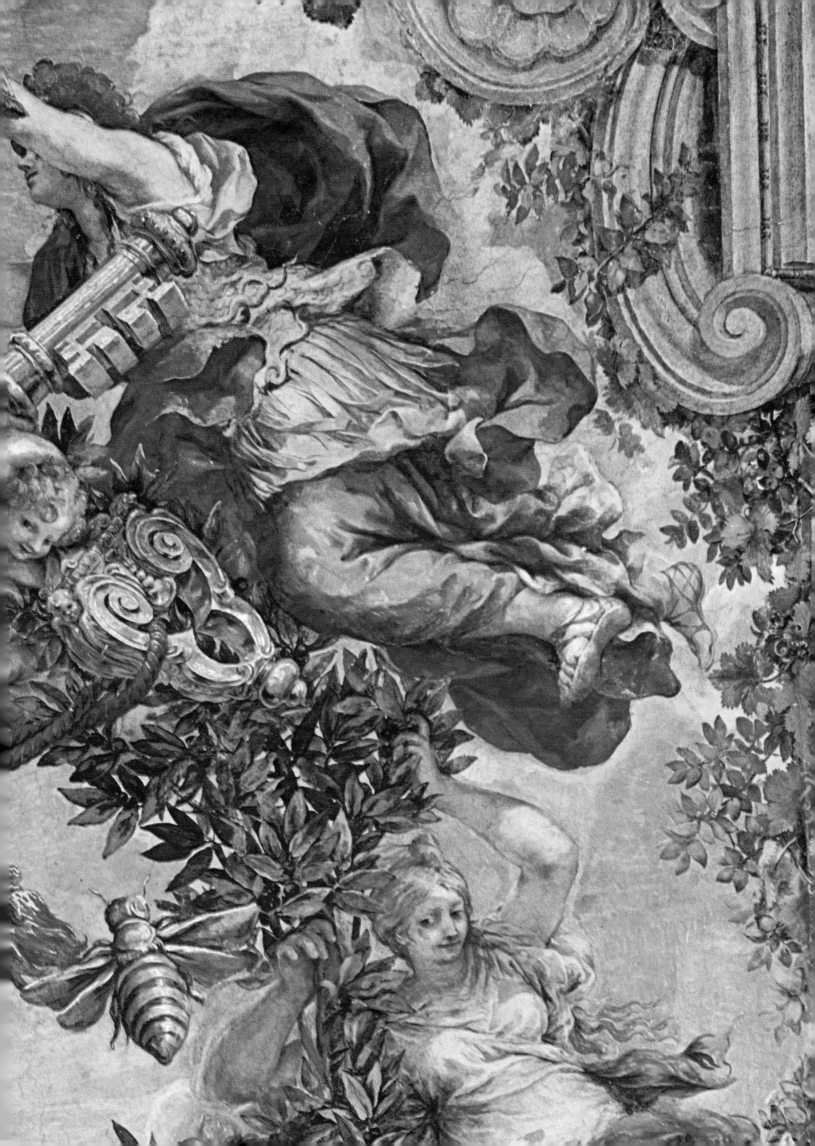

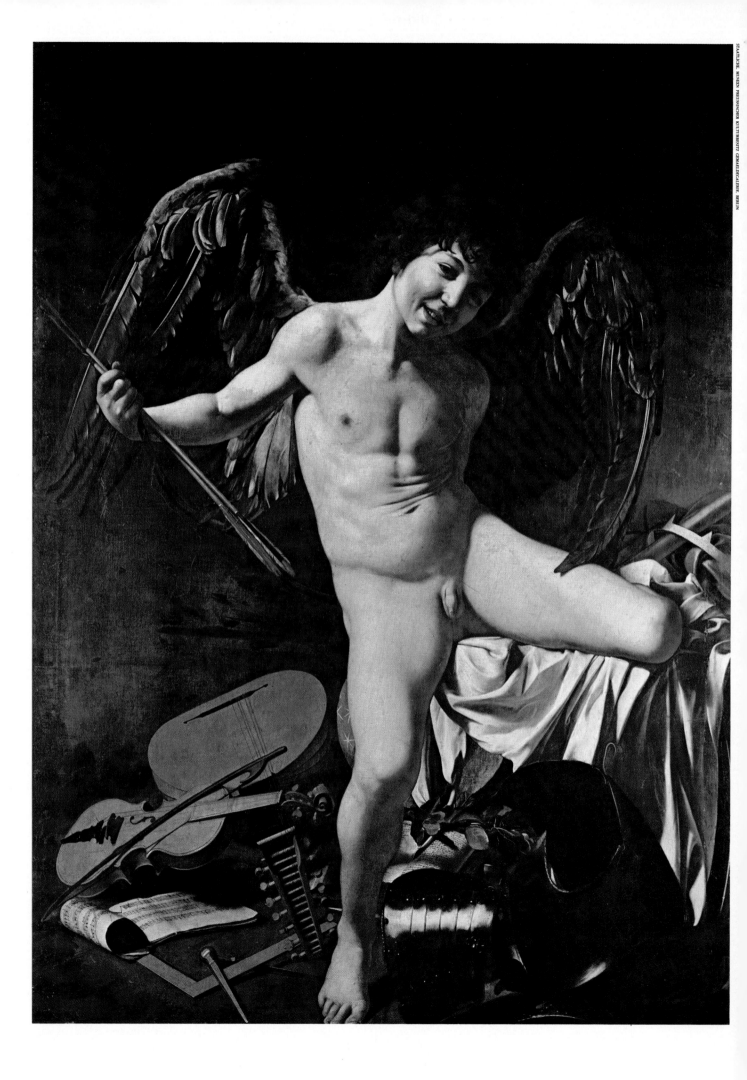

60

III

Caravaggio: Turbulent Genius

Rome's greatest Baroque painter, Caravaggio, portrayed Cupid—all-conquering love—as a sensual, impudent boy with a bird of prey's wings, gleefully spurning man's achievements, symbolized in a lute, a compass, a celestial globe, armor, and a royal crown and scepter. No less impertinent than his triumphant urchin, the artist posed his model in an obvious parody of the revered Michelangelo's statue *Victory (page 62)*.

Caravaggio: *Amor Victorious over Worldly Might, Art and Science*, c. 1600

Although Bernini is said to have produced between 150 and 200 paintings in the course of his busy life, only a dozen or so are known today. The rest either are lost or—since the artist never signed his canvases—are masquerading as the works of others and await correct identification. But the few that have come to light are proof that Bernini could master any technique or medium. His success with oils is all the more remarkable in view of the fact that he never seems to have regarded painting as more than a diversion, something that gave him great pleasure but that he did not take too seriously. According to his biographer Baldinucci, Bernini realized that sculpture was his forte, and while "he felt a great inclination toward painting, he did not wish to devote himself to it altogether."

About half of Bernini's known canvases are self-portraits; the rest are likenesses of contemporaries and religious pictures containing one or two figures. Their coloring, especially in self-portraits, is usually restrained and monochromatic; the brushstrokes are vigorous and self-assured and little attention is paid to details of dress and other accessories. Because of their dark colors and unified tone value, some of these works were once attributed to the Spanish master Velázquez. Most of the pictures date from the 1620s and 1630s, before Bernini became so swamped with commissions for sculptural and architectural projects that he had hardly any time left for painting.

Like his creations in marble, Bernini's paintings convey a strong sense of immediacy. His subjects seem on the point of turning their heads, their half-parted lips seem about to speak, and their faces express some fleeting and realistic emotion. The observer has the sensation of being confronted by an alert and living presence rather than a painting.

Bernini's striving for vitality and his desire to involve the viewer in the action of his work, while characteristic of him, were not entirely his own ideas. Their roots are to be found in a movement toward naturalism that, in his youth, had begun to revolutionize

European art and prepared the way for the Baroque age. In large measure the movement was indebted to an erratic genius who was Rome's reigning painter around the turn of the 17th Century—the tragic and intractable Caravaggio. In 1606, when Bernini was seven, the violent-tempered Caravaggio had killed a man in a quarrel and fled Rome for good, but his influence and that of his followers was still pervasive during Bernini's formative years.

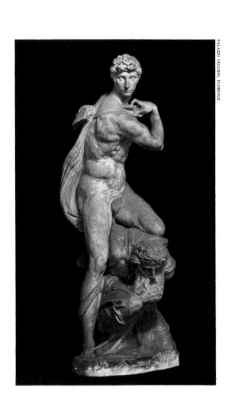

Caravaggio deliberately copied the stance of Michelangelo's *Victory* (above) in his painting *Amor Victorious (page 60)*. Although the position of the legs is identical in both works, the artists' intentions could not be more different. Michelangelo's muscular young hero half kneels on the older foe he has subdued, perhaps an embodiment of virtue triumphing over vice. Caravaggio's brazen boy proclaims the most material of victories: sensual love, dominating every other human impulse.

Caravaggio lived not quite 37 years, but in that brief span he proved himself a rebel in life as well as in art, earning a reputation for disorderly behavior unmatched by any other major painter. His early biographers imply that even as a boy he was unruly, and in the six-year period before he left Rome to escape imprisonment for murder he was almost constantly in trouble with the law for offenses ranging from circulating scurrilous verses about a fellow artist to wounding in a brawl a former sergeant of the guards of the Castel Sant' Angelo.

Besides his birth date—September 28, 1573—few hard facts are known about the childhood of this gifted but stormy man. He was baptized Michelangelo Merisi, after the archangel Michael, and the appellation by which he is commonly known came from the name of his birthplace, the small town of Caravaggio, about 20 miles from Milan. His father, Fermo Merisi, is believed to have been a master mason and superintendent of buildings for a local nobleman. Thus the family must have been at least moderately well off and could afford to apprentice Caravaggio, at the age of 10, to a painter in Milan named Simone Peterzano and pay for the boy's board and education. How the son of a mason came to be apprenticed to a painter is not known, but it seems safe to assume that Caravaggio was precocious and had shown sufficient evidence of talent to convince his family that he had a future in the world of art. A story, now regarded as legend by art historians, claims that he had discovered his love of painting purely by accident, while helping to prepare the plaster base for frescoes in buildings where his mason-father was working.

Simone Peterzano was a mediocre artist whose work reflected the decorative affectations, the artificiality and the reliance on stock poses that had overtaken art since the days of the High Renaissance. But he was a competent teacher, and in his studio during the next four years or so young Caravaggio absorbed a solid practical background in the techniques of the painter's craft. Meanwhile he no doubt had opportunities to see and admire the works of Renaissance masters in the churches of Milan as well as those of Bergamo, Cremona and other large nearby towns. By the time his apprenticeship ended he apparently was already in rebellion against the unrealistic standards accepted and perpetuated by Peterzano and most other Milanese artists and had begun to formulate his own idea of what an artist should be. "In my use of the word," he said years later, after he had become famous, "a good artist means a man who knows how to paint well and to imitate natural things

well." So rather than remain in Milan among painters who regarded beauty and nature as conflicting terms, Caravaggio set off for Rome to seek artistic freedom.

He arrived there around 1590, in what must have seemed to him an era filled with promise. The Catholic Church had by then recovered from the ravages of the Protestant Reformation and from the difficult period of internal reform that followed. An atmosphere of renewed confidence infused Rome, and the princes of the Church were again beginning to patronize artists on a grand scale, as they had done in the Renaissance.

For several years Caravaggio knew none of that patronage. Like most struggling young painters, he had a hard time of it; in order to make a living he was forced to do poorly paid hack work for others. Among his first employers was a fifth-rate Sicilian portrait painter and a minor clergyman in whose house Caravaggio lived while turning out devotional pictures that the clergyman then sold. In future years he spoke of the latter as "Monsignore Insalata," —Monsignor Salad—suggesting that in his employer's home Caravaggio was rarely given anything more substantial to eat than greens. For a time an innkeeper who wanted Caravaggio to do his portrait gave the artist free lodgings, but eventually this sort of hand-to-mouth existence took its toll and Caravaggio became seriously ill, perhaps a victim of the terrible plague and famine that swept Rome in 1591. Since he had no money he was taken in as a charity patient by a hospital run by a religious order, and upon his recovery he found work doing still lifes of fruits and flowers in the studio of Cesari d'Arpino, an up-and-coming painter only a few years his senior. However, being ordered about by someone close to his own age must have been intolerable to a man of Caravaggio's spiky nature, and after a few months he left d'Arpino, determined to paint on his own.

It was probably during this period of independence that he painted his earliest surviving pictures. These include several single and half figures that are very likely self-portraits, drawn after his own reflection in a mirror, perhaps because he was too poor to hire a model. The face they show is that of an intelligent, somewhat unpleasant-looking youth, with full lips, large black eyes, and dark hair and eyebrows, which accords with descriptions of the artist in later life. One of these presumable self-portraits, *Boy Bitten by a Lizard*, foreshadows the remarkable ability to capture on canvas the action and emotion of a transitory moment that was to become a Caravaggio hallmark. The boy, startled by a lizard hidden in a bunch of flowers, seems to cry out in fright at the instant the lizard nips his finger. But Caravaggio had little success marketing his own work, and before many months he was as destitute as ever, his clothing almost in rags.

Some generous fellow artists saved him from starvation, and when at last it was arranged for a picture dealer named Valentino to take on some of his unsold paintings, Caravaggio's luck began to

turn. According to one of his biographers, Giovanni Baglione, it was through Valentino that Caravaggio "made the acquaintance of the Cardinal del Monte, an enthusiastic lover of painting, who took Caravaggio into his house, and now, having a place to live and receiving an allowance, he regained his courage."

Fortune would have been hard put to provide a more satisfactory benefactor. Cardinal Francesco del Monte, besides giving Caravaggio a home and buying a number of his paintings and commissioning others, was a protector of Rome's newly founded Academy of St. Luke. This was an organization dedicated to improving the social status of artists, to instructing them in what were then considered the highest ideals of their profession and to promoting their talents. Through his association with the good cardinal and his coterie, Caravaggio soon found other important patrons, including Maffeo Barberini, later Pope Urban VIII, who sat for a portrait and ordered a picture showing Abraham about to sacrifice his son Isaac. Within a few years the penniless, ragged artist befriended by Cardinal del Monte was being called "*celeberrimus pictor*" (renowned painter).

B esides having connections in Rome's artistic circles, the cardinal was one of the supervisors of the building and property of St. Peter's and other churches in the city and thus a person of considerable influence at the court of the current pope, Clement VIII. It was probably through del Monte's recommendation that, around 1597, Caravaggio received his first public commission—the altarpiece and two side paintings for the Contarelli Chapel in the Church of San Luigi dei Francesi.

Years earlier a Cardinal Matteo Contarelli had donated funds for the building of the chapel, and after his death, in 1585, his will provided for its adornment with scenes from the life of his patron saint, Matthew. However, for various reasons—among them a protracted lawsuit over the cardinal's estate—the decorations remained unfinished for some years. Finally, after Pope Clement VIII took an interest in the matter, it was decided to complete the project and Caravaggio was selected for the job.

But his altarpiece, *St. Matthew and the Angel*, pleased nobody. Instead of portraying the saint in the established, idealized way that would be instantly recognizable to the common people who worshiped at San Luigi dei Francesi, Caravaggio turned to nature for his model and showed Matthew realistically, as a rough and simple man wearing laborer's clothes and with callused, dirty feet. The painting was at once condemned as indecorous by the clergy of San Luigi dei Francesi, and the artist compromised by substituting a less offensive picture in which the saint, while still portrayed from life, is properly haloed and clad in flowing robes; his feet have been washed. One of the side pictures, *Martyrdom of St. Matthew*, was also repainted because Caravaggio again made the saint appear too much like an ordinary person. The other was found acceptable: in it the artist presented Matthew in a more exalted manner, his face

bathed in what appears to be a shaft of celestial light at the moment when Christ calls him from his companions to join His disciples.

The criticism of Caravaggio's Contarelli Chapel decorations did not lessen the demand for his work by wealthy patrons, among them Pope Paul V, a successor to Clement VIII, who rewarded the artist handsomely for painting his portrait. Moreover, the rejected version of *St. Matthew and the Angel* was bought by the Marchese Vincenzo Giustiniani, possessor of a celebrated collection of antique sculpture and contemporary paintings. This nobleman also commissioned Caravaggio to paint for him a secular picture, *Amor Victorious (page 60)*, which shows a Cupid so lively and mischievous that he could easily have been modeled after an urchin picked from the streets of Rome. This picture, far removed from the classical, idealized portrayal of the god of love, is said to have been regarded with such affection by the marchese that he kept it covered with a green drapery, unveiling it to visitors to his collection only after they had seen the rest. Vincenzo Giustiniani and other broadminded men were not greatly disturbed by Caravaggio's unconventionality; rather, they admired the freshness of his naturalistic approach to his art.

For the rest of his life Caravaggio devoted himself almost exclusively to religious paintings. He continued to interpret spiritual subjects in rational, earthly terms, peopling his canvases with figures based on life. But at the same time, he infused his scenes with a mysterious unearthly quality, often by placing his naturalistic figures in semidarkness or against a background of deep shadow, and illuminating them with a strong light emanating from an unseen source. His detractors claimed that the obscurity of Caravaggio's backgrounds concealed an awkwardness in handling the perspective of his compositions; actually they were a carefully considered device that, combined with his dramatic lighting, served to establish an intimate relationship between the spectator and the painting.

Caravaggio heightened the emotional impact of his pictures by stressing the climactic moment in a Biblical event—the astonishment of the disciple Thomas as the risen Christ draws back his robe to reveal the wound in His side, or the spectators recoiling in horror as the executioner's sword is about to strike the martyred St. Matthew. Or he used expressive gestures or similar devices to induce the viewer to take part in the scene. For example, in his original altarpiece of *St. Matthew and the Angel*, he had painted one of the saint's soiled feet as though it were emerging from the canvas into the space occupied by the spectator; in the *Supper at Emmaus (pages 76-77)*, completed around 1600, he achieved a like effect with the foreshortened hand that Christ extends toward the viewer in blessing the bread as well as with another hand, flung wide in amazement by a disciple who suddenly recognizes his divine table companion.

Although art connoisseurs remained Caravaggio's devoted patrons, most of his religious pictures commissioned for Roman

Scores of freakish faces surround a classic profile in Agostino Carracci's sketch at right. The Carracci school at Bologna—composed principally of Annibale Carracci, his brother Agostino and his cousin Lodovico —revived studies of such natural oddities in imitation of Leonardo da Vinci. But, whereas the Renaissance master's drawings probe the esthetic problem of what constitutes beauty or ugliness, the Carracci's purpose was simply to amuse.

churches during his mature years were considered shocking by conservative lower clergymen and the people at large. One graphic illustration of these conflicting viewpoints is the reception given his *Death of the Virgin*, painted for a church of the Discalced Carmelites, Santa Maria della Scala. Here the dead Virgin is portrayed with vivid realism; she is dressed in a poor garment, her body and limbs are swollen, and her bare legs and feet are exposed to the group of mourners. The Carmelites refused to accept the picture, calling it altogether too irreverent, and malicious tongues spread the story that Caravaggio had used as his model the bloated corpse of a prostitute drowned in the Tiber. However, the great Flemish painter Peter Paul Rubens happened to be in Rome at the time and recognized the painting's exceptional dramatic power and its profound religious feeling—the Virgin, for all her stark realism, is modeled with great sensitivity, and the grief of her mourners is almost audible. Acting on Rubens' enthusiastic advice, the Duke of Mantua, a discerning art collector and the Fleming's patron in Italy, bought the *Death of the Virgin* for his gallery. Before the picture was sent to the duke's palace in northern Italy, it was put on public exhibition in Rome for a week and attracted large crowds. Opponents of Caravaggio's revolutionary style, unable to reconcile themselves to his true-to-life Virgin, came to damn it for its seeming impropriety; but in the crowds there were almost certainly young painters who shared Rubens' appreciation, and many of them would echo their appreciation through their own work. Rubens himself was strongly influenced by Caravaggio's realistic style, and on his return to Antwerp it was he who became mainly responsible for the impetus toward naturalism among the artists of northern Europe.

While the Duke of Mantua and other prominent art collectors and patrons voiced their admiration for Caravaggio's creations, there is reason to believe they may have found the artist himself

66

considerably less attractive. A biographer, Pietro Bellori, has left us a glimpse of Caravaggio around the peak of his career in Rome: "He adorned himself with velvet and other fine materials but when he had put on one costume, he never changed it until it had fallen into rags. He was very negligent of personal cleanliness and for many years morning and evening he used the canvas of a portrait as a tablecloth."

Moreover, as his fame increased so did Caravaggio's notoriety as a troublemaker and public nuisance. But this, like his slovenly habits, did not deeply affect his artistic standing among influential Romans. Perhaps the reason behind his strange social behavior was that his enormous creativity, together with his volatile, rebellious temperament, built up a pressure within him that could not find release in painting alone. According to his biographers he would work at his easel for a couple of weeks almost without interruption; then for a month or so he would live riotously in the sordid quarters of Rome. Or, armed with a long rapier, he would swagger through the streets, alone or accompanied by a band of rowdy companions spoiling for a fight. If a brawl failed to materialize, he soon succeeded in provoking one among his acquaintances and sometimes with complete strangers.

The first mention of him in the city's police blotter—dated November 19, 1600, when the artist was 27—was a complaint by a Girolamo Spampa that Michelangelo Merisi da Caravaggio had attacked him at night, apparently without cause, as he knocked at a candlemaker's door to get some candles. "The defendant came up with a stick and began to beat me," claimed Spampa. "He gave me a good many blows. I defended myself as best I could, shouting: 'Ah, traitor, is that a way to act!' Some butchers arrived with lights, and then Michelangelo drew his sword and made a thrust at me, which I parried with my cloak, in which he made a gash, as you can see, and then fled."

From that time on, Caravaggio's name appeared in Rome's police records every few months. On one occasion, after he had been sued for unpaid rent by a former landlady, he was arrested for pelting her window with stones. Another time he was booked for hurling a plate of artichokes and then threatening at sword point a waiter he considered insolent. He bodily assaulted a notary over the affections of a woman—a "Lena who is to be found in the Piazza Navona" and presumably a prostitute—and was jailed for carrying a sword and dagger without a license, and once when he *was* able to produce a permit he insulted the police corporal who had asked to see it, telling him "you and as many as are with you can shove it." Sometimes the court dismissed the artist with only a reprimand, on other occasions he was bailed out of jail by friends, including a French Ambassador. After one scrape he was put under house arrest, with strict orders not to leave the property without permission in writing from the governor of Rome.

The climax to Caravaggio's excesses and the event that was to

make a drastic change in the course of his career came in May of 1606. Following a ball game—it was a form of tennis known as *palla a corda*—an argument broke out between the artist and a member of the opposing team, Ranuccio Tomassoni, who had won 10 scudi from Caravaggio. Tempers quickly flared out of control, swords or daggers were drawn, and Tomassoni received a thrust that killed him. Caravaggio was himself seriously cut in the throat and on one ear and went to the house of a friend to recover. When the authorities questioned him there about his wounds, he claimed ignorance of the affair. "I wounded myself with my sword in falling on these streets," he said. "I don't know where it happened, and no one was present." He was forbidden to leave the house under penalty of a heavy fine. But a day or two later Caravaggio had vanished from Rome.

Around the same time that Caravaggio disappeared, Rome lost another great rebel in art—not as the result of any act of violence on his part but by his surrender to a deep melancholia that robbed him of the will to work. In 1595 Annibale Carracci, one of a family of artists already noted for their church decorations in their native Bologna, came to Rome at the request of Cardinal Odoardo Farnese to paint, in collaboration with his brother Agostino, the famous frescoes in the Farnese Gallery of the cardinal's family palace. For the better part of a decade Annibale labored on these and various other projects commissioned by the cardinal, but he was so poorly paid that when he began to sink into depression in 1605 and became unable to paint, his illness was said to have been caused by Farnese's stinginess.

Annibale and others in his family were, like Caravaggio, in revolt against the artificialities infecting contemporary art. But they undertook a return to nature in quite a different way. They did not strike out boldly in new directions, as Caravaggio did by painting his scrupulously realistic Virgin, swollen in death, or by portraying St. Matthew as an ordinary man with unwashed feet. Instead they based their revolution on a reassessment of the works of Raphael, Michelangelo, Correggio and other High Renaissance masters. Whereas Caravaggio limited his borrowings from these painters mainly to matters of composition, the Carracci took over the classic values of the old masters to create a new and more rational blending of natural and ideal beauty.

Of the several Carracci, Annibale was the most successful in achieving this alliance between naturalism and classical forms, and his monumental frescoes in the Farnese Gallery *(pages 80-83)* represent the climax of his art. The pictures that cover the vaulted ceiling and extend onto the gallery's upper walls illustrate scenes from ancient mythology—a typical Renaissance theme. But although his subject matter, his rich and glowing colors, and elements of his compositions all hark back to Renaissance models, Annibale gave to his paintings an exuberant vitality of his own, and infused his figures with a down-to-earth quality unknown in the work of the old

68

Lodovico Carracci's red-chalk sketch at left is one of several preliminary designs for his last major work, a fresco of the Annunciation above the choir of the Church of San Pietro in his native Bologna. Like the work of his younger cousins, Annibale and Agostino, Lodovico's paintings are solidly based on painstaking drawing and preparation. But his soft style seems rather insipid compared to Annibale's generous, bold vitality, expressed in glorious frescoes like those shown on pages 80-83.

masters. Hundreds of surviving chalk sketches for the largest picture, in the center of the ceiling, show how painstakingly and lovingly he studied nature, drawing each figure from life.

There is no record that Carracci and Caravaggio ever met, but on one occasion they worked on the same commission, the decorating of the Cerasi Chapel in the Church of Santa Maria del Popolo. Carracci did the altarpiece, *Assumption of the Virgin*, and Caravaggio painted the *Crucifixion of St. Peter (page 78)* and the *Conversion of St. Paul (page 79)* as side pictures. It is instructive to compare the work of the two men. In his altarpiece, Carracci, for all the vitality and realism of his figures, does not invite the spectator to participate in the miracle portrayed; his Virgin and angels, floating above a crowd of worshipers, seem reserved, more like actors on a stage, and the viewer is conscious of being kept at a distance. Caravaggio, on the other hand, reduces the composition of the side panels to its bare essentials, limiting his figures to three or four individuals so intensely human that the spectator immediately feels drawn into their sphere of action.

When Caravaggio fled Rome he first took refuge in the Sabine Mountains east of the city. There he was safe from the papal courts but not so far away that he could not keep in touch with influential friends, hopeful that they might be able to obtain a pardon from the Pope on the grounds that the killing had not been premeditated and that he himself had been wounded by his opponent. Toward the end of 1606 or early the next year, pressed for money and with no pardon forthcoming, he moved south to try his fortunes in Naples. That city had not known a painter of outstanding talent for many years, and Caravaggio had no difficulty obtaining a number of high-paying commissions for altarpieces and other religious works. These kept him busy—and apparently out of further trouble with the law—until he set sail for Malta late in 1607.

Exactly what prompted Caravaggio to go to Malta is uncertain. Perhaps he had heard that there was a pressing need for artists to decorate a new and important church there. Another motivation could have been a desire to become a knight in the Order of St. John, the religio-military body that had taken control of the island in 1530 to defend it against Islam's aggression. In 1600 Cesari d'Arpino, for whom Caravaggio had worked during his struggling days in Rome and who had since become one of the city's most sought-after artists, had been created a Cavaliere di Cristo by Pope Clement VIII. Caravaggio may have hungered for an honor equal to that of his rival. Whatever the reason for his trip to Malta, soon after his arrival he met Alof de Wignacourt, Grand Master of the Order of St. John, and painted two portraits of him, one in full armor and the other wearing the robe of his rank. The Grand Master was delighted with these, and shortly thereafter Caravaggio was received into the order with the title Knight of Obedience.

For several months all went smoothly and there was no lack of commissions, among them several for paintings in the Church of San Giovanni in Valetta, the Maltese capital and headquarters for the ruling knights. One of these pictures—an enormous canvas measuring about 12 by 17 feet—was a powerful scene of the beheading of St. John the Baptist in which, says his biographer Pietro Bellori, "Caravaggio exerted his skill to the utmost." The Grand Master of the Order of St. John was so impressed with the result that he gave Caravaggio "a rich collar of gold about his neck, and two [Turkish] slaves, with other marks of esteem and appreciation of his work."

Attended by his slaves and honored for his genius, the refugee from Rome lived for a time like a lord—until one day the dark side of his unpredictable nature once again got the better of him. On that day in the fall of 1608, for reasons unknown, he quarreled with a fellow knight of higher rank, and for this serious offense he was thrown into prison. Not waiting to hear what the punishment might be, he scaled the prison wall under cover of darkness and managed to find a shipmaster willing to carry him to Sicily. After his dramatic escape a general assembly of the Order of St. John voted unanimously that the artist be "deprived of his habit, and expelled and thrust forth like a rotten and fetid limb from our Order and Community."

During his months in Sicily Caravaggio did not stay for long in any one place. Apparently fearful of retribution by agents of the powerful and far-reaching knights of St. John, he moved from Syracuse to Messina to Palermo; in each of those cities, his fame as an artist having preceded him, he carried out commissions for important church paintings. In one case at least it seems not to have been fear alone that prompted Caravaggio to move on. According to an early 18th Century Sicilian writer, the artist became a *persona non grata* in Syracuse after a local schoolmaster's suspicions were aroused by his attention to some young boy pupils. But at

some point during his stay in Sicily Caravaggio had evidently heard that friends in Rome were negotiating with the Vatican to obtain a pardon for him in the murder of Ranuccio Tomassoni. In order to be closer to home when and if the pardon materialized, he finally embarked for Naples.

From Naples, hoping to appease the Grand Master in Malta, Caravaggio painted and sent him *Salome with the Head of St. John;* if it is the same impressive picture of the event that hangs today in the Escorial, near the Spanish capital of Madrid, it is Caravaggio's last known surviving work. But it seems that the Grand Master was not to be placated, and it may have been his cutthroats, finally catching up with the artist, who cornered him one night in the doorway of a Neapolitan inn. When they were finished with him he was so terribly gashed about the face that he was barely recognizable, and a rumor spread that he had been murdered.

Although Caravaggio recovered from this near-fatal attack, his remaining days were to be few and tragic. In June 1610, after eight or nine months in Naples, he loaded everything he possessed aboard a felucca bound for Port 'Ercole, a coastal town in Tuscany then under Spanish jurisdiction. His friends must have sent word to him that a papal pardon now seemed imminent, and he probably wanted to be as near to Rome as possible—but without actually setting foot in papal territory, in case the Pope suddenly changed his mind.

And in Port 'Ercole or its neighborhood—very likely for the first time in his picaresque life—Caravaggio was arrested for a crime he had not committed. Spanish soldiers, mistaking him for another, seized him and held him until his identity was established a couple of days later. While he raged in jail, the felucca had departed, apparently with all of the artist's worldly goods still on board. Nearly beside himself with fury and desperation, Caravaggio tried to catch up with the ship by hiking along the swampy, malaria-ridden shore under a pitiless summer sun. He had not gone far from Port 'Ercole when he was felled by fever and exhaustion, and on or about July 18, 1610—a little more than two months short of his 37th birthday—he died. A few days later the Pope confirmed his pardon. As a capping irony, it was discovered that his belongings had never left Port 'Ercole but had remained in the safekeeping of local officials.

When Caravaggio's death was announced in Rome his contemporaries mourned the loss of a great artist. None of the obituaries was more eloquent or more to the point than one in verse by the poet Giambattista Marino:

Death and Nature, Michele, made a cruel plot against you:
Nature feared being surpassed by your hand in every image that
you created . . .
Death burned with indignation because your brush returned
to life, with large interest, as many men as his
scythe could cut down.

Medusa's severed head, the classical mask of terror, fills the polished shield (*above*) of her slayer, Perseus. Caravaggio painted the screaming Gorgon from his own mirrored features. Earlier, Leonardo da Vinci (*below*) and Michelangelo (*bottom*) used this open-mouthed expression to portray the rage of a battling warrior and the terror of a damned soul.

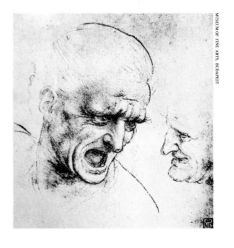

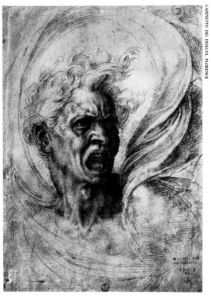

Painters of the Baroque

Between 1598 and 1601 two painters from northern Italy, Michelangelo Merisi da Caravaggio and Annibale Carracci, radically changed the taste of Rome's art patrons, clearing the way for Bernini's exuberant Baroque splendors.

By this time, the vigorous and heroic genius of the High Renaissance had evolved into an artificially refined style called Mannerism. Caravaggio ignored the elegantly distorted figures of the Mannerists and emphasized robust realism. His figures, solidly shaped by a controlled flow of light, convey a dramatic immediacy based on the common man's expressive vocabulary of gestures. The viewer can almost hear Matthew's surprised "Who, me?" as Christ summons him to the apostolate (page 75), or the disciples' astonished gasps as the Lord reveals Himself to them at Emmaus (pages 76-77). Princes of the Church and connoisseurs prized Caravaggio's revolutionary work, but the minor clergy and unlettered populace found it vulgar. Used to the ethereal elegance of late Mannerist religious painting, they were shocked by saints in tatters, with bunions and callused hands.

Carracci's main reform was to return to the canons of classical art. His dazzling frescoes in the Farnese Gallery (pages 80-83) widely influenced other artists and established a style of grand-scale decoration that reigned for the next 200 years.

A violin-playing angel lulls the Holy Family in this detail from young Caravaggio's *Rest on the Flight to Egypt*. The musical notes on the score that Joseph humbly holds for the angelic musician are an actual melody, a precise touch that foreshadows the 22-year-old artist's concern with realism.

Caravaggio: *Rest on the Flight to Egypt*, detail, 1595-1596

Caravaggio arrived in Rome fresh from his apprenticeship in Milan around 1590. One of his earliest religious commissions was the tender *Rest on the Flight to Egypt (below)*. In the painting, traces of his northern training are evident in the S-shaped pose and swirling draperies of the celestial violinist, the gaily colored landscape setting—one of the very few Caravaggio ever painted—and the soft lighting. The *Calling of St. Matthew (right)*, painted only three years later, shows an extraordinary change in the artist's approach: he had abandoned the lyric for the dramatic. Paring away distracting elements and toning down his palette, he pinpointed the pivotal instant when the wealthy tax collector Levi became the apostle Matthew, future saint and martyr. Caravaggio set the scene for this spiritual drama in a simple tavern, accentuating Christ's commanding gesture and Matthew's amazed wonder with a powerful, form-defining light from an unseen source.

Caravaggio: *Rest on the Flight to Egypt*, 1595-1596

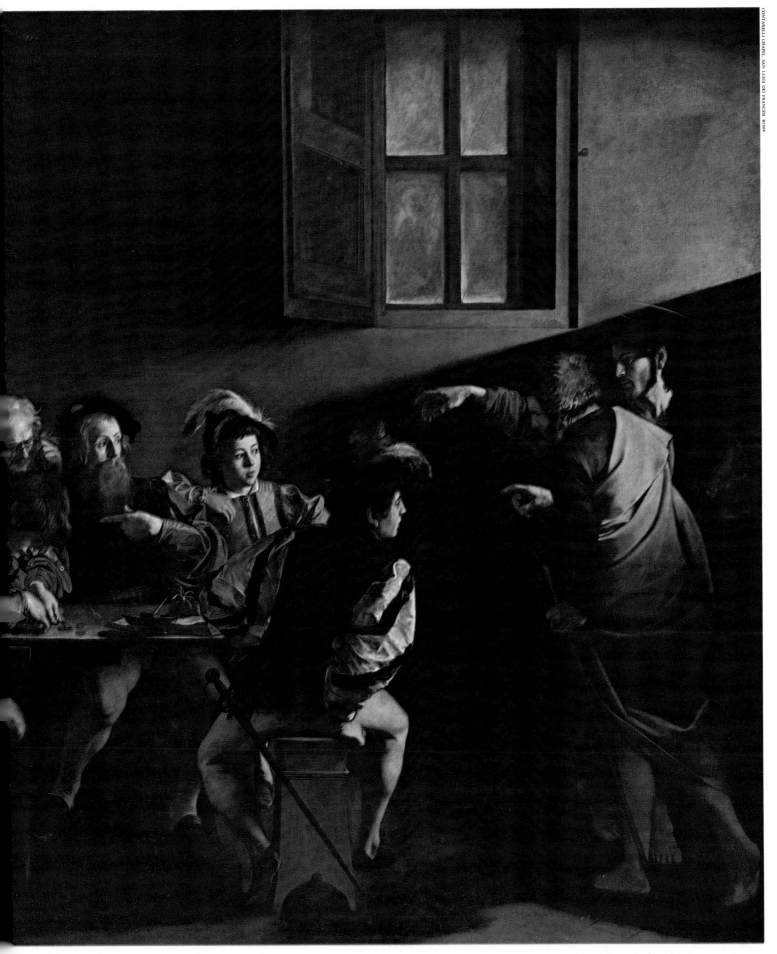

Caravaggio: *Calling of St. Matthew*, 1598-1599

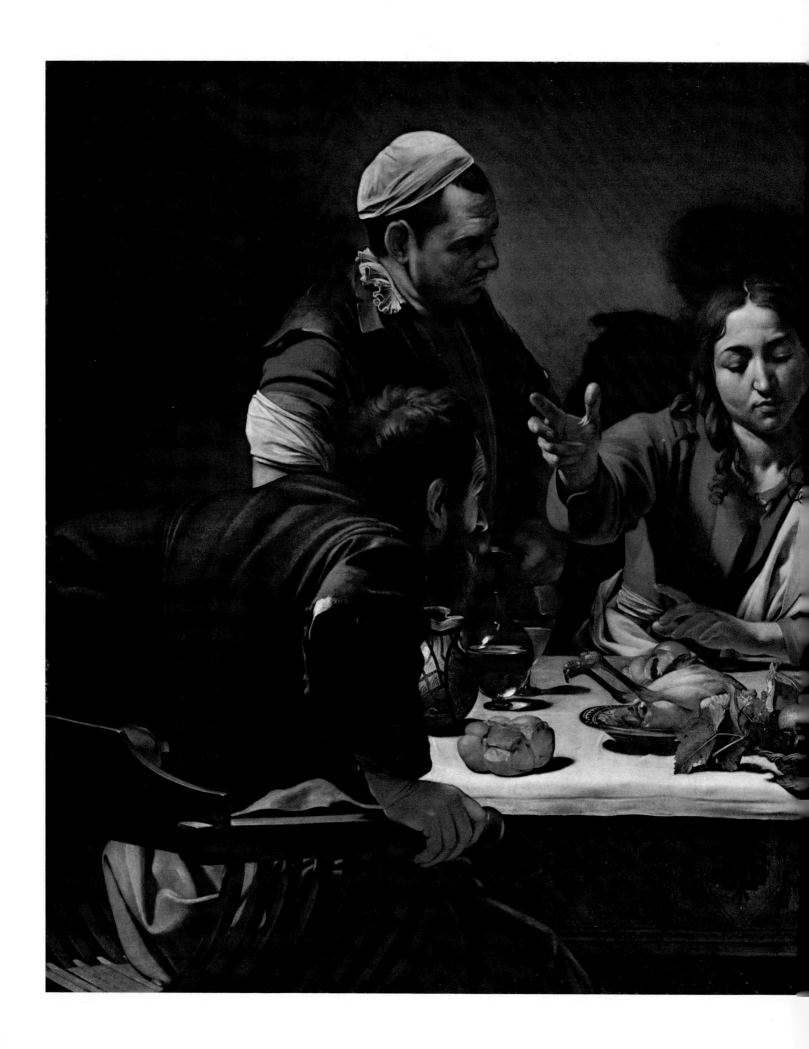

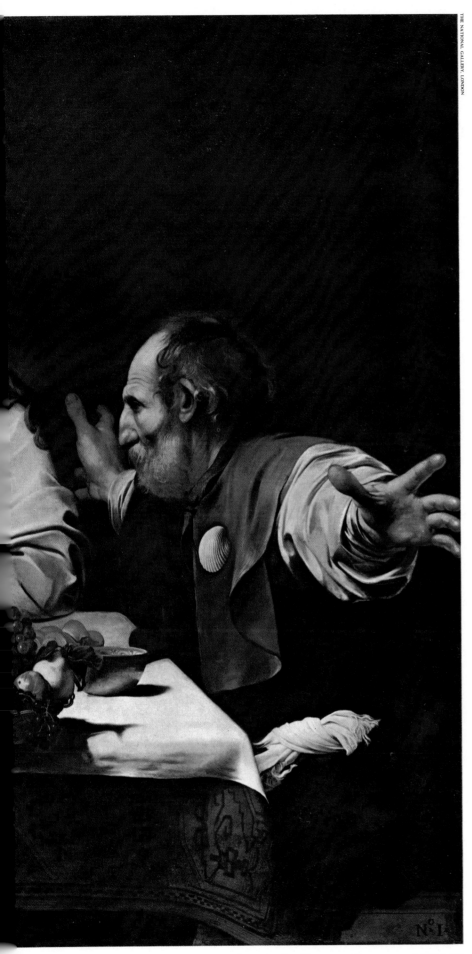

Caravaggio: *Supper at Emmaus*, c. 1598-1600

In *Supper at Emmaus* Caravaggio pictured the moment when Jesus, risen from the dead, disclosed His identity to two disciples who had unknowingly invited Him to share their meal. Caravaggio re-created the scene with such stunning immediacy that the viewer becomes almost a participant in the drama. The moment is so heightened that the startled disciple at the left seems about to shove his chair right out of the picture; the other disciple's outstretched arm is so daringly foreshortened that it seems to pierce the surface of the canvas. The innkeeper's stolid bewilderment lends a note of simple reality.

Caravaggio broke with tradition by portraying Christ without a beard, but His gentle gesture of benediction and meek expression, combined with the commonplace setting and workaday clothes, convey a profound sense of the humility that He preached.

The repast itself is a subtly symbolic still life. The painter's characteristic light floods the table, contrasting such blemished earthly food as a scrawny fowl and spotted fruit with the perfect loaves of bread Christ is blessing.

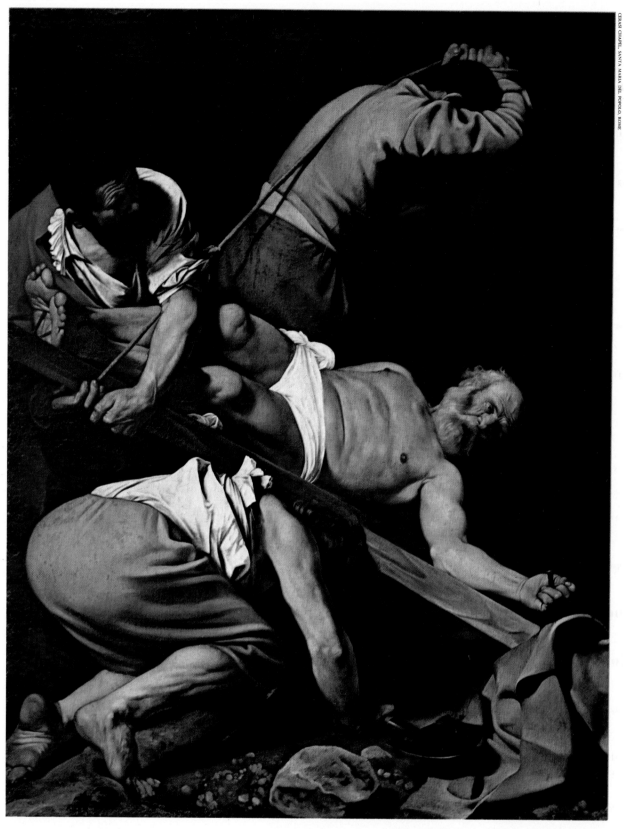

Caravaggio: *Crucifixion of St. Peter*, 1601

At 27 Caravaggio was commissioned to paint a *Crucifixion of St. Peter* and a *Conversion of St. Paul* as side panels for the Cerasi family chapel in Rome's Santa Maria del Popolo. It was a double challenge: Michelangelo had paired the same subjects in the Vatican's Pauline Chapel; and the panels were to flank a superb fresco altarpiece by Annibale Carracci, an established artist of 40 whose work was widely admired by connoisseurs.

Caravaggio met the challenge brilliantly. For dramatic emphasis, and to relate his paintings to their site, he imagined that the source of light for

Caravaggio: *Conversion of St. Paul*, 1601

both works was in a painted burst of golden rays —called a "glory"—on the chapel ceiling. Modeling the figures with strong contrasts of highlight and shadow, this imaginary light drenches Peter and seems powerful enough to fell young Saul. Caravaggio's huge panels were meant to be seen diagonally rather than head on. The artist was aware that they would face each other across a narrow chapel, so he compensated for this in his powerful composition. The original effect can be reproduced by partly closing this book and looking at each picture at about a 45° angle.

ome's Farnese Gallery ceiling *(left)* is a radiant 60-by-20-foot masterpiece. Only Michelangelo's Sistine Chapel and the Raphael frescoes in the Vatican surpass it. It was painted by Annibale Carracci, with help from his less talented older brother Agostino.

The gallery was intended as a showcase for the Farnese family collection of antique statues. Carracci wittily designed the coved vault as if it were a complementary display of easel paintings. His subject, the mythical loves of the all-too-human Olympian gods and goddesses, is divided into 11 panels surrounded by molded frames and interspersed with what appear to be huge marble statues and bronze low-relief medallions.

Actually, all is illusion; Carracci's masterful brush transforms the flat plaster surface into richly textured, subtly modeled three-dimensional forms. The panel below, for example, portraying Venus' love affair with the Trojan prince Anchises, is flanked by statuesque warriors and an ornate frame —all painted.

On the following pages is a detail from the ceiling's central panel—its largest—depicting a riotous procession of bacchantes, satyrs and cupids. The skill of the painter and his love of fully rounded forms and brilliant, luminous color are abundantly evident.

Annibale Carracci: Farnese Gallery ceiling, Palazzo Farnese, detail, 1597-1600

81

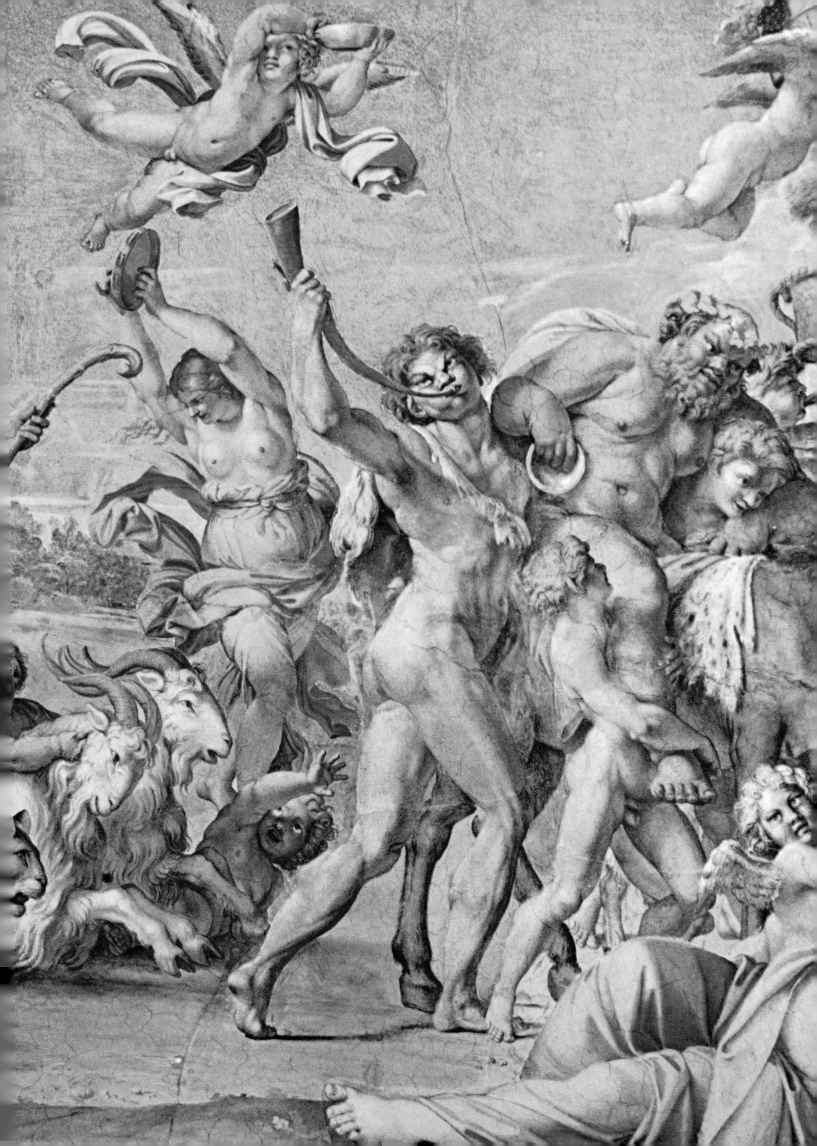

IV

The Fountains
of Rome

In Bernini's triumphant career in the service of eight popes there
was only one hiatus, a relatively brief period when the artist ap-
pears to have been discomfited. The interruption, which had its
roots in the final years of Urban VIII's reign, was attributable as
much to the malice of Bernini's enemies as to his own error. It was
Bernini's misfortune to inherit an architectural project begun by
Carlo Maderno, his predecessor as Architect of St. Peter's, who
had designed a façade for the basilica that was to be flanked by two
bell towers. In Maderno's time the bases for these structures had
been built up to the level of the balustrade across the top of the fa-
çade and appeared much as they do today. To carry out Maderno's
plan, Urban ordered Bernini to design towers to be placed on the
bases, and in 1637 work was begun.

When he undertook the project Bernini was well aware that con-
struction problems might arise. The ground beneath St. Peter's is
treacherous, containing springs of water. Before erecting his tow-
ers Bernini had Maderno's foundations investigated by master
builders who reported them sound. Possibly the builders erred in
their judgment or perhaps Bernini should have called for further
opinions. At any rate, when the first of the towers—on the left as
one faces the basilica—had attained a considerable height and
weight, ominous cracks appeared in the structure below. Work
was halted while cause and cure were considered, and Bernini's crit-
ics intimated that his mistakes would no doubt bring about the
collapse of the entire basilica. They did not speak very loudly, how-
ever—Urban VIII was still alive and would hear no insult to his fa-
vorite artist.

But in 1644, as the debate over the tower continued, Urban died
and Bernini immediately became vulnerable. Among the critics
who now felt free to raise their voices was Francesco Borromini,
one of Rome's leading architects (examples of his work appear on
pages 43-47). Borromini had been associated with Bernini on oth-
er projects in the past, and being a moody man he may have grown

weary of hearing the master constantly acclaimed. Whatever the case, he and other critics hastened to persuade Urban's successor, Innocent X, that Bernini was a bungler. Adding weight to their argument was the fact that Innocent bore a grudge against Urban for leaving him a sadly depleted papal treasury, and had hard feelings toward anyone who, like Bernini, had benefited from Urban's favor. The upshot was that Bernini's tower was pulled down and its designer temporarily disgraced.

The depth of that disgrace is debatable. Bernini did not lose his post as Architect of St. Peter's (he kept it to the end of his life), but for several years he received no major commissions from Innocent X and was not even asked to submit suggestions. However, there was no lack of commissions from other sources, including that for the Cornaro Chapel *(page 136)*, which was designed for Cardinal Federigo Cornaro and which Bernini thought was the finest work he ever produced.

An interesting aspect of the artist's character is illuminated by a sculpture he began at this time and which, for reasons unknown, he never completed. Feeling deeply wronged by those who held him responsible for the failure of his bell tower, he turned his attention to a piece of art he thought might stand as his vindication as long as marble endures—*Truth Revealed by Time (left)*.

At first glance *Truth Revealed* is baffling. It portrays a seated, naked woman with one foot on a large globe; in her right hand she holds a disembodied, godlike face with rays emanating from it; and she looks upward at an irregular spire formed by her own drapery, which seems to be spontaneously unwrapping itself and making off toward heaven. The woman is surprised and delighted.

Truth Revealed is an allegory but only half of one. Bernini's original intention was to complete the sculpture with the figure of Time flying over the woman's head and carrying his scythe, while with his free hand he removed the drapery that concealed her form. His figure would have been supported in mid-air by broken columns and ruined funeral monuments. If it had been finished, the allegory, with the aid of its title, would have been clear enough: Truth, who holds the light of the sun in her hand and like the sun dominates the globe, will always be rescued from temporary obscurity by the passage of time.

In like manner Bernini, upon whom a passing cloud had fallen, would soon be vindicated. But in the meanwhile Bernini's adversary, Francesco Borromini, stood first in the favor of Innocent X and received some choice commissions. The Pope's family palace, the Palazzo Pamphili, is situated in Rome's Piazza Navona with the Pamphili family church, Sant' Agnese, beside it. Like most popes of that era, Innocent wished to create an impressive family memorial, and the Piazza Navona seemed ideal for the purpose. Borromini was given work in the design of both palace and church, which had been begun by another, and it was planned to erect an important fountain in the center of the piazza. This idea became

GALLERIA BORGHESE, ROME

Bernini began to evolve a change in his style with this allegorical work, *Truth Revealed by Time*. In this sculpture he elongated the figure and limbs in a way that was unlike his earlier, more classical treatment of the human body. Bernini left this unfinished work to his family as a token of his skill and a reminder that Truth is the greatest virtue on earth.

86

·even more important after the rediscovery of a large obelisk that had been brought from Egypt in classical times to Rome and had long lain forgotten near the Appian Way. In April 1647 the Pope went out to have a look at it and decided that it should be incorporated in his fountain.

When he invited artists to submit designs, Innocent sent no invitation to Bernini, although he was well aware that the sculptor had already created several fountains for Urban VIII. However, it chanced that Bernini had a good friend in Prince Niccolò Ludovisi, who was married to the Pope's niece. According to the account set down by Bernini's biographer Baldinucci, the Prince persuaded the sculptor to make a model of a fountain featuring the obelisk and then arranged to have it secretly placed in a room of the Pope's family palace where Innocent could not fail to notice it.

"Upon seeing such a noble creation and a design for such a vast monument" says Baldinucci of the Pope, "he was nearly ecstatic. Since he was a Prince of the clearest intelligence and of the loftiest thoughts, after spending a half hour or more around the model, continuously admiring and praising it, he burst out in the presence of the whole Secret Council with the following words: 'This is a trick of Prince Ludovisi, but it will be necessary to make use of Bernini despite those who do not wish it, since those who do not want his works need not look at them.' He immediately sent for Bernini, and with a thousand signs of esteem and love and with a majestic manner, almost apologizing, he explained to him the motives and various reasons for not having made use of him before, and he gave him the commission to make the fountain after his model. Afterward and for the rest of his pontificate, Bernini was always in favor and held in the high esteem to which he was accustomed. Indeed, he was so much in the good graces of that pontiff that every week or so the Pope wanted him at the palace, and there he passed several hours in delightful discourse. It was often said that Bernini was a man born to associate with great princes." The artist's enemies, after hearing of all this, must have been inclined to give up slander forever.

Long after Bernini's day the English poet Percy Bysshe Shelley wrote that the fountains of Rome, alone, would justify a journey there. About two hundred refresh and beautify the city, and none is more pleasant than the one that restored Bernini to papal favor. Indeed, his fountain in the Piazza Navona is among the most remarkable in the world; it is an unlucky traveler to Rome who fails to see it. But there are several other Bernini fountains in the city, either entirely of his design or with important alterations made by him and representing various periods in his career. Each has its particular charm and expresses his deep love of water and his use of the sight and sound of it as materials for art.

It is delightful to walk through Rome past Bernini's fountains. This stroll can be taken in a leisurely couple of hours, with pauses for an espresso or a glass of wine, along a route that begins in the

Piazza Navona, meanders eastward past the nearby Pantheon, north to the Spanish Steps and ends in the Piazza Barberini. It is best to make the walk very early, soon after dawn. The slanting, golden light of morning reveals the fountains at their best and at that hour —before the traffic of the city has begun to thunder—it is possible to *hear* them. Since 1968 the Piazza Navona has been closed to automobiles, but the other fountains are located in busy areas where their sound is easily drowned out.

On first entering the Piazza Navona the traveler is likely to be puzzled by its proportions. It is a compressed oblong, fully 302 yards in length but only 59 wide, surrounded by four- and five-story buildings of great age. Bernini's famous fountain, an island of rock peopled by monumental figures and surmounted by the shaft of the obelisk, stands in the center with a lesser fountain at either end of the oblong. There is a comfortable sense of enclosure in the piazza. The entrances are narrow, reminiscent of those in a stadium, which is precisely what the place once was. The Emperor Domitian completed it in 96 A.D. and there held grueling Greek foot races. Domitian's stadium fell to ruin through the centuries and was plundered for building stone during the Renaissance. Its massive foundations remained, however, and it is upon these that the houses around the Piazza Navona were raised.

Bernini's great central fountain, the Four Rivers *(pages 100-103)*, requires a brief explanation in our time, although in the 17th Century most educated men readily understood it after a few glances. They were far more attuned to allegory and symbolism than we. The four figures seated around the base represent rivers, which in turn stand for quarters of the world: *The Danube* (Europe), *The Ganges* (Asia), *The Nile* (Africa) and *The Rio de la Plata* (America). *The Danube* raises his arms toward a shield bearing the emblem of Innocent X (three lilies and a dove) with the emblem of all popes (the keys of St. Peter and the triple crown) above that. *The Ganges* holds a long oar, symbolic of the extraordinary length of the river's navigable waters, while *The Nile* veils his head to indicate that the river's source is unknown (as it then was). Near *The Rio de la Plata* are coins to suggest the great wealth of the New World.

The most astonishing feature of the fountain is Bernini's use of slender, intersecting arches, carved to represent a watery grotto, to bear the 120 tons or more of the granite obelisk. The shaft appears almost to be hovering in the air; one can look through the grotto from all four sides. According to Baldinucci, "The rock mass is made in such a manner that it appears to be a single piece. It cannot be broken into separate pieces through any accident, as all the pieces are dovetailed and so placed that one makes bond for the other." Secure as the construction may be—it has been standing in the piazza since its completion in 1651—there have always been Romans who predict its imminent fall. In this regard there is a fine tale told by Bernini's son in his biography of his father. The artist, annoyed at

prophecies of disaster, appeared in the piazza one day with an apprehensive face and ordered the onlookers to stand clear. While everyone watched with bated breath he approached the fountain cautiously. He then had his workmen tie the base of the obelisk with strings which he ordered to be attached by nails to the houses nearby. Whereupon, looking greatly relieved, he left.

The supporting grotto is of travertine, the ubiquitous, porous building stone of Rome, and the figures of the rivers and the papal coat of arms are of marble. Travertine is a good deal harder than it looks, but it can be carved readily, as indicated by the minor symbolic creatures in or near the grotto—horse (Danube), lion (Nile), and palm tree and serpent (Ganges). There is another thing —which seems the best way to describe it, although Baldinucci calls it "a terrible monster commonly known as the Tatu of the Indies"—lurking among the carvings at the base of the grotto. Bernini intended it to represent an armadillo, symbolic of the Rio de la Plata. However, he must have worked from an engraving or drawing by someone who had never come face to face with a real armadillo and envisioned it as a fanciful creature in the class of the unicorn and griffin.

The fountain is an excellent example of the Bernini workshop technique. There can be no doubt that the master designed it in every detail, but the execution is another matter. Baldinucci records that "the entire rock mass, the palm tree, the lion and half of the horse are completely by Bernini. The Nile is the work of Jacopo Antonio Fancelli, the Ganges by Adamo, the Danube by Andrea Lombardo, and the Plate by Francesco Baratta. However, in the case of the last figure and that of the Nile, Bernini made many of the strokes with his own hand." It may be disconcerting to discover that only some of the figures were actually carved by Bernini, and that everything else is by others. But it is his conception, not the labor, which is more important. Almost every one of Bernini's major projects, from the time he began to work for Urban VIII in 1624 until he died in 1680, was executed in small or large part by someone else. Bernini was always at hand, in control, and where the work fell short of his conception he picked up the hammer and chisel himself. Highly successful artists of the 17th Century customarily worked in that way.

While looking at the Four Rivers the traveler will find it worthwhile to consider what some of Bernini's modern critics say of him —that "he had the hands of a sculptor and the instincts of a stage designer." The remark would not have offended him. He *was* a stage designer, an excellent one; for his own theatrical productions he produced effects of truly stunning power, and the Four Rivers reveals him in top form. The idea of the fountain is not very profound but it is sheer delight to look at it and it furnishes water—decoratively today, but also in a practical way in an age when the buildings around the Piazza Navona lacked plumbing. What else is to be expected of a fountain? And who else, given a 54-foot ob-

elisk to start with, would have done so well? To this last, Bernini himself might have made a surprising answer. In later years he came to dislike the fountain. When he was being driven through the Piazza Navona he closed the shutters of his carriage and said "How ashamed I am to have done so poorly!"

What Bernini may have meant is that in the Four Rivers his stage designer's instincts perhaps ran away with him. The fountain, if someone feels the need to criticize it, can be called a huge whimsy turned to stone. As master of arts to the popes, Bernini produced a good deal of ephemera; in his day it was not at all unusual for even the most distinguished artists to create for their patrons occasional pieces made of perishable material, meant to serve a specific purpose and then be destroyed. Thus Bernini designed numerous carnival cars and coaches, catafalques, lath-and-plaster figures, decorations for feasts and festivals and the like. For a Forty Hours' Devotion, a particularly solemn Church service, he once devised in the Pauline Chapel of the Vatican a vision of the Heavenly Glory and illuminated it by 2,000 lamps hidden behind artificial clouds. But by its nature ephemeral art should perish. If it is made of enduring material its creator may someday be sorry he made it. Or so the argument goes, and it does seem to apply to a great deal of the art that one sees here and there. But to the Four Rivers? Never!

Bernini, whatever his later remarks, obviously enjoyed making the Four Rivers. (It may be said here, as well as anywhere, that Bernini was an awfully cantankerous man. That is what gives some of his productions such heartbreaking charm. When a curmudgeon offers you a flower, or a fountain, he really means it. Bernini also enjoyed playing little jokes on popes, a hobby not many people have been able to indulge. While the Four Rivers was under construction it was surrounded by a big screen. Occasionally Innocent X would look in to see how work was progressing, and finally there occurred a scene that is best described in the wonderfully Baroque account of Baldinucci: "One morning the Pope arrived and entered the enclosure with Cardinal Panzirolo, his secretary of state, and about fifty of his closest confidants. He remained there more than an hour and a half enjoying himself greatly. Since the water had not yet been turned on, the Pope asked Bernini when it would be possible to see it fall. Bernini replied that he could not say on such short notice, since some time was required to put everything in order.... The pontiff then gave him his benediction and turned toward the door to leave. He had not yet gone out of the enclosure when he heard a loud sound of water. Turning back he saw it gush forth on all sides in great abundance. [Bernini] had, at the crucial moment, given a certain signal to the person whose job it was to open the water ducts.... Overcome by such originality and gladdened by so beautiful a sight the Pope returned with his whole court. Turning to Bernini he exclaimed, 'In giving us this unexpected joy, Bernini, you have added ten years to our life.'"

Innocent X died in less than five years, but surely this was not be-

FIRST MODERN CARICATURES

Caricatures and cartoons had long been known before the 17th Century but Bernini added a new dimension to the art when he began to characterize specific personalities in witty sketches. Below and opposite are Bernini caricatures of various churchmen and soldiers and a French cavalier.

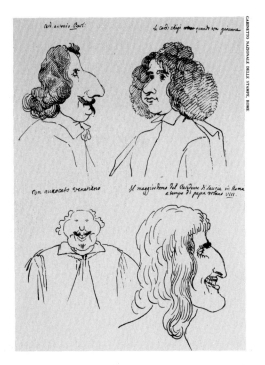

cause of any deficiency in the size of his heart. Baldinucci continues: "As a greater sign of his pleasure the Pope sent to the home of his sister-in-law, Donna Olimpia, in Piazza Navona for a hundred doubloons to be quickly distributed to the men engaged in work on the fountain."

Because the opportunity to talk about pleasantries concerning fountains, Bernini and popes occurs seldom, perhaps a one-paragraph digression may be forgiven. It happened that another of Bernini's popes, Clement IX, was an insomniac. On the day of his election in 1667 the gentle old man called Bernini and explained his problem: he liked to listen to fountains at night, because the sound lulled him, but the one in the Vatican garden was not loud enough. Could Bernini fix it? Bernini tried, but succeeded only in distressing the plumbing to the extent that there was no sound at all. Accordingly he quickly put together a machine that "moved a wheel that upon striking certain paper globes with multiple blows made a sound exactly like a very abundant fountain." The machine was placed in a room next to the Pope's bedchamber. That night, upon what surely must be the most restless bed in Christendom, the Pope slept well. In the morning, informed of what had been going on, he said, "Truly, Signor Cavalier Bernini, we would never have believed that on the first day of our pontificate we would be deceived by you."

If the traveler who has got up at dawn to look at Bernini's fountains is to conclude his walk by dark, it is time to move on. But before leaving the Four Rivers he should step back from it several paces and regard the manner in which Bernini arranged the fall of water. At the corners of the fountain the water spurts out in thin, curved, fanlike sheets. These may seem, to the eye, to be solid—or so at least Bernini may have hoped. They appear to contribute structurally to the base of the fountain, widening it, making it bigger than it is. The observer knows that this is an illusion. Bernini dealt in illusions. He is asking the observer to join with him, even to conspire with him, in yet another. This fountain is somehow borne up, floating, weightless, perhaps kept in balance by something above the rooftops strong as the cables of God.

un cavalier francese

The traveler should take a final glance, too, at the figure representing the Rio de la Plata. This figure is holding an arm aloft in what appears to be a gesture of alarm. One possible interpretation is that *The Rio de la Plata* is afraid the precariously balanced obelisk will fall on him. Another, suggested by a contemporary document, is that it is calling attention to a papal dove at the obelisk's peak. But the Romans, disregarding documentary evidence, have a version of their own. They point out that *The Rio de la Plata* is not even looking at the obelisk. They say he is looking toward the Church of Sant' Agnese close by.

There are various reasons why one might think that *The Rio de la Plata* is looking toward the church. For one thing, it is quite a curiosity in that it is built on the site of a former bordello. In the days

Bernini designed *The Elephant and Obelisk* as an emblematic tribute to a scholarly pope, Alexander VII. The marble elephant, symbol of wisdom, supports an ancient Egyptian monolith topped by papal arms and a cross. A contemporary poem built around a painful pun suggests the meaning of the monument: "The Egyptian obelisk, symbol of the rays of *Sol* [sun], is brought by the elephant to the Seventh Alexander as a gift. Is not the animal wise? Wisdom hath given to the World *Sol*ely thee, O Seventh Alexander, consequently thou hast the gift of *Sol*."

when the Piazza Navona was a stadium, it was underpinned by massive arches. The space beneath an arch was called in Latin a *fornix*. From that, because of the nature of the business transacted in Roman archways after dark, comes the word "fornication." The Church of Sant' Agnese has beneath it the remains of a particular arch and fornix. According to tradition, St. Agnes, to whom the church is dedicated, spurned the advances of a powerful Roman who in anger threw her into that fornix. Somehow she emerged *virgine intacta*, a miracle her church commemorates. But even that may not be why *The Rio de la Plata* seems to be looking toward the church. Romans claim that Bernini knew that his old enemy, the architect Borromini, was going to be involved in creating the building. Consequently he caused *The Rio de la Plata* to stare at it in alarm and to shout, silently, eternally: "Look out! Borromini's lousy building is going to collapse on us!" This, according to Romans, is Bernini's revenge upon the man who was instrumental in persuading Pope Innocent X that the bell tower at St. Peter's should be torn down.

The fountains at opposite ends of the Piazza Navona were not built by Bernini. The one at the south, however, was renovated by Bernini, who designed its central figure during the reign of Innocent X. Because, to some, this standing figure looks like a Moor, the fountain is called Il Moro, although Bernini probably intended the figure to be a version of a sea god. As he struggles with a big, spouting fish, the god looks over his shoulder and seems to be calling to somebody, anybody, to please come and lend a hand. Nobody is doing anything and he is angry.

The figure of the god, or the Moor, is unusual in Bernini's work because, perforce, it was designed to be looked at from all sides. Whenever possible, Bernini liked to place his statues against walls or in niches so that there was only one major viewpoint for them. They were like three-dimensional pictures. But since it is easy to walk completely around *Il Moro*, the figure had to be planned with that in mind, and it comes off with great success. There is a good deal of torsion or twist in the body, more than is usually seen in a freestanding figure; thus *Il Moro* continually presents new and interesting aspects as the observer orbits it.

As one goes out of the Piazza Navona, heading toward another of Bernini's fountains—the Barcaccia at the foot of the Spanish Steps—a slight detour past the Pantheon will bring him to the Piazza della Minerva. In its middle there rises one of the most striking objects any sculptor has ever created: a life-sized elephant standing on a pedestal, carrying a small Egyptian obelisk on his back. It is generally classified with Bernini's fountains because no one knows where else to put it.

At first glance the object *(left)* may appear to be only an overgrown jocularity; the elephant *is* funny, with his determined expression and overlong trunk; but there is far more here than meets the uneducated 20th Century eye. *The Elephant and Obelisk* was

completed in 1667 for yet one more of Bernini's popes, Alexander VII, whose arms—mountains and a star—may be seen at the top of the obelisk. Alexander VII was a thoughtful man who had a coffin moved into his bedroom to remind him not to be an uppity pope. He was also formidably learned, not the sort of man who would have an elephant and obelisk put together in his honor without knowing all the implications.

Seventeenth Century men knew many more things about elephants than we do. Of course it may be, as the American humorist Josh Billings said, that "it is better to know nothing than to know what ain't so," but at least 17th Century men *believed* these things whereas 20th Century men believe scarcely anything. In Bernini's world the elephant was held in the highest moral esteem. Some of the ideas about him came from Pliny, the old Roman naturalist who had occasionally been deceived by his informants, and from others equally misinformed. These ideas were nonetheless still current. The elephant was very chaste, his occasion for sex being but once in his life, and then reluctantly, in order to preserve his race. The elephant was enormously intelligent, his mental capacity being related to his size. He was also polite, strong, meek and a trustworthy guide. Pliny spoke of elephants that would lead lost travelers out of the jungle, and by Bernini's time the guiding elephant had become one of the symbols of Christ, "who, by His example, shows the path to eternal Salvation." It had also been suggested, in the *Iconologia* of Cesare Ripa, published in 1593 in Rome, that "the rare qualities found in that noblest of beasts are worthy of honors higher than those of Cardinaldom." In 1630, when the first elephant in more than 100 years was brought to Rome, Bernini certainly must have hurried to examine him.

Obelisks, too, had many interpretations. For example, if one regarded an obelisk from the bottom up, the narrowing of its sides suggested the transition from earthly to ethereal things. Or if it was considered from the top down, the broadening toward its base suggested the fanning out of a ray of light falling from heaven upon earth. Obelisks were also thought to have some element of divine wisdom about them, a wisdom that had existed since the Creation. Of course, before being incorporated in Christian monuments, obelisks had to be exorcised in an elaborate ceremony involving singing, praying and the firing of guns. In placing the elephant and obelisk together in honor of Alexander VII, Bernini was flattering the learned Pope. As the Latin inscription on the pedestal reads, "Let every beholder of the images engraven by the wise Egyptian and carried by the elephant—the strongest of beasts—reflect on this lesson: Be of strong mind, uphold solid Wisdom."

Bernini's earliest surviving fountain, the Barcaccia (The Old Boat), which the traveler can reach from *The Elephant and Obelisk* by way of the broad avenue of the Corso and Via Condotti, also contains more than may be instantly apparent. Ship-shaped, having a prow at both ends, it bears on each prow three bees, the

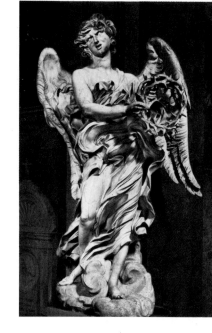
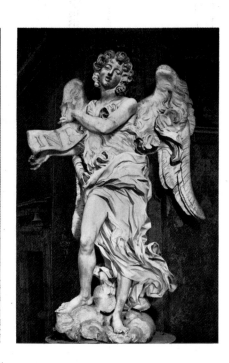

Bernini intended these monumental angels for the Ponte Sant' Angelo, the bridge *(pages 98-99)* leading to the Vatican from the city of Rome. But the Pope considered the artist's marble originals too delicate to be risked in the open air. The two pictured here remained in the sculptor's studio for many years, until finally they were placed in the Church of Sant' Andrea delle Fratte in Rome.

arms of Urban VIII who commissioned it. It is sometimes said, because of its shape and because it appears to be sinking in its surrounding basin, that it commemorates a ship or boat that was washed up on that spot during some ancient flooding of the Tiber. (In 1598, the year of Bernini's birth, the innocent-looking Tiber cut loose with a terrific flood that stood 18 feet deep in the rotunda of the Pantheon.) It it also said that the Barcaccia presents a low profile so as not to obstruct men's view of the Spanish Steps behind it. Neither of these ideas is correct. The Spanish Steps, the gift to Rome of a wealthy Frenchman and so named because the Spanish Embassy was once located nearby, were built a century after the fountain, and no record has been found of any boat ever having been stranded there. The fountain is low because the water pressure of the aqueduct that supplies it, the Acqua Vergine, is low. The fountain has been made to seem even lower by the several repavings of the Piazza di Spagna since 1629, which have successively raised the level of the street.

Very likely the fountain is in the shape of a ship because ships are symbols of the Christian Church, which some early theologians likened to a sturdy bark floating safely in the midst of turbulent seas; the English word "nave," the central hall of a church, probably derives from the Latin for ship, *navis.* When a pope is invested with his office, the seal ring that is placed on his finger shows Peter, the First Apostle and first pope, in his boat: the Ring of the Fisherman.

There are other features of the Barcaccia that may be symbolic, among them the low jets of water that spurt out somewhat like gunfire, perhaps recalling the militaristic nature of Urban VIII. However, the Pope himself once composed a Latin verse that seems to deny this: *"Bellica Pontificum non fundit machina flammas; Sed dulcem, belli qua perit ignis, aquam"* (The papal warship does not

pour forth flames, but sweet water to extinguish the fire of war).

As one looks across the Piazza di Spagna at the Barcaccia fountain, there stands at the right, at the foot of the Spanish Steps, the house once occupied by the poet John Keats. In late 1820 Keats left England, his body devoured by tuberculosis, and came to Rome to die. His poetry is full of references to water—brooks, rills and the like—and possibly he paid heed to the words of his friend Shelley in praise of the city's fountains. He surely must have spent many hours looking out of his window at the Barcaccia. Keats closed his eyes on February 23, 1821, and was buried in Rome's Protestant Cemetery beneath a stone engraved with the famous line, "Here lies one whose name was writ in water."

The function of water, if not to sweep man and his works forever away, is to sustain him, and there is no fountain anywhere that seems more bursting with life than Bernini's Triton in the Piazza Barberini, which can be reached from the Barcaccia by climbing the Spanish Steps and walking to the right along the Via Sistina. The Triton was also commissioned by Urban VIII and like Bernini's Il Moro, designed two decades later, was intended to be viewed from all sides. But despite the papal insignia carved on it, it seems enthusiastically pagan. Four dolphins in a pool support on their upraised tails a huge, open scallop shell upon which *Triton* sits, blowing a great watery blast on his conch-shell trumpet. He is, according to a version of the flood story told by the pagan Roman poet Ovid, sounding retreat to the waters that covered the earth and ordering them back behind their shores and channels. So it may be. But to thirsty men he is the ultimate symbol of watery abundance, his beard soaked with it, his stained chest rippling with it. His conch shell gives the impression of being more like a great cup than a trumpet, and *Triton* seems to be quenching an immemorial and prodigious thirst. That image will remain with every wanderer who has ever seen him, in whatever hot field or dusty town the wanderer may be.

Near the Triton, at the foot of the Via Véneto, is the simplest of all of Bernini's fountains, The Bees, which is comprised only of a well-carved, upright scallop shell above a pool and three large bees representing the arms of Urban VIII, with spouts beneath them projecting water into the pool. It requires no explanation at all, except perhaps a translation of the Latin on the shell: "Pope Urban VIII built a fountain to beautify the city and at the same time, with this convenience, he provided for the needs of the people."

Romans often pause today to drink from the spouts of this fountain; they think the cool, clear water excellent. The traveler, who has walked a long way in tracing Bernini's fountains from the Piazza Navona, is surely entitled now to drink the water too. And may he then, when he goes back to wherever he happens to be staying in Rome, find a pleasant letter from home to fulfill what is said in Proverbs 25:25: "As cold waters to a thirsty soul, so is good news from a far country."

The Face of a City

Three centuries after Bernini's death, his influence can still be seen and sensed on the streets of Rome. In a city that is virtually a living museum of art and architecture, the contributions of Bernini stand out like exquisite gems in an ornate diadem.

It is a tribute to Bernini's genius that three of his most impressive Roman landmarks, pictured on these pages, were achieved in the face of difficult challenges. For the Ponte Sant' Angelo, the main bridge over the Tiber linking the Vatican with secular Rome, Bernini was asked to design statues of 10 angels that would be equally inspiring when viewed from near or far by persons crossing the bridge; the graceful figure on the opposite page is evidence of his success. For the spectacular Fountain of the Four Rivers in the Piazza Navona Bernini had to adapt himself to another man's basic conception and was furthermore required—by papal order—to include in his design an incongruous and awkwardly shaped Egyptian obelisk.

Perhaps the greatest challenge to Bernini's skill, however, was that presented by the tiny site on Quirinal Hill on which he was asked to build a church. His triumphant answer was the stunning Sant' Andrea al Quirinale, a soaring and lavishly decorated edifice, only about 115 feet wide and less than 100 feet deep, that he came to regard as one of the finest achievements of his long and brilliant career.

On the Ponte Sant' Angelo stands a wind-whipped angel, one of 10 similar figures executed from Bernini designs. The angel bears aloft the scroll from Jesus' cross, which reads "I.N.R.I.," the Latin acronym for "Jesus of Nazareth, King of the Jews."

Angel with the Superscription, 1670–1671

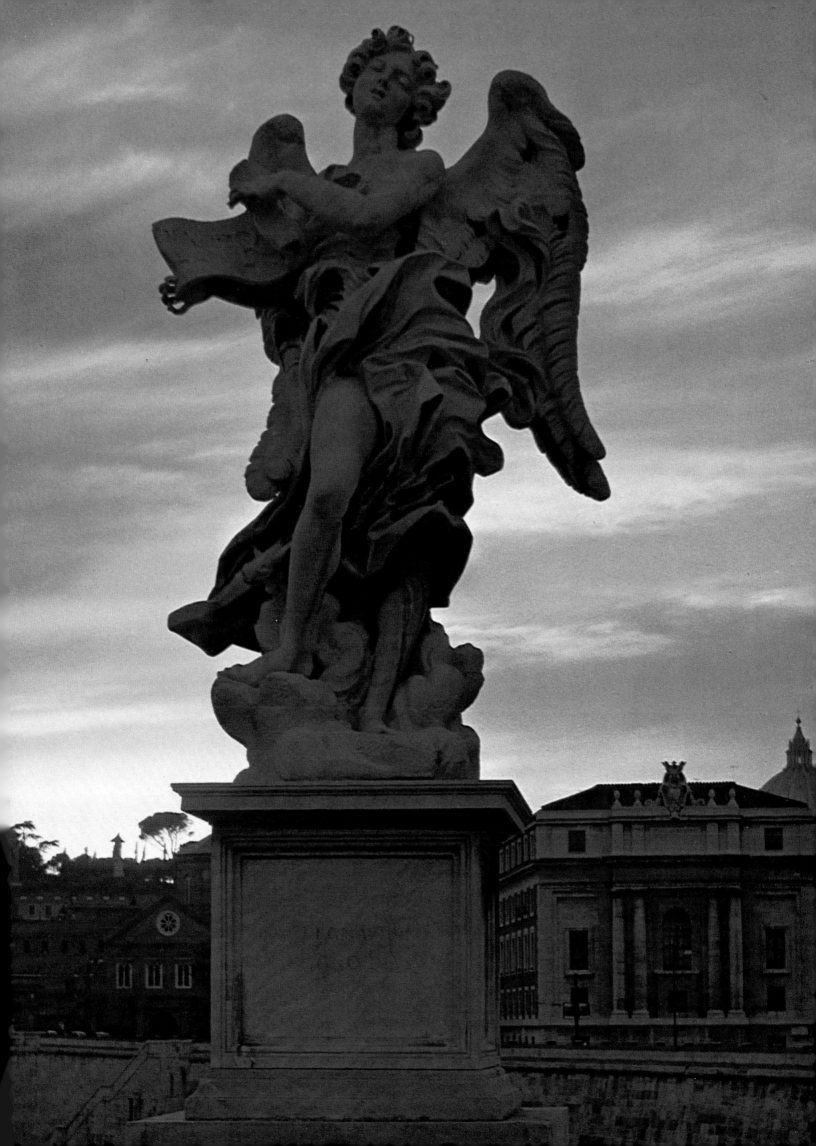

Narrow Ponte Sant' Angelo, named for the fortresslike Castel Sant' Angelo (originally Emperor Hadrian's mausoleum) at its northern end, confronts Vatican visitors with the vista planned by Bernini in 1668: a heavenly gauntlet of 10 huge angels, each bearing a symbol of the Passion.

Carved by a group of prominent Roman sculptors, the statues are variations on a pair of Bernini originals commissioned by Pope Clement IX. Bernini's own works were considered too

precious to be exposed out of doors—they are now installed in Sant' Andrea delle Fratte *(page 94)* —and so copies were made for the bridge. Bernini himself, however, did a large part of the carving of the angel on the preceding page, a copy of one of his originals begun by an assistant.

Bernini's celebrated Fountain of the Four Rivers —shown in full and studied in detail on the following pages—was also a production of the master himself with the aid of other artists.

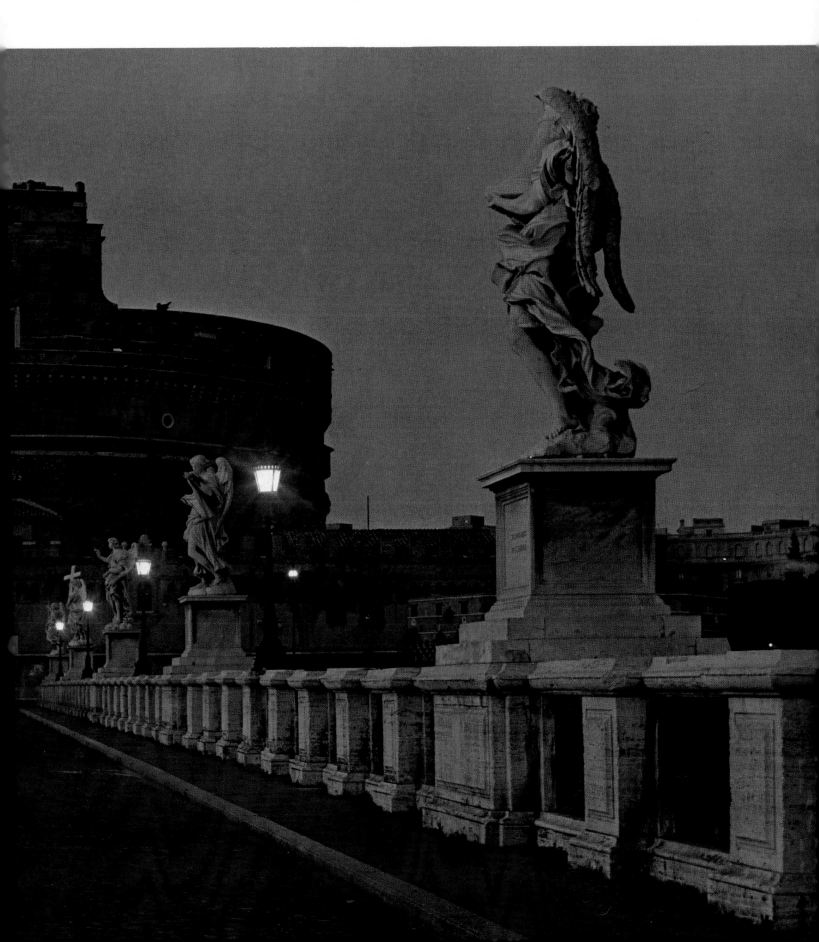

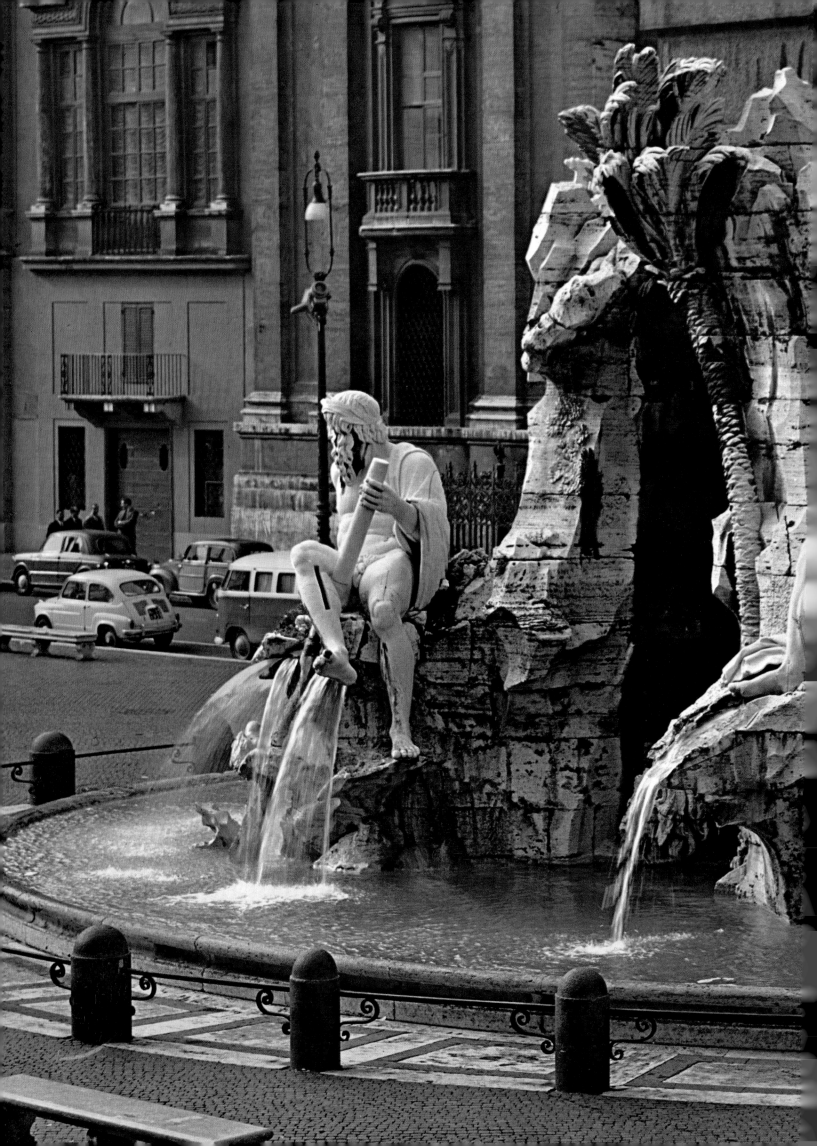

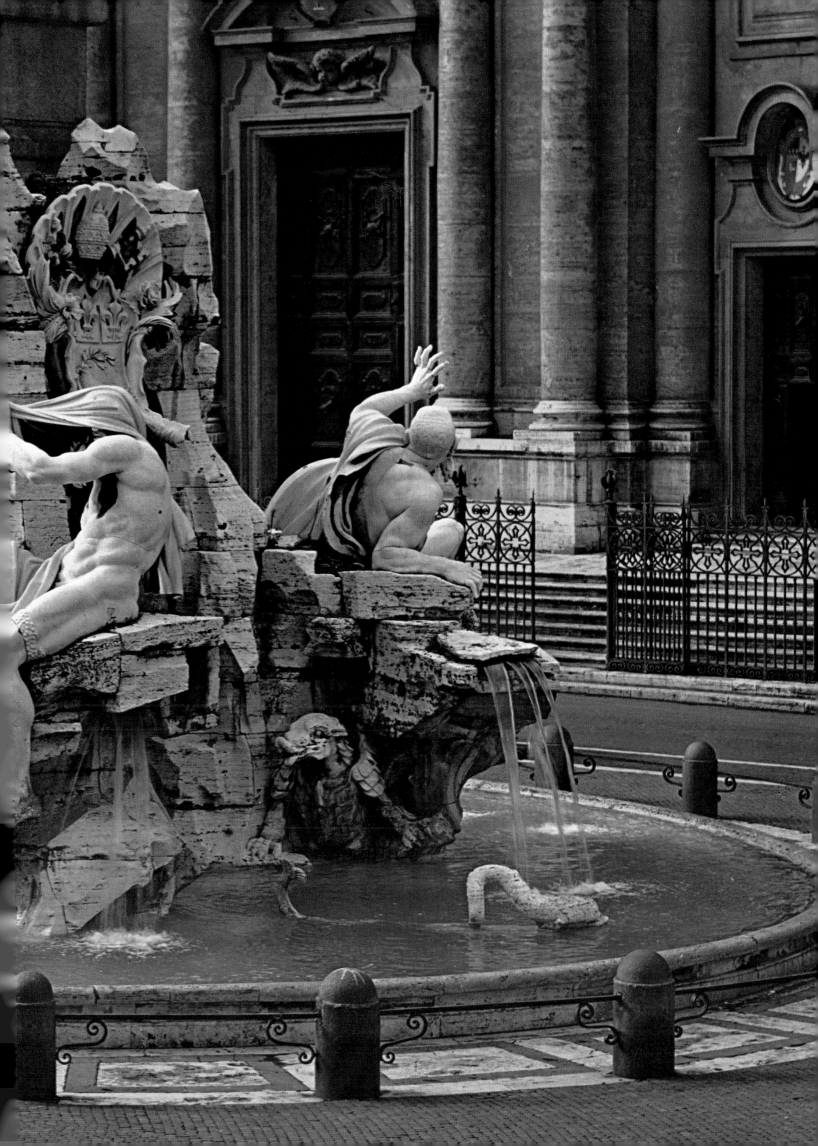

Bernini's obelisk-crowned Fountain of the Four Rivers, at the center of the Piazza Navona, has been a popular Roman landmark since it first began flowing in 1651. Built for Pope Innocent X, whose papal crest and family emblem are carved on it, the fountain is a vivid fulfillment of a theme suggested to the Pope and developed by Bernini's arch rival, architect Francesco Borromini.

The marble figures at each corner of the travertine base represent four great rivers symbolizing different parts of the world. The oar-wielding *Ganges* and the gesturing *Danube*

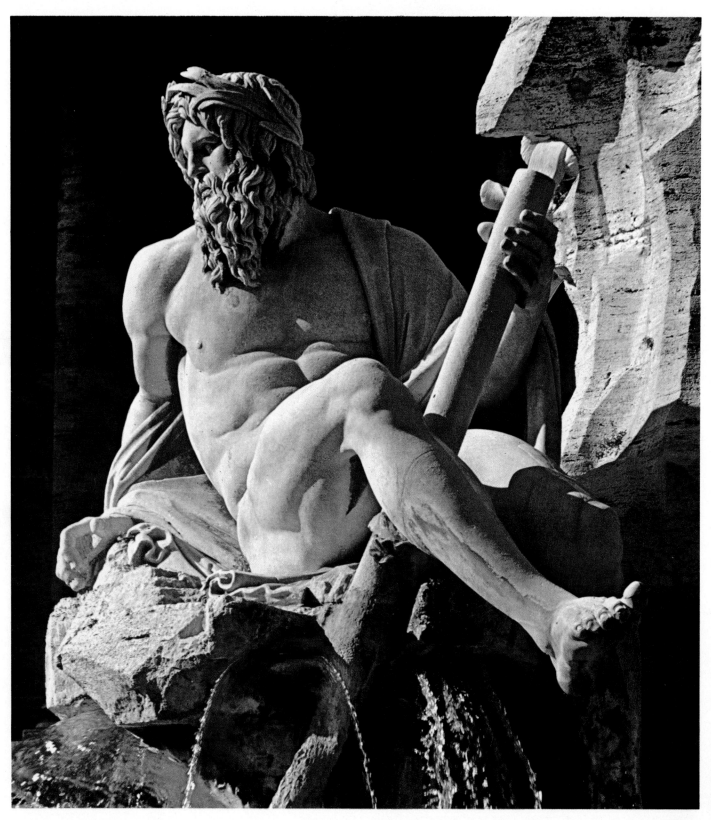

The Ganges

symbolize Asia and Europe. More imaginative is Bernini's portrayal of a hooded *Nile* to dramatize the mystery of Africa. His conception of a South American Indian for *The Rio de la Plata* is completely fanciful—a bald, full-bearded savage with Moorish features and a rich, jeweled leg band.

Two fountains by Giacomo della Porto occupy the ends of the oblong piazza. For one of them, Bernini created a colossal centerpiece, the struggling figure of Neptune, popularly known as *Il Moro (The Moor)*. It is seen in the foreground of the twilight photograph on the following pages.

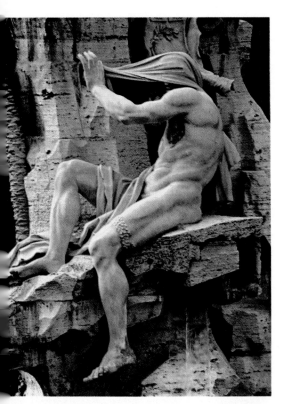

The Nile

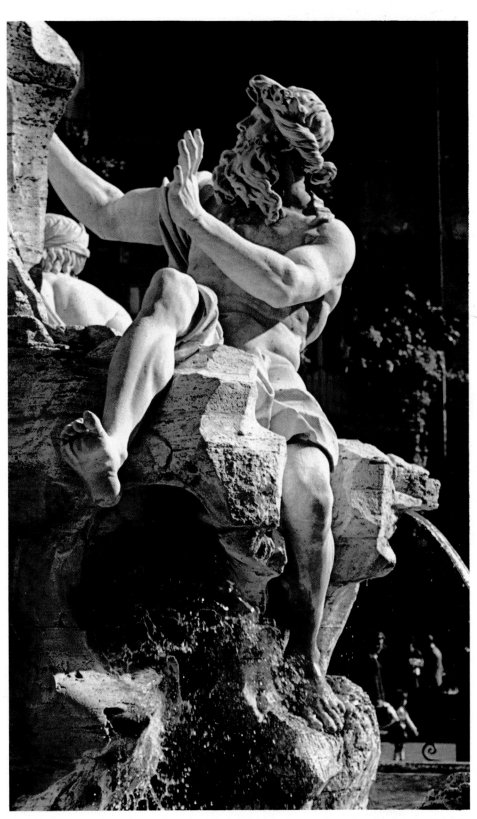

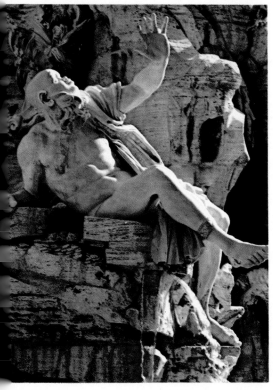

The Rio de la Plata

The Danube

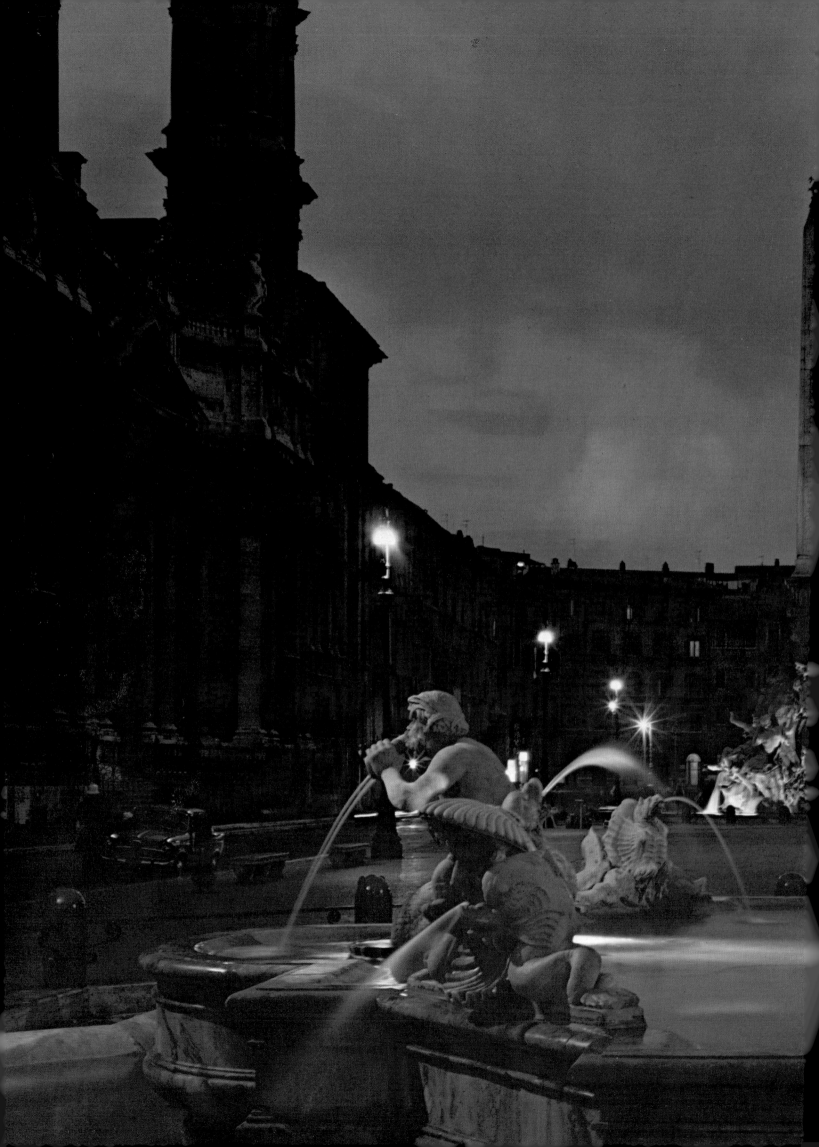

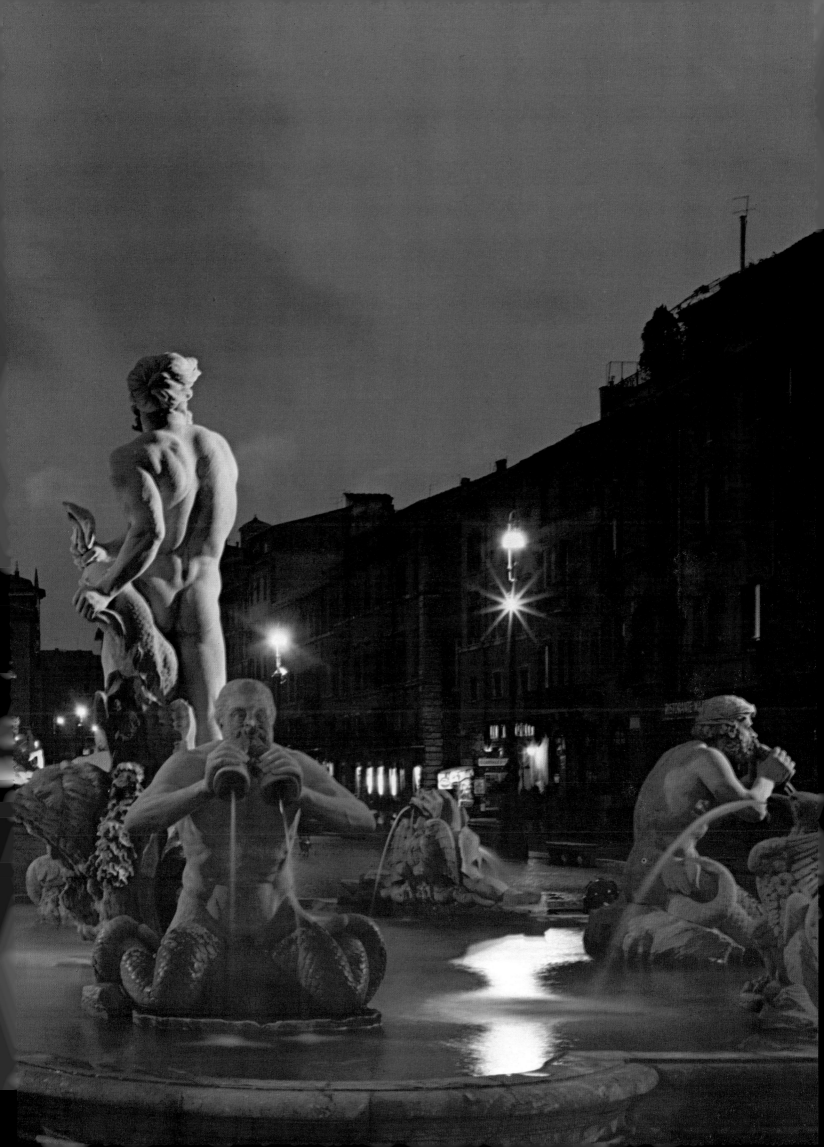

Sant' Andrea al Quirinale, main altar, 1658-1670

Bernini was almost 60 when he was commissioned to design a small church for the Jesuit novices living on the Quirinal, one of Rome's seven hills. It took 12 years to complete the oval building *(left)*, a wedding of Baroque art and classical architecture for which Bernini expressed "a special satisfaction at the bottom of my heart."

In a domed alcove is the richly decorated main altar *(above)*. Behind the altar, gilded angels seem to lift to heaven a painting depicting the martyrdom of Andrew, the saint to whom the church is dedicated. Above the altar, under the large dome, a huge, sculptured figure of St. Andrew gestures heavenward toward the symbolic entrance to paradise represented by the skylighted opening in the dome itself *(next page)*.

107

Louis began to apply pressure to have Bernini come to France. Louis wanted him to examine French plans for the completion of his palace, the Louvre; then to submit his own plans, and finally to supervise construction in Paris. In writing to the Pope about this, the King used the traditional formula employed by Catholic monarchs when addressing the Pope, as though he had never been at odds with the papacy. He began his letters "Most Holy Father" and ended them "Your Most Devoted Son, Louis." Alexander was equally punctilious. His replies began "Pope Alexander VII to our Louis, Most Christian King of the French, most beloved in Christ the Son" and concluded "Given at Rome in S. Maria Maggiore with the seal of the Fisherman's Ring."

Bernini did not want to go to France. In 1665 he was in his mid-sixties and engrossed in two of his greatest works, the *Cathedra Petri* inside St. Peter's and the Colonnade outside. And surely it must have occurred to him, as he walked past that humiliating 40-foot pyramid (it was torn down soon afterward, in 1668), that a considerable part of Louis' motivation in insisting on his presence in France was malicious. The King wished to make plain that he could take Europe's most famous artist away from the Pope. Nevertheless, urged on by friends who feared to provoke Louis again, Bernini undertook the trip with Alexander's consent.

His progress from Rome to Paris was marked by outpourings of cheering people in every city. They did not know or care much about the diplomatic background of his voyage; they simply valued him as a great man. No other artist has ever received such acclaim, nor is any ever likely to. Bernini, casting about for the simile that would best describe it, said that his journey resembled that of a traveling elephant.

In France Bernini's assigned companion, Chantelou, took a good look at him and wrote: "He is a man of short stature but well-proportioned, thin rather than fat, and of a fiery temperament. He has very long eyebrows and a large forehead that is a little caved in toward the middle and rises gently from the eyes. He is bald, and what hair he has is curly and white. By his own admission he is sixty-five . . . [yet he] walks firmly as though he were only thirty or forty . . . he has a special talent for explaining things with words, expressions and gestures, and for making them vivid."

The project for the Louvre was foredoomed. Bernini's plans, which were preserved and had great influence on later architects of large buildings outside France, were too "Italian" and not in accord with the cooler and more classical French taste. The wonderful palazzo he envisioned would have been quite out of place in Paris. Moreover, Louis' own architects were fighting Bernini tooth and claw. Thus it developed that, although there was much discussion about the plans for the Louvre, the only project Bernini executed in Paris was his portrait bust of the King.

"The first thing the artist must consider in working for a resemblance," said Bernini to Chantelou, "is the general impression

In 1664, when France's King Louis XIV decided to refurbish and enlarge the Louvre, his Parisian palace, he asked Bernini to submit a design. The architect's first plan *(top)* featured an extravagant Baroque entranceway; it was rejected. After another try, Bernini drew a subdued classical design *(middle)*. Though the façade was more acceptable, the interior space was considered awkward and this plan, too, was turned down. Finally, a group of French architects —who had jealously lobbied against Bernini's plans—collaborated on the final design *(bottom)*.

of the person rather than the details." In this regard he remarked that "in the evening, if a candle is placed behind someone in such a way that his shadow falls on a wall, one will recognize the person from the shadow, for it is true that no one's head is set on his shoulders in the same way as another's. The same is true of the rest of the body." Bernini had an exceedingly quick eye for "the general impression," which helps to account for his skill as a portraitist.

In this respect the bust of Louis posed special problems. Some of Bernini's finest portraits—*Scipione Borghese, Costanza Bonarelli, Urban VIII*—were of people he knew intimately, whose every flickering expression was familiar to him. But even in the case of Borghese he had made "snapshot" sketches as he collected his ideas. For the bust of Louis XIV more work was required. Bernini began simply by watching the King as he moved about—at court, playing tennis, in Cabinet meetings—in order, as he said, to "steep himself" in Louis' features. Then he made a number of drawings and several *bozzetti*—small clay models—to help clarify his ideas. And yet the finished bust, remarkable as it is, is not a faithful likeness of the King, whose brow was lower and whose eyes were smaller than Bernini indicates. As with Charles I, the sculptor considered Louis an instrument of God and therefore idealized him.

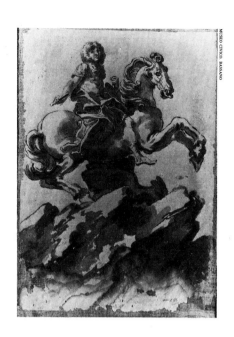

Responding enthusiastically to a request by the French court that he create an equestrian statue of Louis XIV modeled after his earlier *Constantine (page 180)*, Bernini drew plans *(above)* for a heroic marble. But when the statue was completed and sent to Paris in 1684, Louis disliked it intensely and nearly had it destroyed. Finally, a French sculptor changed the rocks at the base into flames and altered the headgear *(right)*; the statue was renamed *Marcus Curtius,* after a legendary centurion who sacrificed himself to save Rome; it was then banished to a remote location in the garden of Versailles.

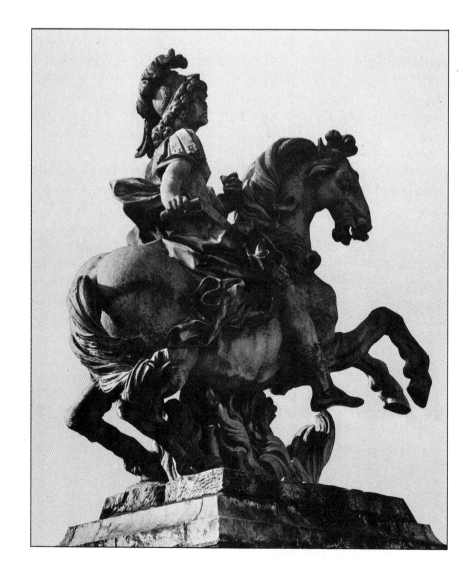

Thus the portrait of Louis is part real individual and part abstraction. The wind-blown drapery of the bust not only solves the standard problem of the truncated body but suggests that the King is being borne onward toward a noble destiny.

Bernini worked on the portrait for a total of 40 days, during which the King sat for him 13 times. "Miracle, miracle," said Bernini at one point, "that a king so meritorious, youthful and French should remain immobile for an hour." At the very last Bernini picked up a piece of charcoal and marked the blank eyeballs in a way that suggested the reflection of light. Then, with a fine chisel, *plink! plink!*—and there was Louis staring forever at the stars.

If Bernini was deeply respectful of the 27-year-old King—and it is worth emphasizing that, with his deep faith, he could not feel otherwise—he did not admire all things French. He did not think much of the human models available to student artists in the French Academy of Fine Arts. What the King ought to do, he said, was to send someone over to the Levantine slave market to buy some Greeks. Greeks had excellent bodies; he used them as models himself. Bernini also made insulting remarks about the sights and buildings of Paris, although he did manage a kind word for Françoise Mansart, the architect who popularized what is today called the mansard roof. Mansart, said Bernini, would have been great if only he had studied in Rome.

Another architect, Claude Perrault, whose plan for the columned façade of the Louvre was used instead of Bernini's, made the mistake of wounding the artist's pride. According to Chantelou, when Perrault ventured to point out what he thought was a fault in Bernini's plan, Bernini at first replied fairly mildly, saying that it had better be someone cleverer than he (pointing to himself) who tried to correct it. Then, warming up, he observed that "Perrault was not worthy to clean the soles of his shoes." Furthermore, Bernini was straightway going to complain to the Papal Nuncio, the King's First Minister and the King himself. As Perrault shook with alarm, Bernini seems to have begun shouting, "That a man of my sort, I, whom the Pope treats with consideration and for whom he has respect, that I should be treated thus! I do not know why I should not take a hammer to the bust after such an insult!"

Bernini's wrath soon vanished and the King's portrait remained intact. Louis offered various blandishments to keep the artist in Paris. It was made plain to Bernini that a French noblewoman with a generous dowry was available to marry one of Bernini's sons. Moreover, the King gave the artist $25,000 as an outright gift and included a handsome pension for life, perhaps not imagining that the tough old man was going to live another 16 years. But Bernini's heart was in Rome, where the Pope, now ailing, had begun to be seriously worried that he might not see his good friend again. So, after six months in France, Bernini said farewell to the most Christian King and went home.

Portraits in Stone

Bernini fathered a quiet revolution in the art of portrait sculpture. He carved his first bust in 1610, when he was only 11, and by the time he was 30 he was executing commissions for the most important men in Europe. During his lifetime he created marble and bronze likenesses of five popes, Kings Charles I of England and Louis XIV of France, and many churchmen and aristocrats.

Success came to Bernini because he revitalized an ancient art that had lately lost its vigor. The changes he introduced gave rise to a new style of three-dimensional portraiture. Where earlier sculptors had fashioned busts that seemed arbitrarily severed from the subject's torso, Bernini created the illusion that his busts were taken from full-length statues. Where earlier sculptors had carved eyes that seemed lifeless, Bernini gave his subjects a forthright, natural gaze that seems to focus on the viewer and invite conversation. In short, he brought animation to the faces of his subjects, often depicting them talking or expressing vivid emotions. In the process he displayed a dazzling virtuosity with stone, carving it as thin as cloth, polishing it as smooth as glass.

Shown behind the portrait opposite and on the following pages are a number of Bernini's architectural plans, some of them commissioned by the men whose likenesses he immortalized.

Bernini used himself as the model for this portrayal of a soul in hell. When he was planning the bust, he apparently contorted his face and studied it in a mirror. Such accuracy marks all his portraits. A pious man who must have enjoyed playing the sinner here, Bernini took special pleasure in his work for St. Peter's basilica: his plans for the piazza appear behind this sculpture.

Damned Soul (Anima Dannata), c. 1619
PALAZZO DI SPAGNA, ROME

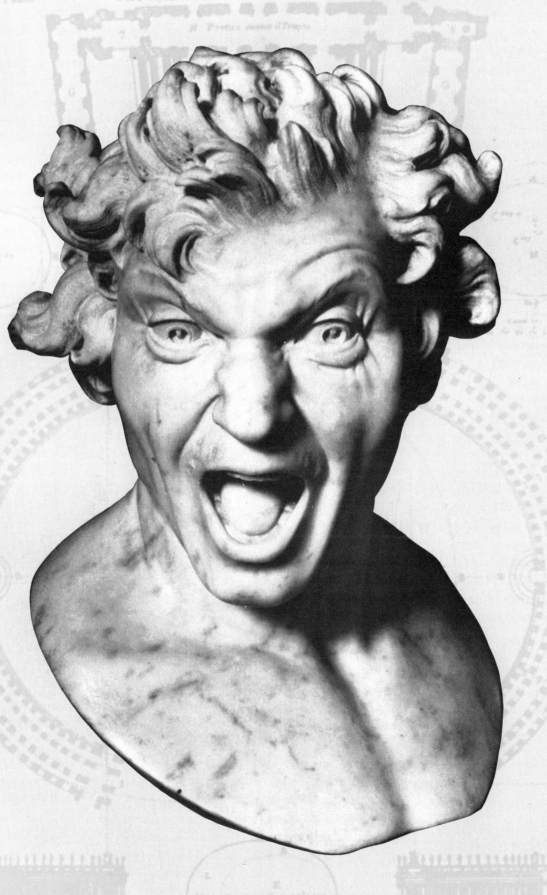

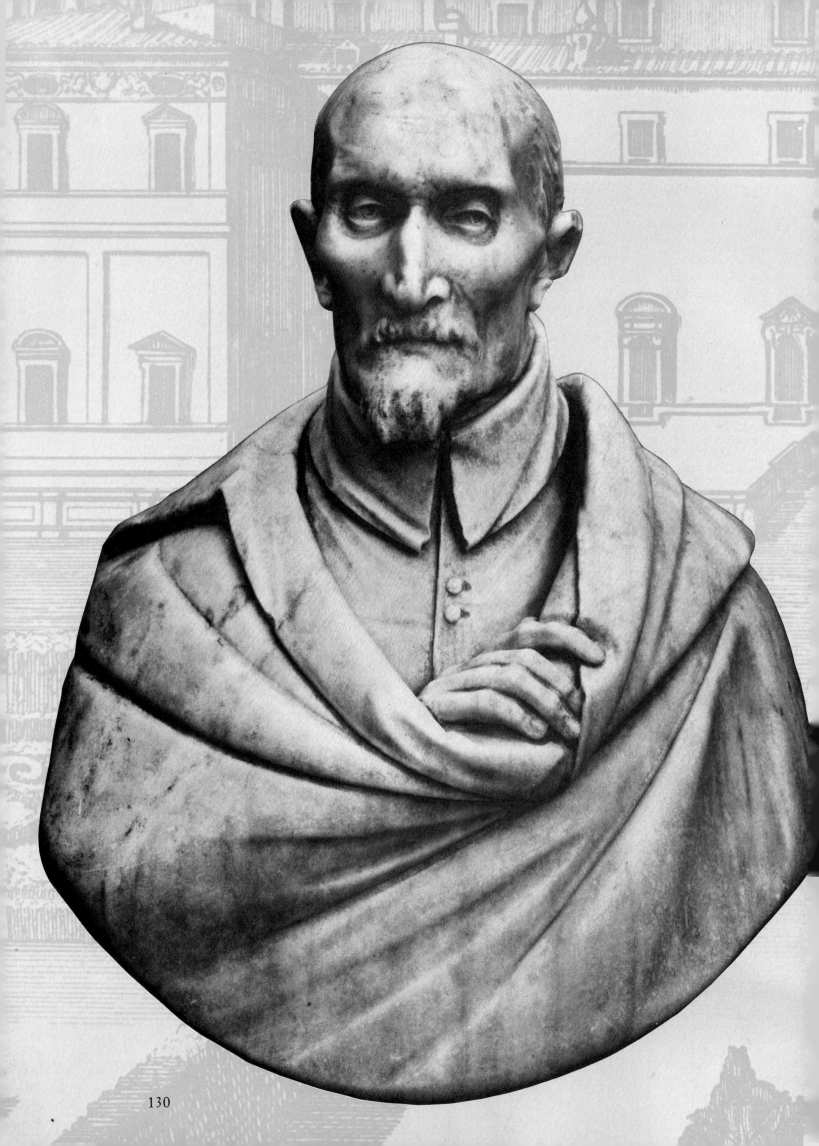

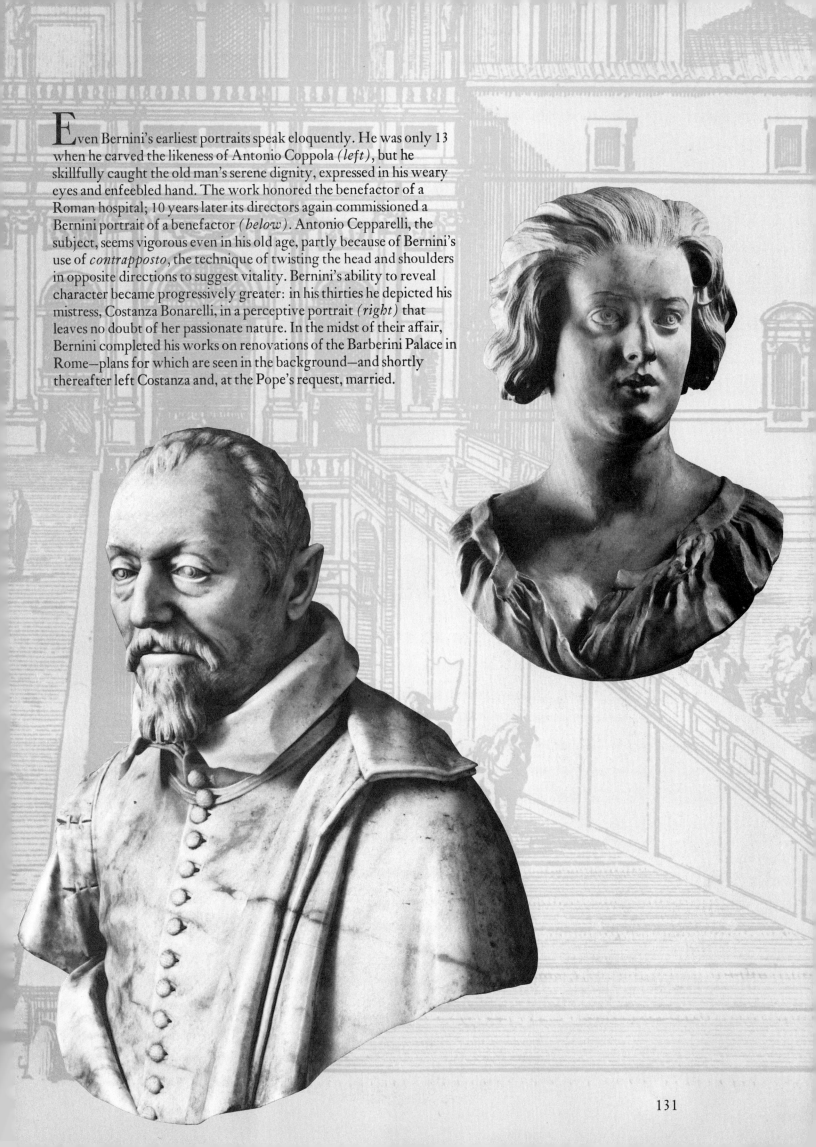

Even Bernini's earliest portraits speak eloquently. He was only 13 when he carved the likeness of Antonio Coppola *(left)*, but he skillfully caught the old man's serene dignity, expressed in his weary eyes and enfeebled hand. The work honored the benefactor of a Roman hospital; 10 years later its directors again commissioned a Bernini portrait of a benefactor *(below)*. Antonio Cepparelli, the subject, seems vigorous even in his old age, partly because of Bernini's use of *contrapposto*, the technique of twisting the head and shoulders in opposite directions to suggest vitality. Bernini's ability to reveal character became progressively greater: in his thirties he depicted his mistress, Costanza Bonarelli, in a perceptive portrait *(right)* that leaves no doubt of her passionate nature. In the midst of their affair, Bernini completed his works on renovations of the Barberini Palace in Rome—plans for which are seen in the background—and shortly thereafter left Costanza and, at the Pope's request, married.

131

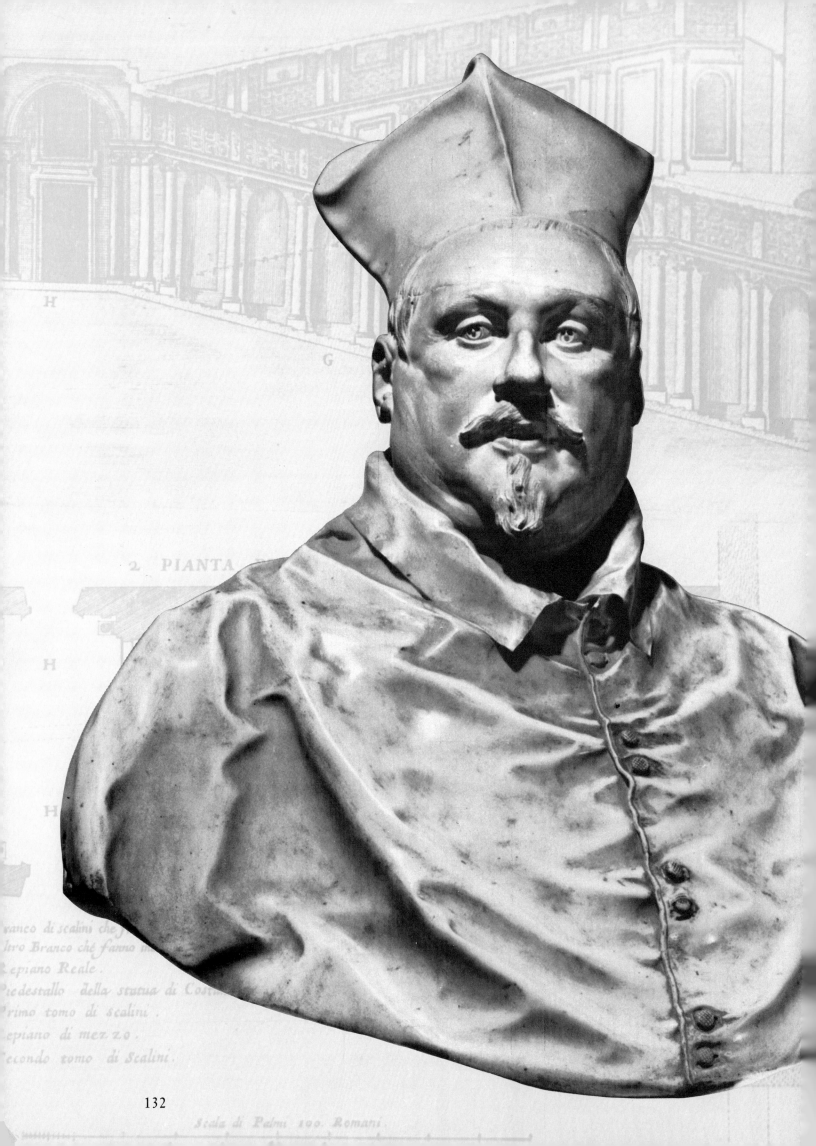

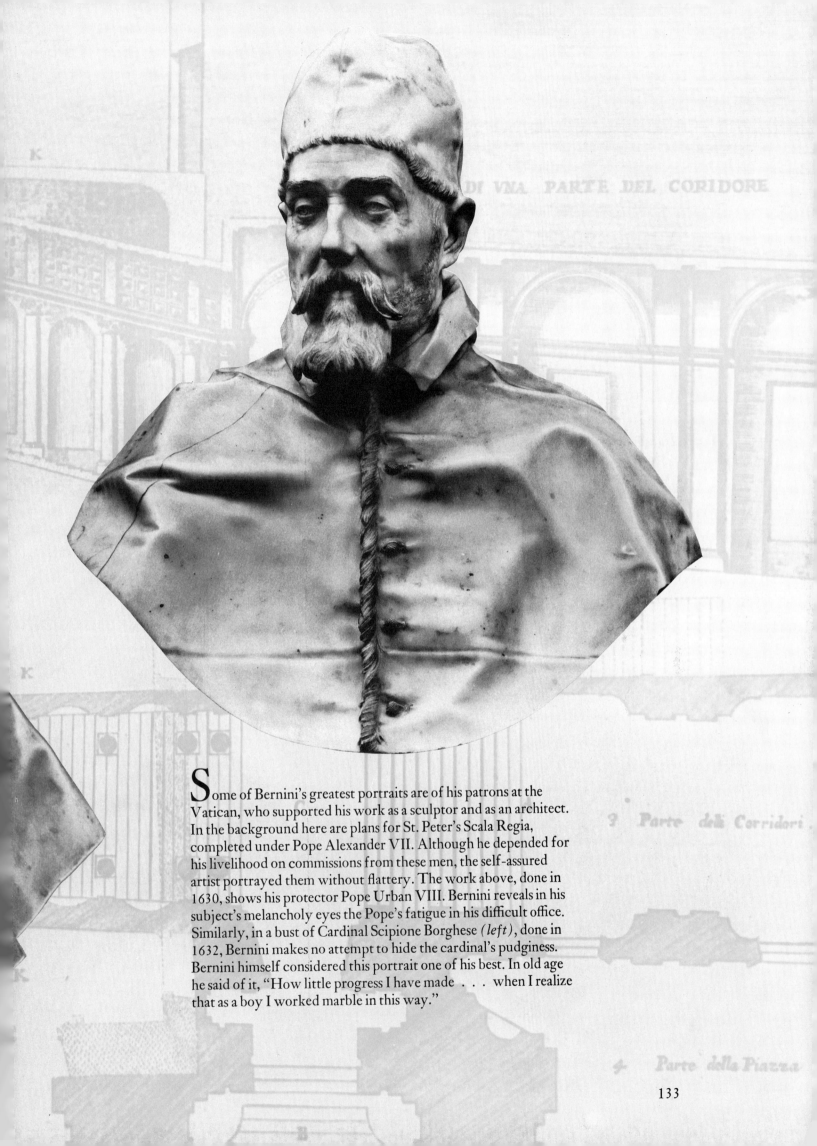

Some of Bernini's greatest portraits are of his patrons at the Vatican, who supported his work as a sculptor and as an architect. In the background here are plans for St. Peter's Scala Regia, completed under Pope Alexander VII. Although he depended for his livelihood on commissions from these men, the self-assured artist portrayed them without flattery. The work above, done in 1630, shows his protector Pope Urban VIII. Bernini reveals in his subject's melancholy eyes the Pope's fatigue in his difficult office. Similarly, in a bust of Cardinal Scipione Borghese (left), done in 1632, Bernini makes no attempt to hide the cardinal's pudginess. Bernini himself considered this portrait one of his best. In old age he said of it, "How little progress I have made . . . when I realize that as a boy I worked marble in this way."

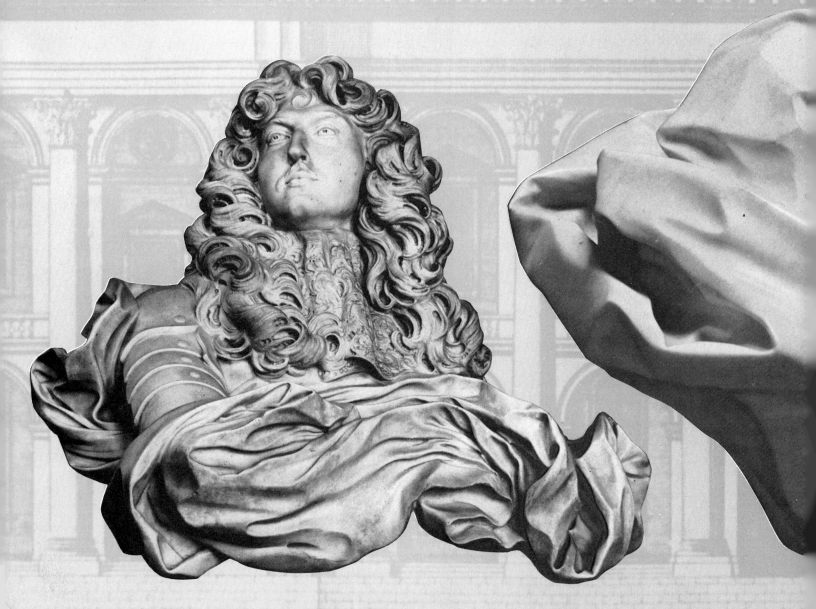

Wealthy and successful in his mid-fifties, Bernini might well
have started to produce portraits according to a formula. Instead,
in 1650 he made a bold innovation. Having devoted most of his
career to the pursuit of realism, in two remarkable portraits he
now swung toward a dramatic idealization. Bernini portrayed the
Duke of Modena, Francesco d'Este *(right)*, clad in antique armor
and swathed in a billowing robe. Fifteen years later Louis XIV
summoned Bernini to Paris to design a new façade for the Louvre
(the plans appear here in the background). In France Bernini
carved the portrait of the Sun King below, using techniques he
had developed earlier in the bust of Francesco d'Este. This time,
however, he made the features and the attitude more heroic, the
overall effect even more imposing. The superb portrait justifies
Bernini's boast to French courtiers who watched him work: "My
king will last longer than yours."

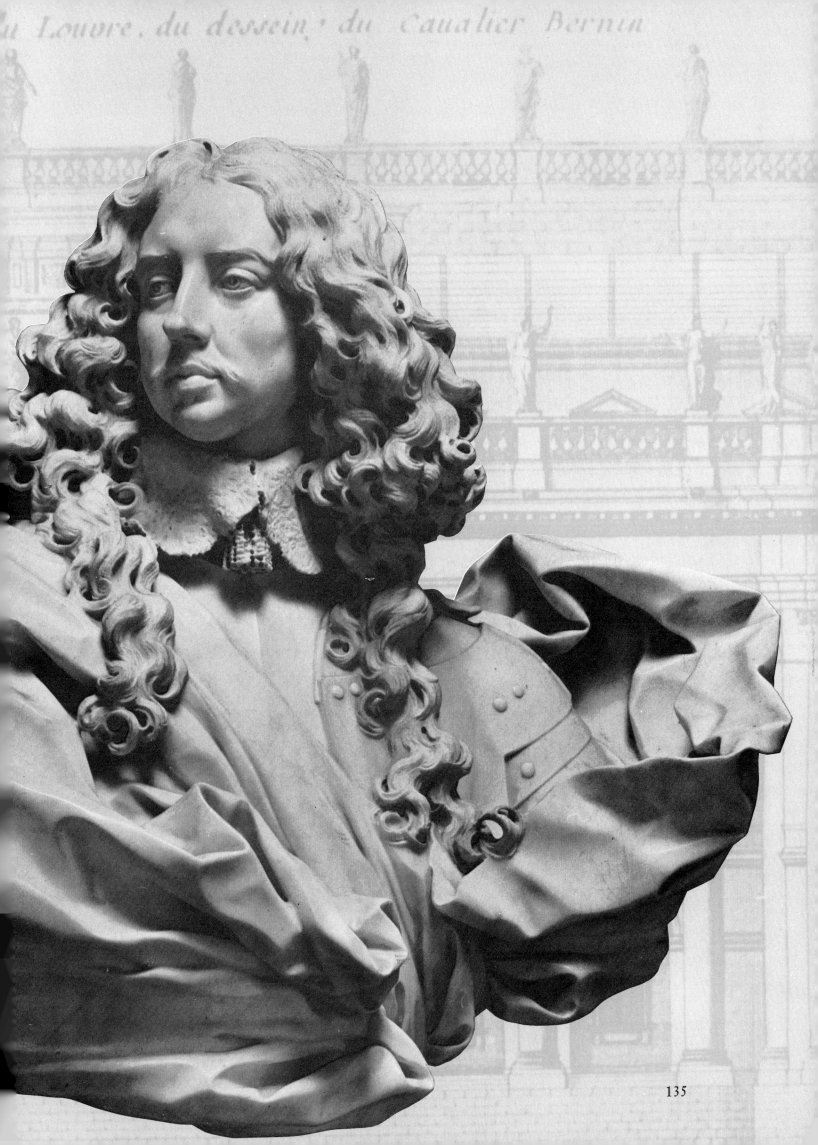

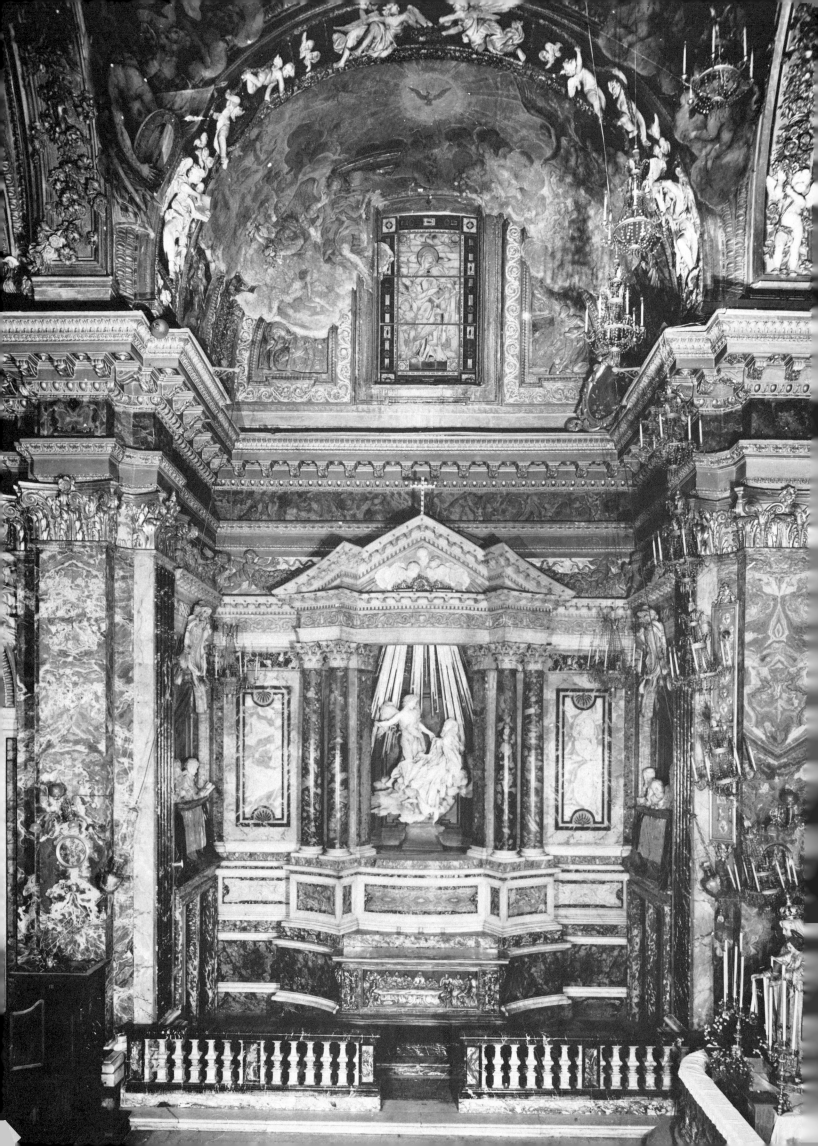

VI

Saints
and Angels

Bernini considered this chapel, designed for the Cornaro family, his most beautiful work. In some ways it resembles a theater. On the stage, the area above the altar, Bernini portrayed St. Teresa swooning in ecstasy before an angel. Eight members of the Cornaro family, like spectators at a play, are depicted at *prie-dieux* (prayer desks) set into the side walls of the chapel.

Cornaro Chapel, Santa Maria della Vittoria, 1647-1652

For many years Bernini walked every day to the Jesuit Church of Il Gesù near his home to make his devotions. Under the altar in the left transept of that church lies buried the Spanish priest Iñigo de Loyola, or St. Ignatius, who founded the Society of Jesus and whose influence on Bernini's life and art was enormous. The influence was exerted through *Spiritual Exercises*, a small book St. Ignatius published in final form in 1548. Sooner or later everyone who is interested in Bernini—indeed in High Baroque art in general —will come to know something about the saint and the book.

As a young man St. Ignatius was a professional soldier. He did not turn to religion until after he had been wounded in battle at the age of 30. When he founded the Jesuit order he organized it on military lines, believing that the Roman Catholic Church was at war with ignorance of the true faith. The Jesuit zeal and vigor can be seen in St. Ignatius' book.

Spiritual Exercises was not intended to provide lofty or comforting reading material for ordinary men. St. Ignatius would be surprised today to find that it has been made available to the general public. The book was intended primarily for the use of the devout who were going on a retreat—withdrawing from the world for a time to a monastery or similarly untroubled place to examine their souls. St. Ignatius envisioned that a man on a retreat would be helped and instructed by another, a monk or priest acting as a sort of benign sergeant, who would use *Spiritual Exercises* as a manual.

The exercises are divided into four groups of meditations. St. Ignatius intended each group to occupy a week, more or less, depending on the instructor's opinion of the progress of the retreatant. In the first week reflection is on sins and hell; in the second, on the life of Christ up to and including Palm Sunday, the day He entered Jerusalem in triumph; in the third, on His sufferings; and in the last, on His resurrection and ascension. The purpose of all the exercises is to cleanse, refresh and inspire a man to return to the world as a soldier of the Lord.

St. Ignatius intended the meditations to be as vivid and dramatic as possible. During the first week, for example, having considered his sins, the retreatant is instructed to create a "portrayal in the imagination of the length, breadth and depth of Hell." Then he is asked to bring all of his senses into play: "To see in imagination those enormous fires and the souls, as it were, with bodies of fire. To hear in imagination the shrieks and groans and the blasphemous shouts against Christ our Lord and all the saints. To smell in imagination the fumes of sulphur and the stench of filth and corruption."

As the retreatant progresses through the exercises he is constantly asked to see specific things—"Represent to yourself in imagination the road from Bethlehem in its length and breadth. Is it level or through valleys or over hillsides? In the same way, study the place of the Nativity. Is the cave spacious or cramped, low or high? How is it furnished?" At the end he is brought to a purified and blissful state in which he "shares the joy of my Creator and Redeemer" after the Resurrection.

Such instructions had a very strong impact on an artist as pious and as imaginative as Bernini. If ever there was a portrait of a man who is seeing, hearing, smelling, tasting and feeling hell, it is the *Damned Soul (page 129)*, carved when Bernini was about 20. His relations with the Jesuits were exceedingly close, probably from his earliest youth. It is known that he went on an annual retreat and that he obtained and always kept close at hand a copy of *Spiritual Exercises*. He took it with him when he went to France; indeed the man who chiefly persuaded him to make the journey was his intimate friend Padre Gian Paolo Oliva, Superior General of the Jesuits. Bernini in many ways was as close to being a Jesuit as it is possible for a layman to be, and in a sense he took in his art the role of the instructor in the *Exercises*. His creation of striking, colorful work was not merely his inclination but, he believed, his sacred obligation: it helped others, less gifted with imagination than he, to visualize and participate in the miracles of the Savior and the saints.

Bernini believed that the ideas for his art were sent to him by God. He took it as his duty to employ all the God-given talents and resources at his command. Much of his religious art can be better understood if his work for the Baroque stage, as well as the *Spiritual Exercises*, is borne in mind.

Bernini spent a good deal of time writing and producing plays. Only one of his theatrical works has thus far been unearthed, a comedy that reads like most of the wildly complicated farces of his day. Its plot need not be set forth here, although it does contain an idea typical of Bernini. The protagonist, a famous old stage designer named Gratiano, decides that within the play he will put on another play about a famous old stage designer named Gratiano. The two hold a remarkable conversation in which the first Gratiano, who like all the characters in the play is imaginary, talks to a twice imaginary Gratiano. The spectator is thus involved once more in Bernini's contemplation of various levels of existence.

The amount of time and effort Bernini expended on his productions indicates how seriously he took them. "Sometimes," wrote Baldinucci, "it took an entire month for Bernini to act out all the parts himself in order to instruct the others and then to adapt the part for each individual." He enjoyed seeing his guests caught up in the action, as in his *Inundation of the Tiber*. The stage seems to have contained a number of dams or dikes arranged so that water could be seen bursting through as it advanced toward the spectators. "When the water broke through the last dike facing the audience, it flowed forward with such a rush and spread so much terror among the spectators that there was no one, not even among the most knowledgable, who did not quickly get up to leave in fear of an actual flood. Then, suddenly, with the opening of a sluice gate, all the water was drained away."

In another of his plays, Baldinucci reported, "He made it appear that by a casual, unforeseen accident the theater caught fire. Bernini represented a carnival carriage, behind which some servants with torches walked. The person whose job it was to perpetrate the trick repeatedly brushed his torch against the stage set. . . . Those who did not know the game cried out loudly for him to stop so that he would not set fire to the scenery. Scarcely had fear been engendered in the audience by the action and the outcry when the whole set was seen burning with artificial flames. There was such terror among the spectators that it was necessary to reveal the trick to keep them from fleeing."

Neither the flood nor the artificial fires, nor the machinery employed to create them, originated with Bernini. Other Baroque designers had flooded the stage for marine performances; scenes of burning hell had already been incorporated in other plays. What was original in Bernini's productions was his deliberate involvement of the spectator, who was no longer placidly observing an insulated spectacle but was suddenly in the midst of a happening and forced to become an actor in it, or at any rate to jump out of the way. It was this that intrigued Bernini in his work for the stage.

Although Bernini has been glowingly described as a designer of stage effects for 17th Century theatrical productions, including elaborate sunrises and frighteningly realistic fires and floods, none of his stage designs has survived. Other settings of the period, like those from the opera *St. Alessio* shown below, provide a clue to contemporary technique. But though these designs are lively and imaginative—they depict the triumph of a pagan army and a raging hell—writers of the time indicate that Bernini's were far more spectacular.

Spectacle for its own sake was unimportant; what counted was spectacle with a purpose, spectacle that reached out and laid hold of the viewer. And so it was in his religious art. Bernini never employed a theatrical device merely to dazzle the spectator. His purpose was always to deepen the spectator's involvement.

Bernini's first important religious commission, undertaken when he was 25, was the remodeling of the small Church of St. Bibiana on the outskirts of Rome. According to legend the saint was martyred—tied to a column and lashed with lead-weighted cords. A church was erected over her grave and long afterward, in the time of Bernini and Urban VIII, her remains were discovered during routine restoration work. The Pope then decided to remodel the church, commissioning Bernini to design a new façade and to make a statue of the saint to be placed above the high altar. Bernini's sculpture shows St. Bibiana resting her right arm on a low column while in her left hand she holds the palm of martyrdom, a familiar symbol in Christian art.

St. Bibiana bears certain affinities to *David*, the youthful work that set forth so much of Bernini's artistic credo. Both are concerned with the capturing of an instant—in the saint's case, it is the moment in which she welcomes her martyrdom and looks up, half smiling, at heaven. But while in *David* the spectator is called on to invent or imagine Goliath, the vision of heaven is actually present in *Bibiana*. The line of the saint's rapt gaze leads to a painting in the vault above, in which amid angels God the Father opens His arms to receive her into His kingdom. The painting on the vault was not executed by Bernini but the conception was of course his own, for it is as if the space between the statue of the saint and the vision on the vault had been charged with elecrticity, becoming a part of the work itself.

In his role as the artistic instructor in the spiritual exercises of his century Bernini employed the idea of charged space more than once—there are two examples in St. Peter's *(Chapter VII)* and another in the Church of Santa Maria del Popolo in the heart of Rome. The Santa Maria effect is particularly dramatic; it sets up a reaction not between a sculptured figure and a painting, or between a figure and a source of light, but between two sculptured groups, electrifying an entire chapel. When Pope Alexander VII in 1655 asked the sculptor to renovate the chapel, it contained four niches for sculpture in its walls. Two of these flank the entrance and two the altar opposite. The niches beside the entrance were already filled with Raphaelesque statues of the prophets Jonah and Elijah by Lorenzetto, while those beside the altar were empty. Bernini made statues of two more prophets, *Habakkuk* and *Daniel (page 153)*, that might simply have filled the vacant niches, but his idea was more complex than that.

The story of Habakkuk and Daniel appears at the end of the Book of Daniel in Roman Catholic versions of the Old Testament. Habakkuk, having prepared a basket of food, was about to take it

to the reapers in a field when an angel commanded him to take it instead to Daniel, who was imprisoned in a lions' den in Babylon, miraculously preserved from the beasts. Habakkuk protested, but the angel "took him by the top of his head and carried him by the hair of his head, and set him in Babylon, over the den." Daniel, his prayer for help answered, gives thanks: "Thou hast remembered me, O God, and Thou hast not forsaken them that love Thee."

Bernini, seizing on the spiritual relationship between Habakkuk and Daniel in the story, made it visual in the design and placement of his sculptures. He installed *Habakkuk* in the empty niche at the right of the altar, moved *Jonah* to the left of the altar and, leaving *Elijah* where he was at the right of the chapel doors, placed his *Daniel* in *Jonah's* old niche at the left of the entrance. *Habakkuk*, who points with his forefinger in the direction he had intended to go, toward the reapers, glances up quizzically at the angel, who tugs at *Habakkuk's* hair and points in a different direction, toward the figure of *Daniel*. The pointing gesture of the directing angel creates a line of force running diagonally across the chapel. The effect of the diagonal is very powerful; the chapel is unified as though by a great iron bolt. But more important than that is the creation of a climate of miracle within the chapel, an air in which fragile faith may be strengthened.

The fragility of faith again became a matter of deep concern to the Catholic Church, and to Bernini as its faithful soldier, as the 17th Century wore on. The challenge now came not from the waning force of the Reformation but from the progress of science. Galileo's beliefs, although the man himself had been silenced, found ever-increasing acceptance in Italy. From England there came a succession of mighty books and announcements—Francis Bacon's *Advancement of Learning*, a treatise proposing the thesis that man should reason from observed phenomena rather than dogmatic revelation; William Harvey's proof of the circulation of the blood; Isaac Newton's formulation of the law of gravity. In Holland Anton van Leeuwenhoek announced his discovery of bacteria with the newly invented microscope; in France Blaise Pascal formulated the laws of probabilities. Although it was far from their intent, these men by their collective labors created a wave of skepticism that rolled across Europe. Once more unquestioning faith in the teachings of the Church was put sorely to the test. Science shook the Church as much as had Martin Luther and Henry VIII.

Bernini's reply to the challenge to faith was simply this: more faith. In the final portrait bust of his career, completed when he was in his seventies, he carried the depiction of faith as far as it may be taken. The bust employs the device of charged space as forcefully as do any of his works. The portrait, of *Gabriele Fonseca (page 149)*, a Portuguese physician who asked Bernini to design a funerary chapel for him in the Church of San Lorenzo in Lucina in Rome, is much more than a mere likeness. It is in fact the most emotionally vehement of all Bernini's portraits. Fonseca is in a par-

oxysm of faith, his rosary clenched in his hand, his eyes riveted on an event that he believes will lead to the salvation of his immortal soul—for, above the altar, there is a painting of the Annunciation in which Mary is shown being informed by an angel that she is to be the Mother of Christ. Fonseca is so intent upon the miracle that the space between the painting and his eyes is well-nigh tangible. Some observers may find the work a bit strong, but it was intended to be just as strong as Bernini could make it: *more faith*.

The sculptor had other means of expressing intense emotion. Among them was the carving of drapery in agitated folds like those of the *Fonseca*, echoing the turmoil in men's hearts. At times the swirling, convoluted garments do not seem subject to gravity at all. It is feeling, not logic, that determines their fall, the conception of a genius who does not choose to bother with Newton's law. The draperies of *St. Jerome (page 151)* and *St. Mary Magdalen (page 150)*, in the Chigi Chapel in the Cathedral of Siena, constitute an additional case in point. The inner states of the saints, who are racked with remorse for their sins, are also reflected in the bending, swaying poses of their bodies. St. Jerome, a brilliant man who translated the Old Testament from Hebrew into Latin and revised the Old Latin of the Gospels to create the Vulgate Bible, also took great interest in the pagan literature of Greece and Rome—and that was his sin, for which Christ reproached him in a dream. Bernini's sculpture shows Jerome in the midst of another dream or trance. His eyes are closed and his hands are not really supporting the crucifix before him, for it is unreal, an apparition that will vanish when he awakens. And here appears another aspect of Bernini's faith—mysticism.

St. Ignatius' *Spiritual Exercises* are simple and straightforward, calling upon men to envision concrete things—the path to Bethlehem, the fires of hell. But Thomas à Kempis' *The Imitation of Christ*, in which Bernini read passages every day, is of a different order. Thomas à Kempis was a 15th Century German monk whose work, translated into English, was given an apposite title: *Ecclesiastical Music*. The book contains no hymns, to be sure, but it is an incantatory work, a mosaic of thoughts and sentences from the Bible and the writings of medieval mystics and Church philosophers that are better chanted or prayed than read. It calls upon men to turn away from the world, sometimes in cadences (even in translation) close to hypnotic: "In the Cross is health, in the Cross is life, in the Cross is protection from enemies, in the Cross is heavenly sweetness, in the Cross strength of mind, in the Cross joy of spirit, in the Cross the height of virtue, in the Cross perfection of holiness." *The Imitation of Christ* appeals far more to the heart than to the mind, to the mystical and supernatural rather than to the natural—and the supernatural appears to a much greater extent in Bernini's work than has been noted.

Look at the hands of the angels on the *Baldacchino (pages 172-175)*, in the *Ecstasy of St. Teresa (page 152)*, in the *Habakkuk*

and on the Ponte Sant' Angelo *(pages 97-99)*. In every case the hands are in an extremely delicate lifting position. Only the thumb and forefinger are employed, while the other fingers remain airily unengaged. This is by no means an affectation on Bernini's part; it has a great deal of meaning.

The angel in the *St. Teresa* is holding a golden spear that he is preparing to thrust deep into the saint's body. Yet his grasp would scarcely serve to lift a twig. Similarly, the angel in the *Habakkuk* is about to pick up the prophet by the top of his head and carry him through the air to Babylon, but the angel has laid hold of the merest wisp of hair. The angels on the *Baldacchino* are holding ropes of laurel that run beneath the crown of the structure to support it. However, the angels cannot, because of the manner in which they are holding the laurel ropes, exert any real force. (The crown of course is actually supported by the massive twisted columns below it, but they do not serve that function artistically.)

Bernini is expressing in these works the mystical idea that angels are hovering all around us. Sometimes they actually penetrate the world of men, performing acts that, for men, would require great strength. But angels, as agents of God, have no need of strength as men conceive it. Their strength is faith, and it is exerted through contacts as gentle as a breath of air. But since angels are invisible, appearing only to particularly favored humans in dreams, visions or trances—as to St. Teresa and Habakkuk—how is it that the spectator can see them? The spectator sees them because he accepts the tacit agreement Bernini offers, an agreement that says: of course real angels are invisible, and for the sake of this work of art we will pretend that this marble angel is invisible too. Such agreements are necessary in other fields as well—painting and literature among them—and are covered by Samuel Taylor Coleridge's classic critical suggestion that an observer or a reader must on occasion exercise the "willing suspension of disbelief."

When Bernini wished disbelief to be suspended, he indicated as much by carving angels' hands holding objects with that inexpressibly gentle, otherworldly touch. Moreover, that touch is seen *only* when the angels in some way impinge upon this world. When angels are in their own world, heaven, they are presumably quite visible and take firm hold of objects. For example, the large angel flying in the clouds above and to the right of the *Cathedra Petri* *(pages 176-177)* is gripping a sheaf of palm leaves with all the fingers of both hands.

An interesting aspect of the *Ecstasy of St. Teresa* concerns who can see angels and who cannot. However, because that great work, which is permeated by mysticism, has been so often disparaged for having a sexual sensationalism it really does not possess, it is well to know something of its background before examining it in detail. Teresa de Cepeda Dávila y Ahumada was born in the Spanish town of Ávila, in the province of Old Castile, in 1515. She is considered one of the very greatest of saints, and there are a good many re-

liable accounts of her life, work and miracles. A humorous, intelligent, feminine woman, she also had remarkable executive ability. As a young Carmelite nun she became disillusioned with the soft ways into which her order had fallen and devoted her life to reforming it. Amid great difficulties and hardships she founded no fewer than 16 convents throughout Spain, all of them strict in their observance of religious vows.

St. Teresa, the most practical and hardheaded of women, frequently had seizures in which she saw Christ and angels. She struggled against these visions, distrusting them because they might have been sent by the devil. She used all the power of her reason to combat or explain them and was much embarrassed by them. At times in public, before witnesses who stated that they had observed the phenomenon, she was the victim of levitation, literally rising from the ground and remaining suspended in the air.

The saint wrote a fascinating autobiography in which she detailed many of her visions, including this one, which is sometimes thought to have sexual undertones: "I saw an angel close by me, on my left side, in bodily form. This I am not accustomed to see, unless very rarely. . . . He was not large, but small of stature, and most beautiful. . . . I saw in his hand a long spear of gold, and at the iron's point there seemed to be a little fire. He appeared to me to be thrusting it at times into my heart, and to pierce my very entrails; when he drew it out, he seemed to draw them out also, and to leave me all on fire with a great love of God. The pain was so great that it made me moan; and yet so surpassing was the sweetness of this excessive pain, that I could not wish to be rid of it. The soul is satisfied now with nothing less than God. The pain is not bodily, but spiritual; though the body has its share in it, even a large one. It is a caressing of love so sweet which now takes place between the soul and God, that I pray God of His goodness to make him experience it who may think I am lying."

That is the particular vision Bernini chose to illustrate—or rather, to use as the core of a large and very complex project in the Church of Santa Maria della Vittoria in Rome. During the time of his temporary "disgrace" in the mid-1640s, when he had no major papal commissions in hand, Bernini was asked to create a funerary chapel for the Cornaro family (*page 136*) in the left transept of the church. His patron was Cardinal Federigo Cornaro, the seventh member of his family to be made a cardinal, and the son of the Doge of Venice, Giovanni Cornaro. Portraits of the eight men may be seen in groups of four behind *prie-dieux* (prayer desks) on both sides of the chapel.

The shallow transept housing the *St. Teresa* is about 24 feet wide, 45 feet high and only 11 feet in depth. Almost all of it is occupied by Bernini's work, which combines architecture, sculpture, painting and specially directed light in an astonishing fusion of art that seems to suggest the whole range of man's spiritual existence. Whenever he could, Bernini arranged it so that the spectator is obliged to

Bernini's *Death of the Blessed Ludovica Albertoni*, finished in 1674, when the sculptor was in his seventies, is one of his most theatrically displayed works. Bernini intensified the otherworldliness of his expressive marble by focusing light on it through two hidden windows in the otherwise dark chapel *(detail on pages 154-155)*. Disembodied cherubs appear to float down from above, beside a painting of the Virgin and Child for which Bernini provided a gilt setting.

144

look at his work from only one viewpoint, and that is the case here: straight on. One way of "reading" the work is to start at the bottom and slowly look upward. Inlaid in marble in the floor are two skeletons that seem to be emerging from funerary crypts beneath. Their heads are tilted up, as though they can see the miracles taking place above them, and their wildly animated gestures indicate joy, adoration and upward flight. Now rising but long dead, they represent the world below that will yet be saved through Christ.

On the next higher level, where the spectator himself exists, are the eight members of the Cornaro family. Although only one of them was then alive, they are all represented as living, moving, excited human beings belonging to the present world. Presumably, like men in box seats at a theater, they are discussing the miracle taking place close by. However, they cannot see it. It can be seen only by the enraptured St. Teresa—and by the specially privileged spectator who has suspended disbelief on the terms agreed on. That the Cornaro cardinals cannot see the angel is made quite plain by Bernini, who placed the scene and the columns of the "stage" in such a way that the cardinals' line of sight is blocked.

At the third level of spiritual existence, in the mystical realm between earth and heaven, float St. Teresa and the angel. Streaming down on them, in the form of gilded wooden rays and actual daylight, directed through yellow glass in a window hidden by Bernini behind the pediment, is a golden light that floods the miraculous vision. The sculptor follows St. Teresa's account of it faithfully, as a practitioner of the *Spiritual Exercises* might be expected to do, although he adds two elements that may seem considerably more suggestive than they are. St. Teresa is borne up on a cloud and her face reflects consummate emotion—not, however, because she is in a state of sexual ecstasy.

It would be ridiculous to contend, reading her own account of it, that St. Teresa's experience did not have a great deal of unconscious sexuality in it, but to think of it only in those terms would be to make a great mistake. It is God's love, not only for St. Teresa but for all mankind, that is involved here. Moreover, in the 17th Century it was common for artists to express spiritual love in sensual terms. Artists, most assuredly including Bernini, were conscious of their mission as teachers, and it is worth repeating that they spoke in terms understandable to ordinary men.

On the fourth and highest level of the *St. Teresa* is heaven itself. Angels have pulled aside the clouds to permit the light of the Holy Ghost to pour down, reaching even the tombs far below. Bernini's fantastic combination of painted clouds and stucco clouds, angels painted and angels carved, stone, paint, light and color is like a triumphant shout in the vault: Behold the Love of God! This love, which permeates all levels of life, has saved St. Teresa and it can save any man. If the spectator is moved to step forward, kneel and pray in that benediction of falling light, he comes face to face with

the bas-relief Bernini caused to be carved on the front of the altar. It is the Last Supper, at which, through the mystical institution of Communion, men were joined to Christ.

The *St. Teresa*, in addition to being a remarkable work of art, is also an environment. About 10 years after designing it Bernini applied this environmental idea in the creation of an entire church, Sant' Andrea al Quirinale *(page 106-111)*, which he built for Jesuit novices who lived on the Quirinale Hill. Because the site was small he selected a fairly unusual shape for his work—an oval, with the main entrance and altar opposite each other.

On entering the church and glancing around, the spectator has a momentary feeling of buoyancy. In part it is caused by the sight directly in front of him: a large marble figure of the martyred disciple Andrew soaring up through the pediment above the altar, apparently being lifted into heaven by a rising white cloud. The dome of the church, which represents the vault of heaven, also contributes mightily to the effect—it is brilliantly lighted by windows and a soaring lantern, and hovering in it are cherubs and fishermen carrying oars, shells, reeds and nets in token of St. Andrew's earthly occupation. As the visitor's glance sweeps around the dome and up into the lantern, the sensation of buoyancy increases. It is far more spiritual than physical, and in such environment St. Teresa's levitations become more comprehensible. Bernini himself felt heartened by it. His son Domenico found him in the church one day and asked, "What are you doing here, all alone and silent?" Bernini replied, "I feel a special satisfaction at the bottom of my heart for this one work of architecture, and I often come here to console myself."

Bernini in fact needed little consolation as the years wore on. He continued to work at a pace only slightly diminished in his old age, and was never without distinguished friends. Perhaps the most interesting in these latter years was Queen Christina of Sweden. Her admiration for Bernini was great; it was she who commissioned Baldinucci to write his biography. Christina, daughter of Sweden's great warrior King Gustavus Adolphus, a militant Protestant, became queen at 18 and soon made Stockholm an intellectual center of Europe. The French philosopher René Descartes, among many other brilliant men, joined her court. Her reign ended prematurely when she voluntarily abdicated and became a convert to Catholicism, then outlawed in Sweden. Christina journeyed to Rome, where she spent much of the rest of her life.

Bernini became so fond of the Queen that, when he was 81, he carved the last sculpture of his life as a gift for her. It was a half-length figure of the blessing Christ, his *Salvator Mundi* (Savior of the World). Christina gracefully but firmly refused to accept the gift, to Bernini's deep sorrow, saying that not all of her wealth could recompense him for it.

As he approached the age of 82 Bernini fell ill. In the first half of his life he had been afflicted with migraine headaches that he be-

lieved were caused by bright sunlight, but in his last four decades his health had been excellent. However, he had, as Baldinucci reported, "always kept fixed in his mind an intense awareness of death," looking forward to it with "great and continual fervor." His last illness has been described as "a slow fever," followed by a stroke that paralyzed his right arm. According to Baldinucci, he took that in good cheer, remarking: "It is good that this arm which has so wearied itself in life should rest a bit before death."

Facing his bed Bernini hung one of his own paintings, now lost, a large canvas of the crucified Christ floating in the air above a sea of blood, testament of the artist's faith in the purifying of the world through the blood of his Savior. In his anticipation of death Bernini had feared that at the end he might lose the power of speech to make his final confession, and so had arranged with his confessor to communicate by means of gestures. As it developed, he did in fact become almost speechless, but by motions of his left arm and hand he made his thoughts clear, and the priest was able "to lead him with admirable calm to his end." After an illness of two weeks, he died on November 28, 1680.

So great was the press of churchmen, Roman nobility and ordinary citizens who came to pay a final farewell that Bernini's funeral had to be postponed for days. At length he was laid to rest in the Church of Santa Maria Maggiore in a lead coffin beneath the floor. His tomb marker, in contrast to his own extraordinarily complex and colorful works, is a simple flat stone.

When his will was read it was found that Bernini had bequeathed paintings and busts to three cardinals and the Pope. To Queen Christina, who could not now refuse it, he felt the *Salvator Mundi*, which remained in her collection until her own death in 1689. She willed it to Pope Innocent XI, who died in the same year and bequeathed it to a nephew. The sculpture was in the Palazzo Odeschalchi, the family home in Rome, at least until 1713, when its presence was noted in an inventory. Soon afterward the Odeschalchi collection was sold to the Spanish Crown and presumably the *Salvator Mundi* was taken to Spain, where it vanished. It seems unlikely that a work with that subject, size and quality could be forever lost or buried in a trash heap. Somewhere it must await the scholar who has the perseverance, wit and luck to find it.

Queen Christina, talking with a papal official after Bernini's death, inquired about the estate the sculptor had left. When she was told that it was in the neighborhood of 400,000 scudi—a sum that would, in today's terms, have caused Bernini to be reckoned a millionaire—she said, "I would be ashamed if he had served me and left so little." Bernini's legacy of course may be seen everywhere in the old part of Rome, enduring as the stone and bronze of which it is made. By far the greatest concentration of it is in the church of St. Peter's, where he labored for more than half a century and where this book, like all pilgrims to the city, will turn in the concluding chapter.

Queen Christina of Sweden, for whom Bernini created his last work, was pictured in this 1657 engraving by Pierre Mariette. A strong-minded woman who preferred the company of artists and intellectuals, Christina was a skilled equestrienne. One observer wrote: "Although she rides sidesaddle, she sways and bends her body in such a way that, unless one sees her from close quarters, it is easy to take her for a man. She rides so intrepidly that none can follow her."

"For the greater glory of God"

Church doctrine and religious fervor helped guide Bernini's hand as he carved the great sculptures of his maturity. From 1623, when the 24-year-old sculptor's protector and friend Maffeo Barberini became pope, Bernini got prestigious, lucrative Vatican commissions for the rest of his life. For pious men, he created pious art. Nearly all his works done after 1623 portray saints, martyrs, or highly placed and visibly reverent contemporaries *(right)*.

Bernini's strong personal religious feeling inspired his work for his Vatican patrons. He was so devout, according to an early biographer, that for most of his life he was "worthy of the admiration of the most perfect monastics." He believed firmly in the Jesuit doctrine that laymen, laboring not only for their own salvation but also "for the perfection and salvation of their neighbors," should consecrate their talents to the Church. In this belief, Bernini carved statues that allow ordinary men and women to enter for a moment into the profound experience of the saints and martyrs. As portrayed by Bernini, the great figures of Catholicism are exceptionally easy to identify with —real people with real, although heightened, emotions. In the Church's long history, few artists have been as successful as Bernini at working, in the phrase popularized by the Jesuits, "*Ad maiorem gloriam Dei*" (For the greater glory of God).

In 1663 Pope Innocent X's physician, Gabriele Fonseca, commissioned this portrait of himself. It is Bernini's most intense study of devotion. The zealous Fonseca, clutching his heart with one hand, grasps a rosary with the other. His eyes turn toward heaven, and his lips part, seemingly in prayer.

Gabriele Fonseca, c. 1668

FONSECA CHAPEL, SAN LORENZO IN LUCINA, ROME

148

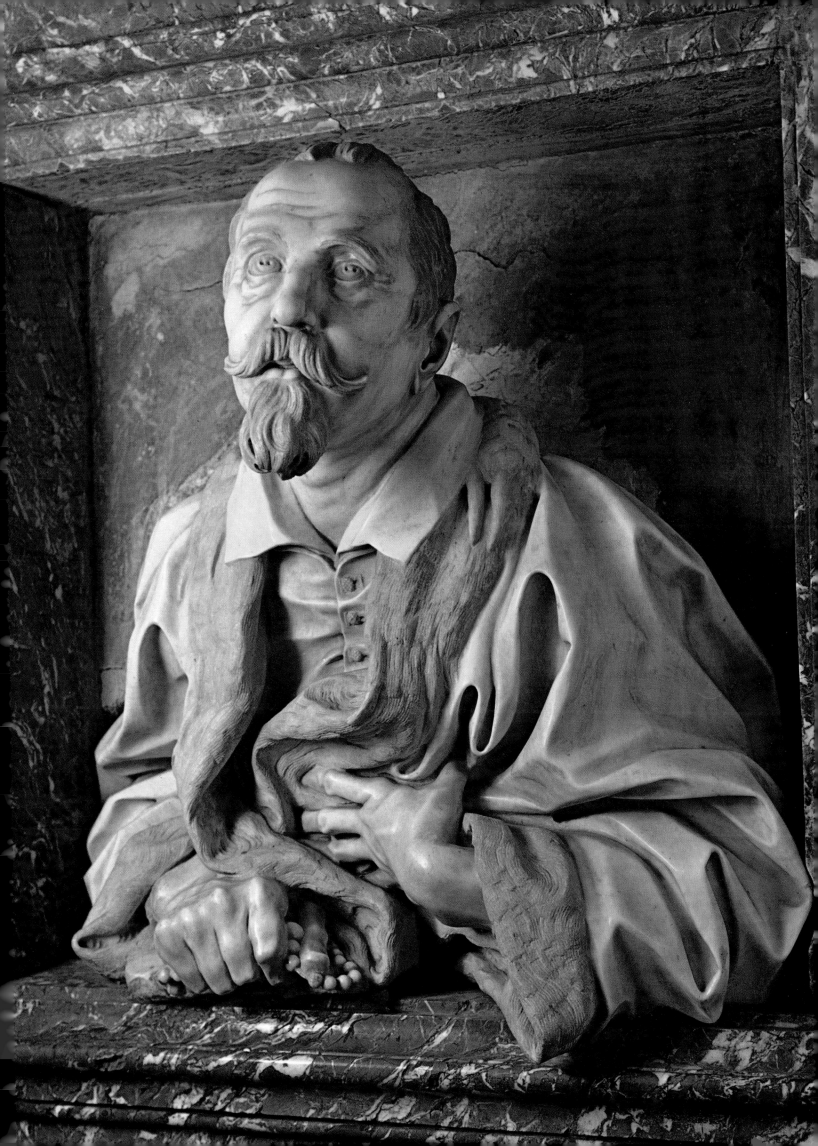

Bernini touches many themes in his religious sculptures, but none is more poignantly expressed than divine mercy. Mary Magdalen *(below)*, twisting her body in shame at the memory of her carnal sins, seems prepared for forgiveness: she fixes her eyes steadfastly on heaven. St. Jerome *(right)* reverently cradles a crucifix that has miraculously appeared to him—a token of God's pardon for the scholarly priest's sin of studying pagan authors more than the Scriptures.

St. Mary Magdalen, 1661-1663

150

St. Jerome, 1661-1663

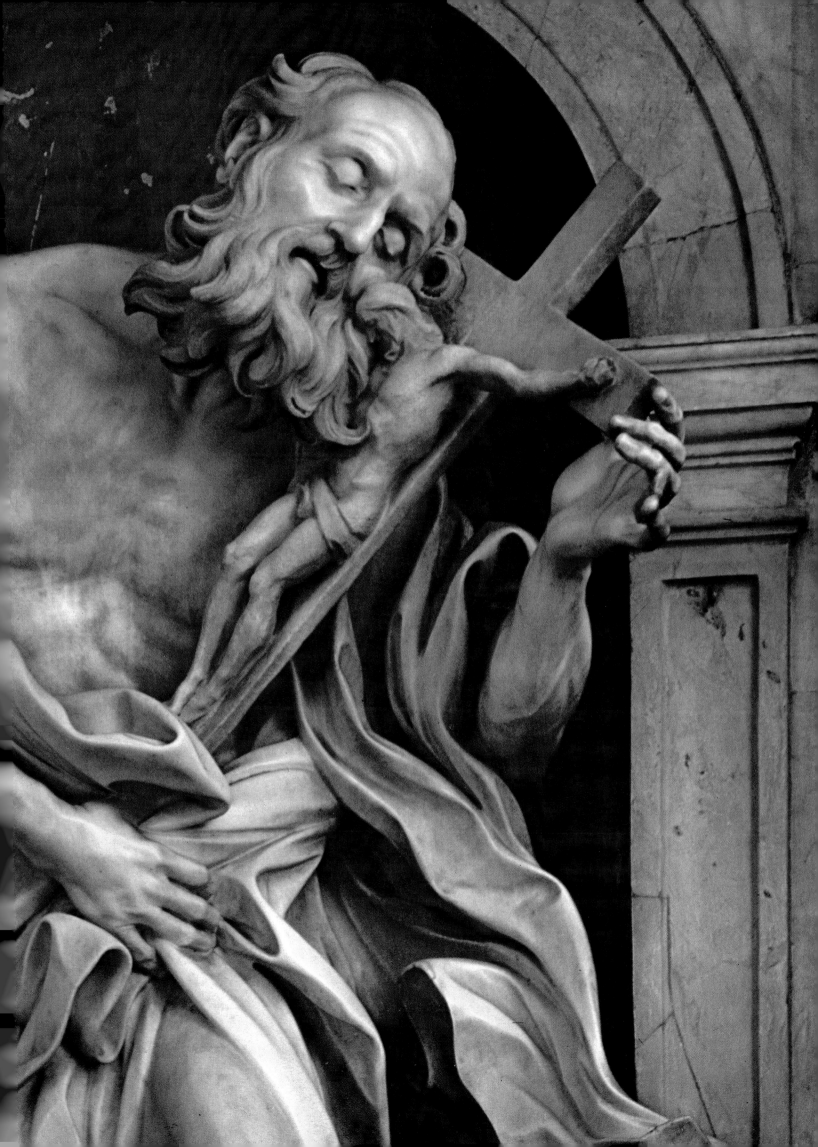

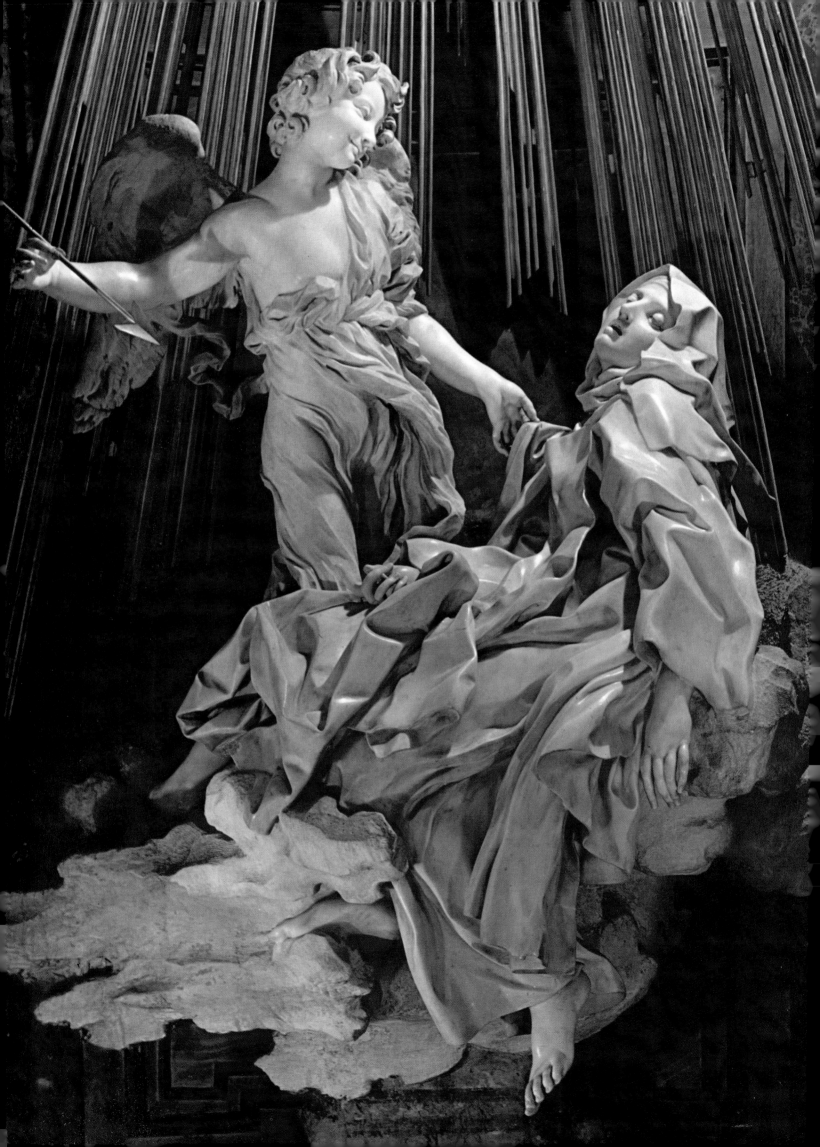

Bernini's sculpture appeals to the senses and emotions of the everyday world even when he portrays the miraculous. Evocative, concrete details create the illusion of reality in the *Ecstasy of St. Teresa (left)*, Bernini's representation of a vision experienced by a 16th Century Carmelite reformer. St. Teresa's autobiography tells how an angel plunged into her breast a golden spear, symbolizing Divine Love. When the spear was withdrawn, she was "utterly consumed by the great love of God." As depicted by Bernini, the saint ecstatically sinks back onto a cloud, her eyes nearly shut, her lips parted in a soft moan.

Bernini later carved two sculptures to illustrate the tale of Daniel and Habakkuk. When Daniel was imprisoned in a lions' den in Babylon, the Catholic Bible relates, an angel saved him from starvation by kidnaping the prophet Habakkuk, who was carrying food to his laborers, and directing him—and the food—to Daniel. One sculpture *(below, right)* shows a smiling angel descending and taking Habakkuk "by the hair on his head," as the Bible says, while Habakkuk futilely points in the opposite direction. When Daniel *(below, left)* sees the angel approaching with Habakkuk and the food, he falls to his knees and raises his arms in a prayer of thanks.

On the following pages is a tomb portrait that Bernini created to commemorate the intense piety of Ludovica Albertoni, a relative of Pope Clement X. Realistically portrayed in her death agonies —throat swollen and eyes sightless—Ludovica nevertheless glows with the dream of paradise, her pain converted to ecstasy.

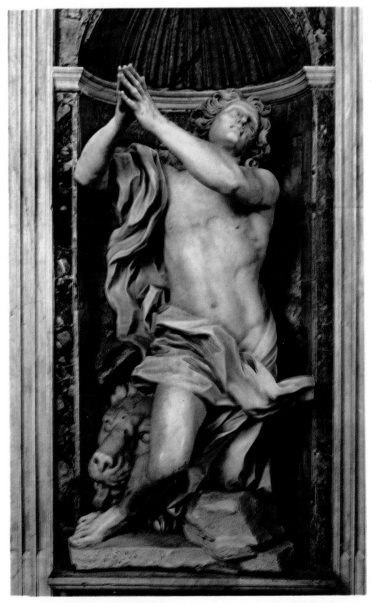

Daniel, 1655-1657

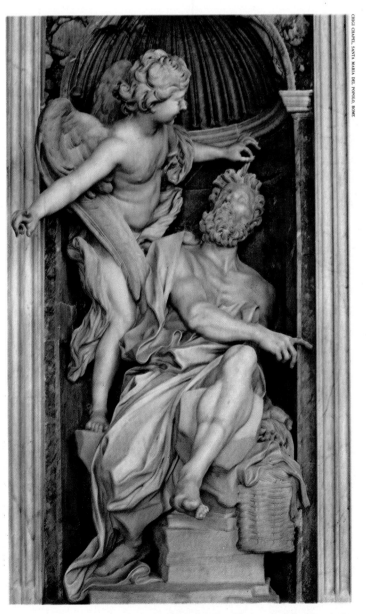

Habakkuk and the Angel, 1655-1661

◀ *Ecstasy of St. Teresa,* 1645-1652

Death of the Blessed Ludovica Albertoni, 1674 ▶

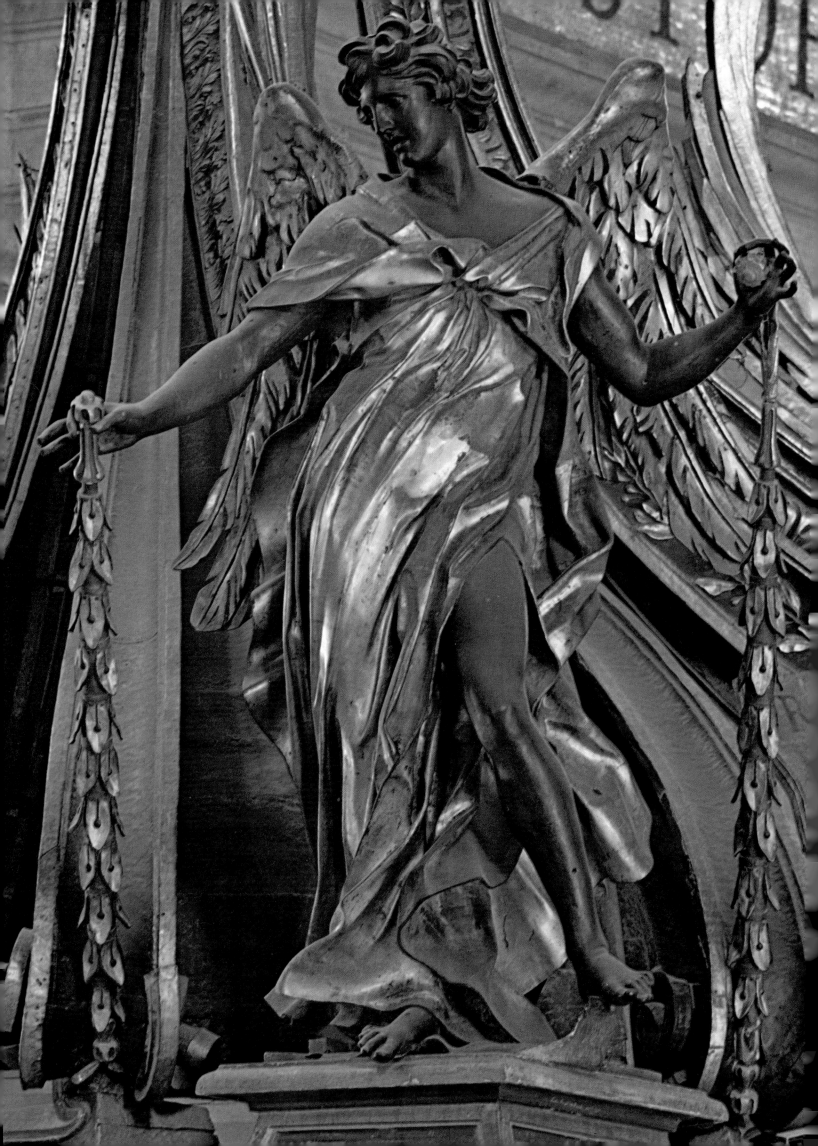

VII

Pilgrimage to St. Peter's

In Bernini's time there was only one bridge, the Ponte Sant' Angelo, spanning the Tiber between the old city of Rome and the precincts of the Vatican. In 1667 Pope Clement IX ordered the modernization of the 1,500-year-old bridge, and thus the artist, who had already enriched St. Peter's with his work, had the opportunity to influence to some extent the route and even the frame of mind of pilgrims approaching the church.

Besides designing angels carrying the Crown of Thorns, the Superscription and other objects of Christ's Passion for the Ponte Sant' Angelo, Bernini remodeled the bridge itself. He lowered the high balustrades, making it easy for people crossing the bridge to see the dome of St. Peter's about a half mile to the west. This is one of the great sights of the world, one that has brought tears to the eyes of a good many travelers who are neither Catholic nor even Christian. It was Bernini's intention that St. Peter's should be seen in the distance, a golden vision, while close at hand are the instruments associated with the Crucifixion, reminders that heaven is attained only through death. Having glimpsed the vision, the pilgrim completed his crossing of the bridge, turned left and plunged into a dim, constricted, tunnel-like street that led him—his spirit meanwhile being chastened—to the vast piazza before St. Peter's, a symbolic heaven where 96 of Bernini's saints and martyrs loom against the sky above the colonnades.

Today it is no longer possible to follow that route, or rather to receive from it the impressions Bernini intended to transmit. The ancient bridge is closed to automobiles and buses, in which most pilgrims now make their approach; few of them go on foot or indeed on their knees, as some used to do. Moreover, Benito Mussolini, during an attack of grandeur in the 1930s, destroyed the narrow streets that once led from the Ponte Sant' Angelo to St. Peter's. Now the pilgrim goes by way of Mussolini's Via della Conciliazione, a broad avenue bordered by 20th Century obelisks, of which Bernini would have disapproved altogether. The atmosphere

This colossal bronze angel, delicately holding a pair of laurel garlands, is one of four partly gilded figures gazing down from atop Bernini's towering baldachin structure in St. Peter's.

Baldacchino, detail, 1624-1633

157

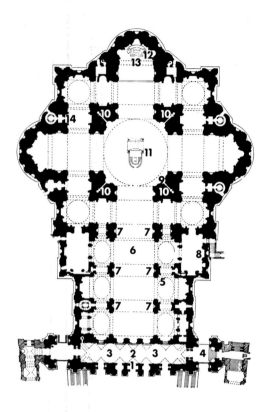

1 *Floor of the Benediction Loggia*
2 *"Pasce Oves Meas"*
3 *Marble floor of the portico*
4 *"Constantine" and the Scala Regia*
5 *Tomb of Countess Matilda of Tuscany*
6 *Marble floor of the nave*
7 *Decoration of nave piers*
8 *Altar in the Cappella del Santissimo Sacramento*
9 *"St. Longinus"*
10 *Reliquary niches*
11 *"Baldacchino"*
12 *Tomb of Urban VIII*
13 *"Cathedra Petri"*
14 *Tomb of Alexander VII*

In his role as Architect of St. Peter's for more than half a century, Gianlorenzo Bernini not only oversaw the work of craftsmen and artists working on decorations in the basilica, but designed a number of major projects himself. These are located in the plan and accompanying key above.

causes the pilgrim to reflect not so much upon death and life, as Bernini originally intended him to do in that dark, vanished street, as upon urban renewal.

As the traveler completes his approach, it is worth offering him two pieces of information, even at the risk of troubling him with something he already knows. First, St. Peter's, the largest church in the world, is not a cathedral. The word derives from the Latin *cathedra* (chair), and refers to a church—any church—in which the bishop of a diocese maintains his chair, or throne. Since the Fourth Century the bishop of Rome, who is also the pope, has maintained his chair in the ancient Church of San Giovanni in Laterano, which is therefore Rome's cathedral. ("Laterano" stems from the family name of some landlords who once owned the area around the cathedral, on the opposite side of the city from St. Peter's.)

A second fact that bears repeating is the reason why St. Peter's is located exactly where it is. It is built above the presumed grave of St. Peter, the disciple selected by Christ to lead His church after His ascension. St. Peter, who became the first pope, was martyred in Rome around 65 A.D. and was buried in the cemetery that still exists beneath the present church. Early Christians, who venerated his grave, had built a shrine there in the Second or Third Century. Around the year 320 the Roman Emperor Constantine long a follower of Christianity but who was not baptized until on his deathbed, erected a great basilica above the grave, taking pains to place it exactly (to do so, he was obliged to level a steep slope in the cemetery). Constantine's basilica was pulled down during the Renaissance to be replaced by the present one, which required 120 years and the reigns of 20 popes to complete. St. Peter's grave, which was beneath the apse of Constantine's old church, is beneath Bernini's towering baldachin in the new. Although the most careful excavations, as recent as those initiated by Pope Pius XII between 1940 and 1950, have failed to produce incontrovertible evidence of this, the accumulated probability is impressive enough to convince many scholars. Cardinal John Henry Newman, the English theologian, put it thus: "He who made us has so willed, that in mathematics indeed we should arrive at a certitude by rigid demonstration, but in religious enquiry we should arrive at certitude by accumulated probabilities."

Bernini's first commission in St. Peter's was begun in 1624; his last was completed in 1678. During that 54-year period he worked everywhere in the basilica save on the ceiling, and while he could not have predicted at the outset what his various projects would be, he was able to relate them all. There is a definite progression that begins on the remodeled Ponte Sant' Angelo and ends at the Cathedra Petri, the Chair of Peter, in the apse of the church. It is best to follow this line of progression, as would any traveler except a stickler for chronology. Bernini's works will thus be encountered out of the proper time sequence but in the order in which a pilgrim would see them.

Bernini's colonnades *(pages 170-171)* enclosing St. Peter's piazza may very well constitute the most successful piece of architecture on earth. As the traveler enters the piazza he is exalted by its spaciousness—as many as 250,000 people gather in it on various occasions every year. Yet he is not overwhelmed, an effect that Bernini calculated with great precision. He thought of his colonnades as two enormous arms, the arms of the Church embracing its children, and it was this idea that chiefly influenced the design. Visibility was another factor. At Easter and on other special days the pope extends his blessing *urbi et orbi*—to the city and to the world—from the window of the Benediction Loggia above the portico of St. Peter's. On other occasions, however, he gives the blessing from a window in the papal apartment high in the Vatican Palace to the north. Both of these windows must be visible from as much of the piazza as possible, and for that reason, as well as to suggest an embrace, the colonnades are fairly low and curved—the northern arm swings close to the Vatican Palace and the southern arm away from it, allowing the maximum of space from which the high palace window can be seen.

The colonnades are low for another reason—to create a particular optical effect. The façade of St. Peter's, flanked by the bell-tower foundations that seem a part of it, presented an ungracefully broad aspect in the 17th Century. Bernini's ill-fated towers would have corrected this, but in their absence he had another solution. He connected the curved colonnades with the basilica by a pair of straight, enclosed corridors of the height of the colonnades and faced with pilasters in the same style. These corridors, much lower than the façade, give the illusion of pinching it between them and making it taller. Today there are few complaints about the width of St. Peter's façade.

Although it has been said that the colonnades are fairly low, the term is only relative. The columns all reach a height of 39 feet, and since the ground slopes away from the church, Bernini had to compensate for this by varying the level of the foundation supporting the colonnades; moreover, the 96 saints and martyrs above them, carved by many sculptors under Bernini's direction, are taller than might be guessed: 15 feet. As one walks across the piazza toward the church, the forest of columns flickers on both sides. There are, however, two points on the broad axis of the piazza—the line that runs through the two fountains and the central obelisk—from which the four-deep columns appear in single rank. Bernini himself enjoyed these viewpoints, which are marked by inconspicuous stone disks set among the cobbles.

A broad ramp flanked by stairs, also designed by Bernini, leads the traveler to the portico of St. Peter's. After entering the portico but before going into the church itself he should turn to the right to make a brief detour. At the north end of the portico there are doors that open on the Scala Regia, the Royal Stairway, leading up into Vatican premises closed to casual visitors. Swiss Guards, in

the resplendent Renaissance uniforms designed by Michelangelo, stand sentry at these doors and will permit the visitor to look beyond but not to enter.

High against the wall opposite the doors is Bernini's equestrian statue of Constantine *(page 180)*, portrayed at the instant that led to his ultimate conversion. Constantine, who had been proclaimed emperor by his troops while serving as commander in Roman Britain, advanced on Rome in 312 A.D. to fight Maxentius, his rival for the imperial crown. Shortly before the crucial Battle of the Milvian Bridge on the Tiber, Constantine saw in the sky the Cross of Christ and the words *In Hoc Signo Vinces* (By This Sign Thou Shall Conquer). He was victorious and 10 years later began his construction of St. Peter's. In the sculpture, Bernini's idea of charged space is employed again; both rider and horse respond to what they see, a gilded cross fastened to the wall above them.

Returning to the main door of the church, the traveler sees high above it a bas-relief by Bernini that has tremendous significance for St. Peter's. The relief, *Pasce Oves Meas* (Feed My Sheep), illustrates the Biblical lines of John 21:15-17, in which Christ directs Peter to care for the members of His flock after His departure. It is upon these verses that the institution of the papacy is based, together with the lines of Matthew 16:18-19, which in the King James version read, "And I say also unto thee, That thou art Peter, and upon this rock I will build my church; and the gates of Hell shall not prevail against it.

"And I will give unto thee the keys of the kingdom of heaven; and whatsoever thou shalt bind on earth shall be bound in heaven; and whatsoever thou shalt loose on earth shall be loosed in heaven."

Can Christ, in delegating such sweeping authority to Peter, have meant that Peter was to exercise it only for the brief remainder of his natural life? In the Catholic view, Christ intended that Peter be followed by a succession of men, the popes, who would exercise Peter's authority until Judgment Day. In the election of these men, although earthly politics can be heavily involved, the intervention of the Holy Ghost is held to be decisive. And thus Catholics believe that the authority of any pope is a divinely instituted responsibility that can be traced back through an unbroken succession of earlier popes to Christ Himself. That is the statement implicit in Bernini's bas-relief above the main door, wherein Christ confronts the kneeling Peter and gestures toward His "sheep," the people, for whom Peter is to care.

Inside the church the statement is repeated and magnified: the traveler's gaze sweeps down the tremendous nave, where Bernini's canopy soars above St. Peter's tomb, and sees far beyond it, but exactly framed by its twisted columns, St. Peter's Chair in the apse. When the traveler at last reaches the Chair he finds upon it another relief illustrating the identical text: Feed My Sheep.

The church contains a good many other works, large and small,

by Bernini. The patterned marble floor of the nave was designed by him; so too were the decorations of several of the nave's massive pilasters, on which medallions carved in white Carrara marble against backgrounds of brown Siena marble represent the first 38 popes in the succession of St. Peter, along with symbolic keys, tiaras, swords and books. The artist took great pains to achieve the proper placement and style of the medallions, first painting replicas on canvas and attaching them to the pilasters where they could be studied for several weeks. For his other sculptural projects he often made full-sized models so that the effect of the finished works could be gauged precisely in their intended setting. Similarly, while working on the bell tower of St. Peter's, he had a painted wooden version of its upper stage built and put into place.

Set into the second pier of the right aisle of the church is Bernini's tomb-monument to Countess Matilda of Tuscany, a Commission given him by Urban VIII. The Pope, who was dutifully interested in increasing the much diminished secular power of Rome, greatly admired the countess, an 11th Century noblewoman who had owned vast estates in Northern Italy and had bequeathed them to the Holy See. Her example, Urban thought, was worth calling to the attention of contemporary princes. Accordingly he had Matilda's remains transported from Mantua to Rome and reburied with fitting ceremony in St. Peter's. On the front of her sarcophagus is a bas-relief that portrays the Holy Roman Emperor Henry IV, ruler of Germany, Italy and Burgundy, humbling himself in 1077 before Pope Gregory VII at Matilda's castle at Canossa, in a famous incident that marked the high point of the popes' authority in worldly affairs.

A few paces beyond Matilda's tomb is the Chapel of the Blessed Sacrament, containing one of Bernini's last works, completed when he was 75. In designing the altar (*pages 178-179*), Bernini envisioned in his preliminary sketches a ring of several angels holding aloft with the merest touch of their finger tips a tabernacle for the consecrated wafers of the sacrament. But for the final version he chose a less elaborate design. The tabernacle that the traveler sees rests on a firm base and its two gilt bronze angels, larger than life, have no visible contact with it. The angel on the left, eyes closed, is lost in adoration. However, the angel on the right, with eyes open, has turned to face the spectator as though to invite him both to see and to take part in the miracle of transubstantiation at the altar. Bernini used this device several times in chapels he designed, a frank and highly effective reaching out from one world to another. It may be seen, for example, in the Cornaro Chapel (*page 136*), where the figure of one of the cardinals leans forward from his prayer desk, seeming to invite the spectator into the realm of the *St. Teresa*.

Because of its prominence in St. Peter's and because of the vast number of pilgrims who have seen it, Bernini's towering baldachin beneath the dome has probably aroused as much comment in the

A lizard devouring a scorpion *(above)* is only one of a number of tiny bronze reliefs that crop up in unexpected places on the massive columns that support the *Baldacchino* of St. Peter's. Francesco Borromini, who assisted Bernini in the work on the baldachin, probably designed these reliefs, which seem to reflect his rather quirky, animal-oriented fancy. He had his own menagerie at home, including live rats and frogs and stuffed horse heads. The unusual decorations in St. Peter's were unknown until recently: only four to six inches in length, they are situated nine feet above the floor.

past 350 years as any work of art in the Western world. A good deal of the comment centers on its huge, twisted columns of bronze, which are thought by many to be a particularly flamboyant, "Baroque" invention by Bernini. Except for the surface detail, however, the design of the columns is not Bernini's at all.

When Constantine built his basilica above St. Peter's tomb he used twisted marble columns, divided into sections of fluting and ornamentation—they are sometimes called solomonicas because they were thought to have come from Solomon's Temple in Jerusalem. Several of these columns are still preserved in the church, and Bernini very appropriately adopted the style for his baldachin. The latter word derives from the Italian *baldacco*, a silk cloth of the sort long used to make canopies above particularly important places or people; Bernini's work has bronze hangings between the entablatures of the columns.

From the time of its commissioning by Urban VIII in 1624 until its completion nine years later, Bernini was heavily engaged on the baldachin, aided by his father and numerous other sculptors and craftsmen. After the preliminary work of designing it had been done, he faced a particularly agonizing problem: the digging of the foundations. Four openings had to be cut in the floor of the church and four shafts, each 10 feet square and 14 feet deep, had to be sunk into the hallowed ground below. Almost at once the diggers encountered not only Christian but pagan sarcophagi, a discovery disturbing to many who heard of it. (The state of archeology was primitive in the 17th Century; few imagined that St. Peter might have been buried in a cemetery that also contained pagan graves.)

Superstitious tales multiplied as the work continued. But the tales were no match for the weird coincidences that actually took place. After digging had gone on for a few days the Keeper of the Vatican Library, who had been asked by the Pope to prepare a memorandum on the excavation, suddenly died. Other deaths followed rapidly among people connected with the project, until the Pope's private chaplain died and Urban himself became seriously ill. At this the cardinals of the Fabbrica di San Pietro, the board of supervisors of construction, halted the digging.

After his recovery the Pope ordered resumption of the work and there were no more deaths. The excavators carefully removed and preserved the numerous pagan and Christian relics they unearthed, but no one at the time was skillful or informed enough to interpret them properly. The tomb of Peter himself was not found, nor was it expected to be, as the shafts were sunk on four sides of it. There was at least one discovery, however, that may have caused tremendous excitement. Bernini's workmen uncovered several marble sarcophagi that radiated like the spokes of a wheel from the center of the space under the baldachin. One of these contained a man's remains wrapped in cloth that was still well-enough preserved to show the outlines of a chasuble, the garment worn by a

priest (or pope) celebrating Mass. These remains, believed to be those of early Christian martyrs, might have yielded a great deal of information under modern scientific tests, but they have long since disintegrated or been lost. At the time of the excavations the painter Giovanni Battista Calandri, on instructions from the Pope, made detailed drawings of all the important finds—but these too have disappeared. They are probably not lost but more likely are misplaced somewhere in the mountainous and still inadequately explored archives of the Vatican.

The finished baldachin, its columns topped by angels and the whole crowned by the orb and cross, was unveiled in 1633 on June 29, the Feast of St. Peter. In keeping with the custom of adorning papal commissions with heraldic symbols, the work swarms with those of Urban VIII Barberini—bees, laurel leaves and small suns. Among its other functions—canopy, sanctuary, visual frame for the Chair of Peter beyond it in the main apse—the baldachin also serves to mitigate the almost terrifying height of the dome above it. In a sense it mediates between earth and heaven, as does the Church itself. Some critics view the baldachin primarily as architecture; to others it is sculpture. In either case it is a triumph of art over very demanding circumstances—a single small miscalculation in scale or proportion would have been disastrous, as Bernini himself acknowledged in saying with relief that "the work came out well by luck."

The baldachin is an artistic triumph in another sense. It is the first monument of the Baroque to achieve international importance: it was imitated in churches all over Europe, particularly in Italy, Austria and Germany. Even in Paris, where Bernini's architectural ideas had been regarded as too exuberant, a version of his baldachin was built during his lifetime over the high altar in the church of Val-de-Grâce.

While he was working on the great canopylike structure over St. Peter's tomb, Bernini was given charge of other decorations in the crossing of the church—the intersection of the nave and transepts, where the baldachin rises beneath the dome. It was planned to assemble in that space four cherished religious relics—now regarded by many as symbolic rather than authentic—together with larger-than-life figures of the four saints with whom the relics are associated. One of the relics is the sudarium, a kerchief with which St. Veronica wiped the perspiration from Christ's face as He carried the Cross to Calvary, and on which the impression of His face remained miraculously imprinted. Another is the lance of St. Longinus, the Roman centurion who stabbed Christ's side. A third is a fragment of the True Cross that St. Helena, the mother of Constantine, discovered in the Holy Land and brought back to Rome. The fourth is the skull of St. Andrew, St. Peter's brother, who was also a disciple and who is thought to have been martyred in Greece on an X-shaped cross. Pope Paul VI returned this last relic to Greece in 1964.

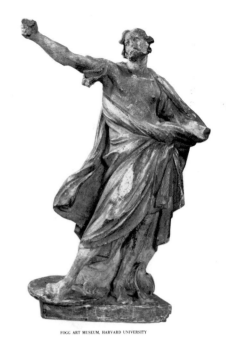

FOGG ART MUSEUM, HARVARD UNIVERSITY

The terra-cotta model above is one of at least 22 that Bernini made in the late 1620s in preparation for his largest statue, *St. Longinus*. Though roughly executed, the model foreshadows the dramatic effect Bernini achieved in the 14.5-foot finished version *(below)*. It depicts the moment when Longinus, the Roman centurion who pierced Christ's side with his lance, recognizes Christ's divinity.

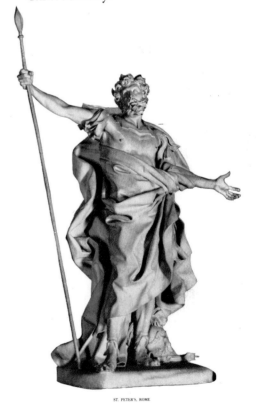

ST. PETER'S, ROME

163

The figures of the saints are set in niches in the four colossal pillars that support the dome, each figure facing the baldachin. Above the niches, accessible by spiral stairs within the pillars, there are balconies on one of which the three remaining relics are displayed on such occasions as Good Friday and Easter. Bernini designed both the figures and the balconies. The latter contain angels in bas-relief carrying images of the relics, and framing them are curious twisted, battered columns of white marble: Constantine's columns salvaged from the ancient basilica.

Bernini himself made only one of the four giant figures of the saints, the 14.5-foot-tall *St. Longinus (page 163)*, although he gave instructions to the other sculptors, whose work unfortunately falls short of his own. *Longinus* is particularly interesting as an illustration of progress in sculpture, and it is enlightening to compare it with Michelangelo's *David (page 19)*. Michelangelo's figures, as noted earlier, were bound both physically and psychologically by the block from which they were carved. However, sculptors who came after Michelangelo were a good deal more experimental. Often they created models with widely outstretched arms or legs, perilously thin or elongated, that were unthinkable to Michelangelo —unless one wanted to chip away a ton of marble to reveal an arm. Having broken out of a single block in thought, the artists needed only to break out in reality. This required simply the skillful joining of several pieces of stone. Bernini's *Longinus*, with its outflung arms, is made up of no fewer than five blocks almost invisibly joined, and stands as a superb example of the liberation both of figures and of thought.

In his conception of the crossing of St. Peter's, Bernini had far more in mind than meets the 20th Century eye. The twisted, Solomonic columns of the baldachin in his day had an immediate connotation: the city of Jerusalem, whence their prototypes were thought to have come. The mere placement of these columns in the crossing of the church was enough to establish, or at least to offer the pretense, that the area of the crossing *was* Jerusalem. Bernini employed what one scholar has called "topographical transfusion," whereby an area of the Holy Land is in some mystical way transported to St. Peter's.

Jerusalem was the place of Christ's crucifixion, His resurrection and His ascent into heaven. In Bernini's conception, so too is the crossing of St. Peter's. There is an altar beneath the baldachin, an altar so sacrosanct that only the pope may say Mass there. An altar by definition is a place of sacrifice; in this case it represents the greatest of all sacrifices, that of Christ Himself, to which the relics and the four saints in the crossing are closely related. Bernini suggested the Crucifixion in the altar, the Resurrection in the triumphant cross above the baldachin, and the ascent into heaven in Michelangelo's distant dome above. He also pointed out the triple nature of the Christian Divinity—the Holy Ghost, in the form of a great dove with outspread wings on the underside of the canopy of

the baldachin; Christ, represented by the cross above it; and God the Father, Who appears in a mosaic by Cesari d'Arpino at the summit of the dome. Bernini's *St. Longinus*, portrayed at the moment of his conversion after piercing Christ's side with his lance, seems to cry "Truly this man was the Son of God!" as he throws out his arms to echo the position of Christ above him on the Cross. But in Bernini's conception the thunderstruck Longinus sees even beyond the crucified man—he sees death and resurrection and the Holy Trinity, the core and compass of the Christian faith, above the grave of its first pope.

Diagonally across the church from *St. Longinus*, against the left wall, is the tomb of Pope Alexander VII *(right)*, completed when Bernini was in his 80th year. The artist's biographer Baldinucci says that Bernini undertook the commission "on account of his gratitude to the memory of this prince . . . notwithstanding his age and the decline of his strength which made him daily less capable of such work." Only small parts of the execution, perhaps the finishing touches on the face and hands of Alexander's suppliant figure surmounting the tomb, are by the aged master himself, although to be sure the whole astonishing work was at all times under his rigid control.

The large niche selected for Alexander's tomb had one major disadvantage: in the center of its rear wall there is a doorway which, for most artists, would have made the niche completely unsuitable for any major work. What can be built around a doorway, even one that is not in continual use? But Bernini, as he very often did, turned the problem into an asset.

In Bernini's day death was commonly portrayed as a skeleton emerging from a tomb and holding up to the living an hourglass, a reminder of time's inexorable passage. The idea was widespread —Bernini's Dutch contemporary Rembrandt used it in an etching called *Death Appearing to a Wedded Couple*. Bernini seized upon this notion and combined it with the troublesome door in the niche. The door then came to represent the entrance of a tomb, and with this simple but brilliant conception, the niche assumed a wholly different character. From the door of the supposed tomb there emerges a bronze skeleton holding aloft an hourglass for the consideration of Pope Alexander, kneeling in prayer above. On either side of the doorway, mourning the death of the Pope, are allegorical figures of Justice, Truth, Prudence and Charity.

Three-dimensional skeletons on tomb-monuments were not commonplace before Bernini's time, although bas-reliefs of them had a very long history. Bernini's startling idea could have stemmed from a remarkable Mass that was held in 1639 in Il Gesù, the Jesuit church he attended during most of his adult life. For that Mass the Jesuit fathers constructed a number of mechanical skeletons, some of which brandished swords and crowns to suggest the dominance of death over this world, while others reached out to seize Adam and Eve a moment after those original sinners had eaten the for-

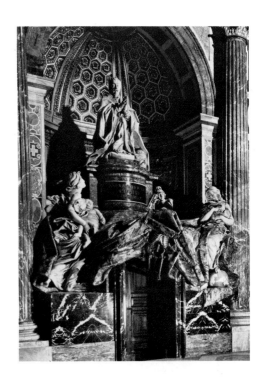

Bernini's monument for the tomb of Pope Alexander VII was not originally intended for St. Peter's, and when it was decided to place it in the basilica, the sculptor had to adapt his plan to accommodate a doorway in the selected niche. Moving the door forward, Bernini surmounted it with a flowing, multicolored marble shroud that is held aside by a bronze skeleton. The skeleton gestures upward toward the praying figure of Alexander with a large hourglass. Work on the monument was carried out by a large group of specialists from Bernini's workshop under the 80-year-old master's close supervision.

bidden fruit. In any case it seems possible that the recollection of these figures remained in the artist's mind and influenced the design of the tomb.

Among the allegorical figures beside the tomb, *Truth* is worth the longest glance. Bernini conceived the figure to be very similar to his earlier and never-completed *Truth Revealed by Time (page 86)*, decorously covered in critical areas but otherwise nude. However, Pope Innocent XI, a successor of Alexander VII, took an extremely severe view of nudity in any form and employed a number of artists to paint loincloths, fig leaves and wisps of fabric upon all the Vatican's works of art. In the case of Bernini's *Truth*, which had already been carved in marble, it was no longer possible to suggest that the sculptor make some concealing stone drapery. Instead he was asked to make a garment of bronze, painted white to simulate marble, to cover the exposed parts of *Truth's* body. Most visitors today do not notice the deception.

In the right-hand sector of the apse is Bernini's tomb of his beloved patron, Urban VIII. In its major features the tomb is not unlike that of Alexander VII: a sarcophagus, a figure of the Pope and allegorical figures mourning his death. There is, however, one unusual feature. The Barberini bees, cast in bronze and perhaps the size of pigeons, are placed at random on the tomb and are particularly noticeable.

After the Pope's death a churchman—evidently one Bernini disliked—questioned him about the bees and was told, "Yes, they are scattered, but as you know, bees reassemble at the sound of a bell." This seemingly cryptic remark was in fact a warning. What Bernini had in mind was the possibility that he might suffer in the political upheaval that accompanied the succession of a new pope. The cardinal-nephews of Urban VIII, who had felt it prudent to flee Italy after his death, were still alive in France and were of

The ornate tomb Bernini built for Urban VIII *(above)* was designed to rivet the attention, and it does. The sarcophagus is flanked by the figures of Charity and Justice, executed in white marble; from behind it Death, a skeletal figure in dark bronze, rises to write the inscription *"Urbanus VIII Barberinus, Pont. Max" (right)*. Towering above this tableau is Bernini's majestic bronze statue of the Pope *(page 30)*.

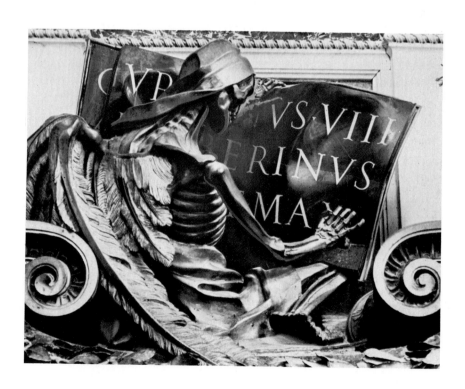

166

course still cardinals. When next was heard the sound of a bell —which tolled to mark the death of a pope and to announce the conclave to elect his successor—the Barberini cardinals would return to Rome and would have votes as weighty as anyone else's. As it developed, Bernini had no need of support from the absent Barberini cardinals, but his loyalty to his late patron, at a time when such a remark might have cost him dearly, is worth noting.

In Bernini's view the goal of the pilgrim to St. Peter's was not only the grave of the saint but the *Cathedra Petri*, St. Peter's Chair. As soon as the pilgrim sets foot in the church he can see the Chair far off at the end of the 600-foot nave, framed as Bernini intended by the columns of the baldachin. Because the church is built on an east-west axis the earliest rays of the sun stream down the central aisle to illuminate the Chair; all afternoon the light strikes it through a western window above it.

The *Cathedra* that the pilgrim sees is actually a hollow reliquary; encased in the bronze chair by Bernini is a wooden one which has been in both the new and the old St. Peter's for many centuries. That chair was believed in Bernini's time to have been used by the saint himself. Recent scientific tests of its wood, however, indicate that it dates from the Ninth Century A.D. But the symbolism dates from the time of Christ and Peter, and what is really significant is the bas-relief Bernini carved on the bronze chair: a second statement of "Feed My Sheep."

The Chair of Peter seems to float in the air above an altar. Near the four legs of the Chair there are four saints, those in the foreground (St. Augustine and St. Ambrose) representing the Latin branch of the Catholic Church and those in the background (St. Athanasius and St. Chrysostom) the Greek. The saints, although their finger tips are linked to the Chair by loops of drapery, do not support it in the air. At most, the saints can be said to be in communion with the Chair, not lifting it; it sustains itself.

Above the Chair there is a glory—an emanation of light—surrounded by angels and cherubs. In the midst of the glory, light floods through a leaded-glass window, illuminating the dove of the Holy Ghost that is outlined in its center. At right and left the glory bursts out of its architectural frame, spilling over the nearby pilasters in billows of stucco clouds and shafts of golden light. To assess this work, even to decide what to call it, is not an easy task. But the traveler who has journeyed this far, and who now knows something about Gianlorenzo Bernini, is well qualified to make his own judgment.

Bernini was essentially a man of belief. He wrote no intellectual treatise concerning his ideas, as did the Renaissance giants Leonardo and Bramante. Even had he done so, it is unlikely that later artists would have been able to imitate him successfully. Bernini was unique. Other artists have been fully as devout, and others equally inventive, but there is perhaps none in all the history of art who was a greater soldier of faith.

Bernini's Masterwork

The awesome dimensions of St. Peter's basilica, the largest church in Christendom, provide an appropriate scale and setting for Bernini's most majestic works. The great edifice, whose basic design was developed by Michelangelo, was completed in 1626 after more than a century of effort. To Bernini fell the herculean task of beautification—an imposing square in front, adornments for the cavernous interior and even a grand staircase for the pope. From 1629, when he was named Architect of St. Peter's, until his death 51 years later, Bernini was almost constantly designing and executing large-scale projects in and around the church. The result is almost as much an artistic monument to Bernini as it is a sacred shrine of the Roman Catholic Church.

The visitor approaching the church is placed in the proper physical perspective by the rows of huge columns *(right)* that embrace the broad piazza. As he enters St. Peter's he is suddenly placed in spiritual perspective: at the far end of the 600-foot nave is a breathtaking sight—an ornate throne (the *Cathedra Petri)* appears to be floating high above the floor in golden light. Of the many works by Bernini that adorn St. Peter's, these—the splendid oval piazza and the glorious *Cathedra Petri*—are the most impressive. Bernini's son Domenico called them "the beginning and the end of the magnificence of that great church."

Massive Tuscan columns bordering the piazza of St. Peter's dwarf a strolling priest. There are 284 such columns, arranged four deep, in the piazza's two curving colonnades.

Piazza of St. Peter's, detail, 1656-1667

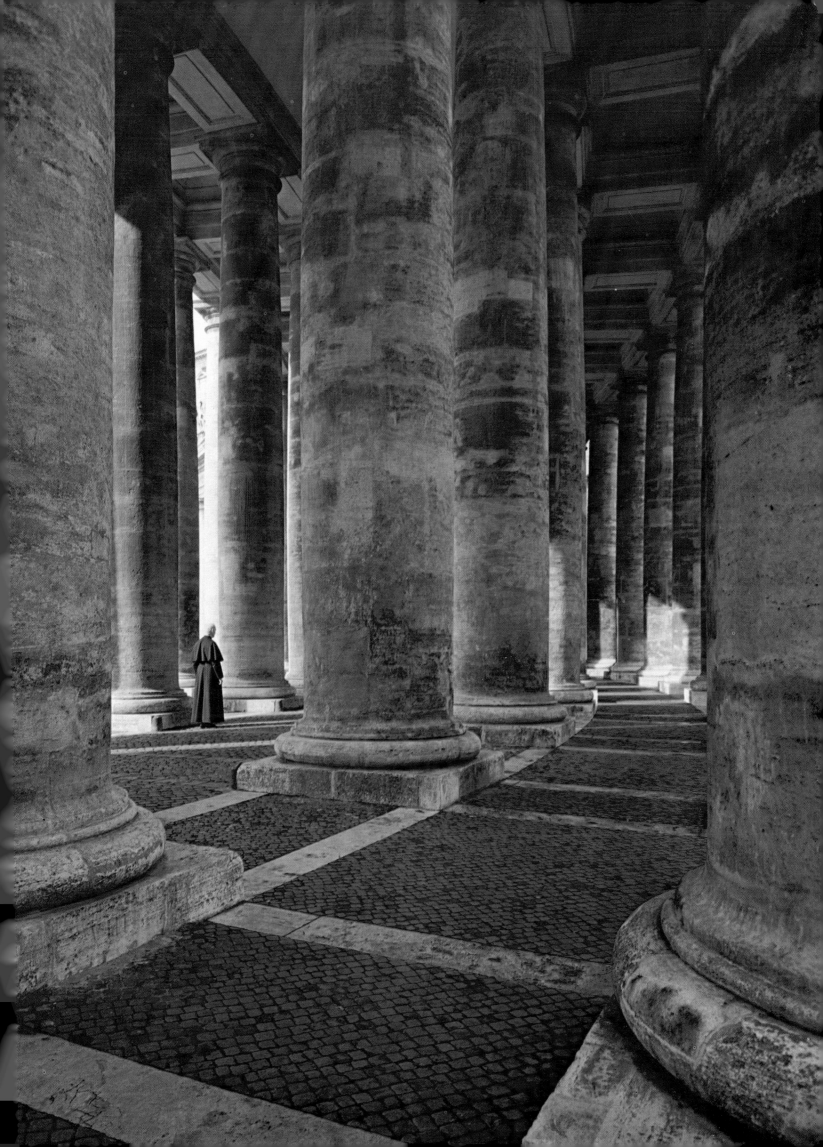

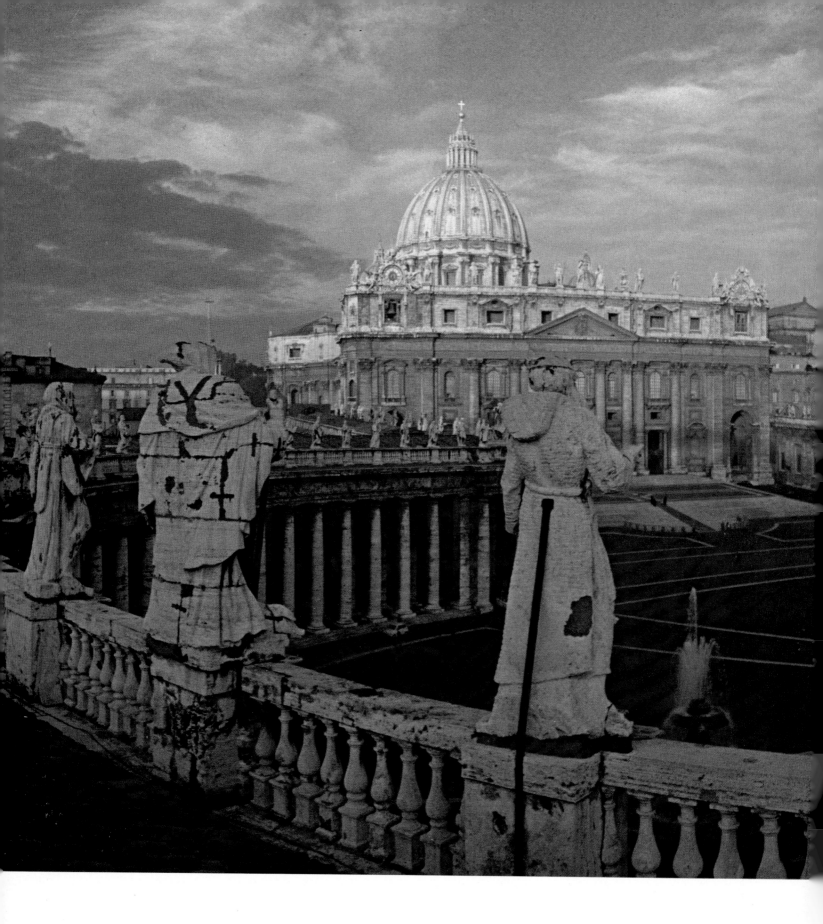

The great piazza of St. Peter's, seen here from atop one of its colonnades, was planned by Bernini to meet both practical and esthetic needs. He had to create a large open area where thousands of people could receive the pope's blessing from either the church or the Vatican Palace, the large building on the opposite page. At the same time, he intended the piazza to enhance the façade of the church and to provide a source of inspiration for both worshipers and Vatican visitors.

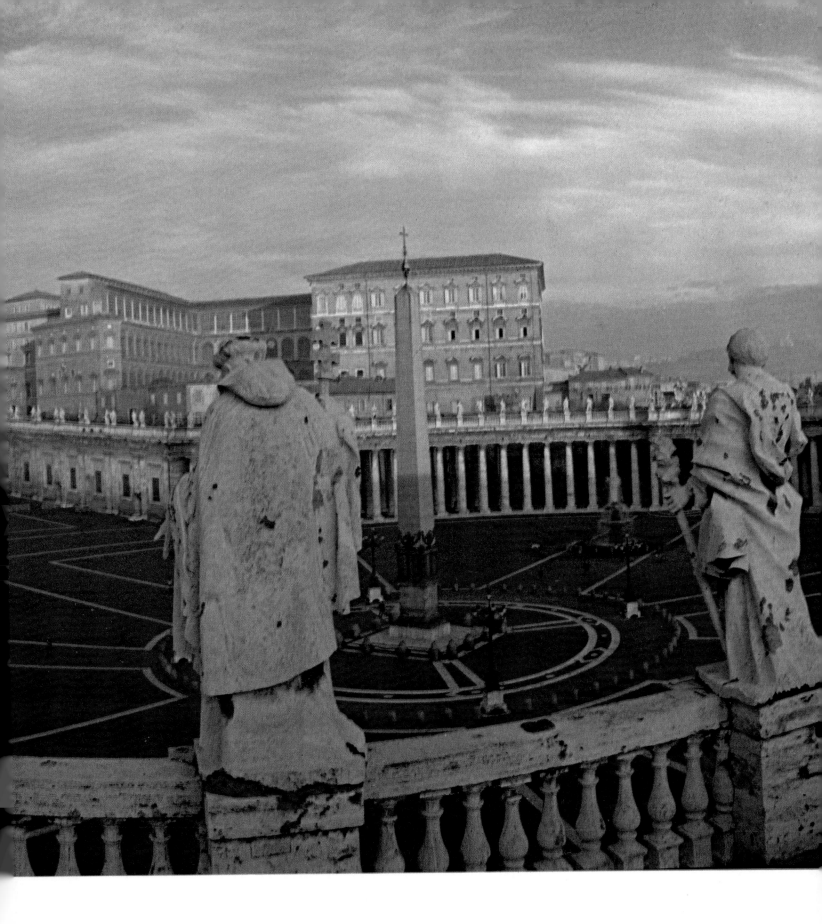

Bernini incorporated an ancient Egyptian obelisk, believed to have once stood in Nero's Circus, where St. Peter was crucified, into the center of his grand oval design. On either side of the oval he placed the colonnades, embellished with huge statues of saints and martyrs, that he proudly described as a pair of motherly arms "which embrace Catholics to reinforce their belief, heretics to reunite them with the Church, and agnostics to enlighten them with the true faith."

171

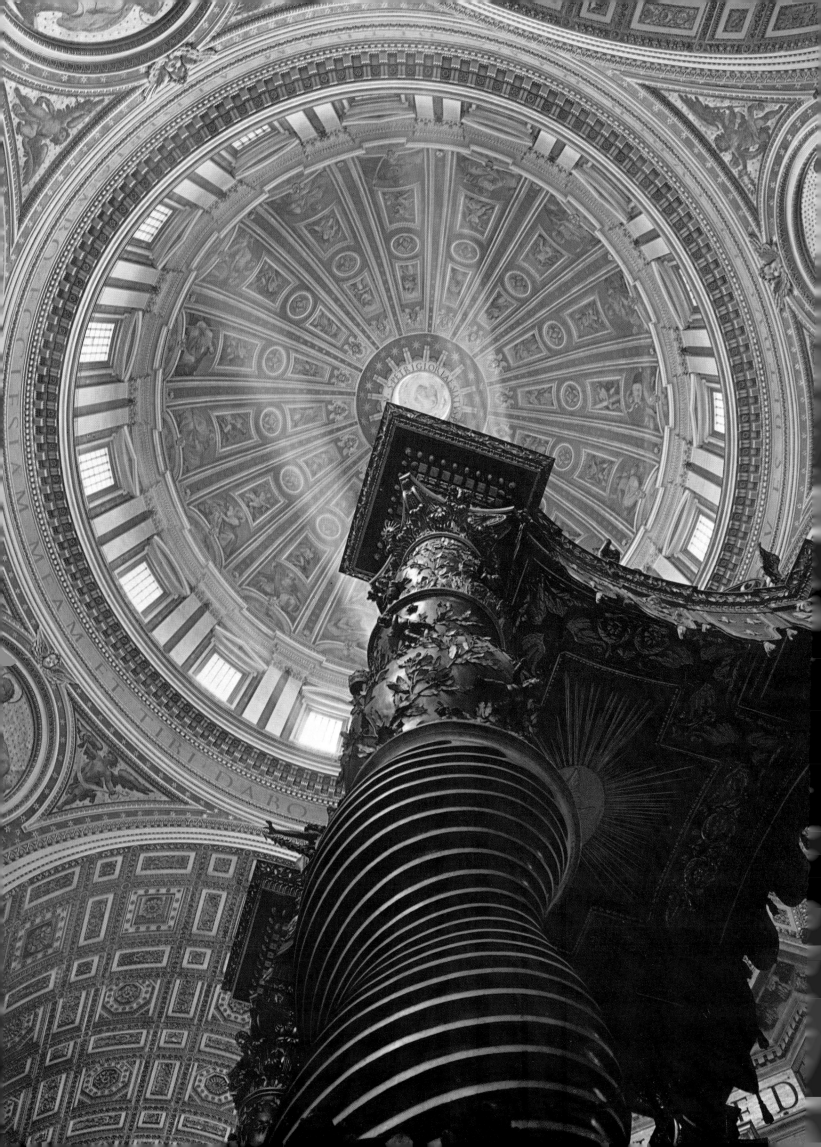

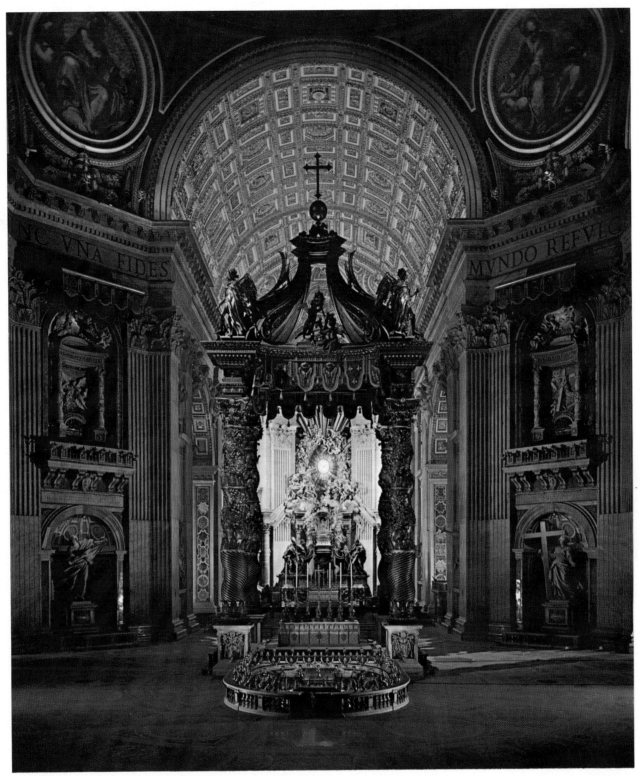

Baldacchino, 1624-1633

At the heart of St. Peter's, over the site marking the saint's tomb, Bernini placed his dazzling *Baldacchino,* the world's first great Baroque monument. Begun in 1624, when Bernini was 25 years old, the bronze masterpiece took nine years to complete. It reaches 95 feet upward toward Michelangelo's enormous dome *(left).* The distinctive corkscrew columns, beyond which

Bernini's *Cathedra Petri* can be seen *(above),* support an elaborately detailed bronze canopy. In the photograph on the following pages, looking upward from the altar used only by the pope, the canopy resembles richly embroidered brocade, including tasseled fringes. At the center of a burst of golden rays Bernini placed a triumphant dove, symbolizing the Holy Spirit.

173

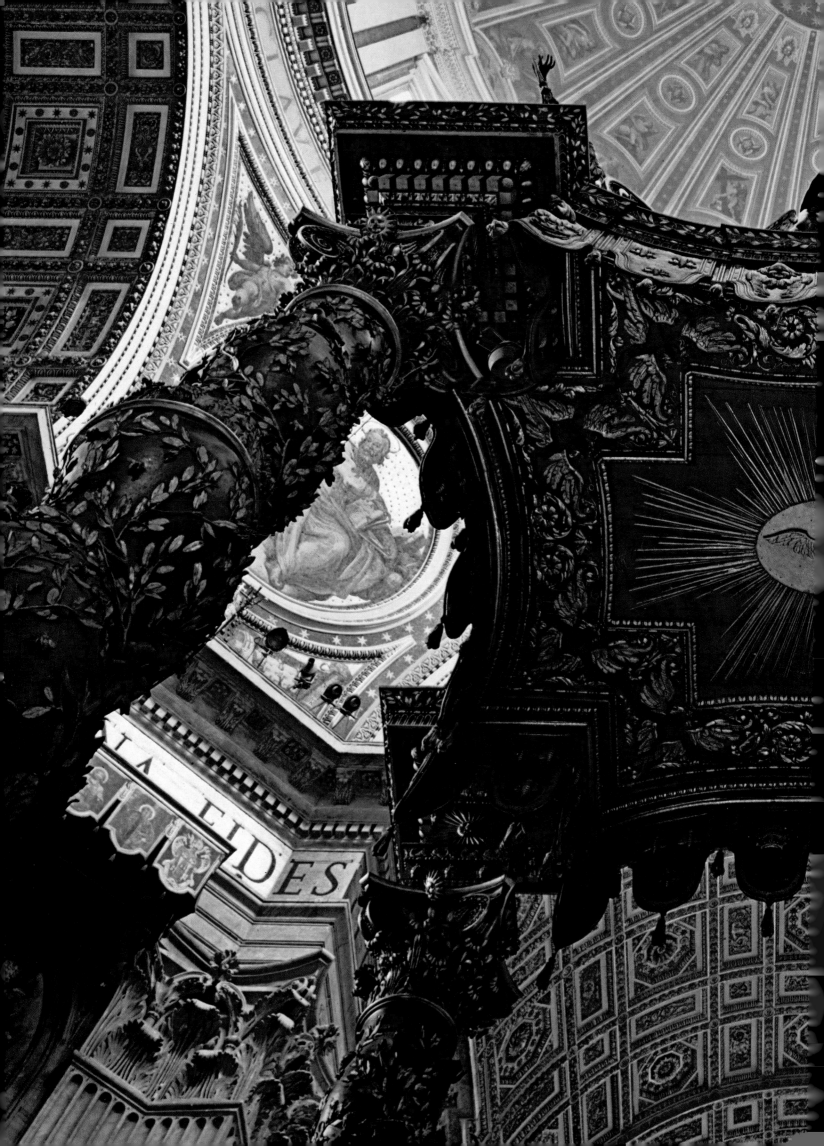

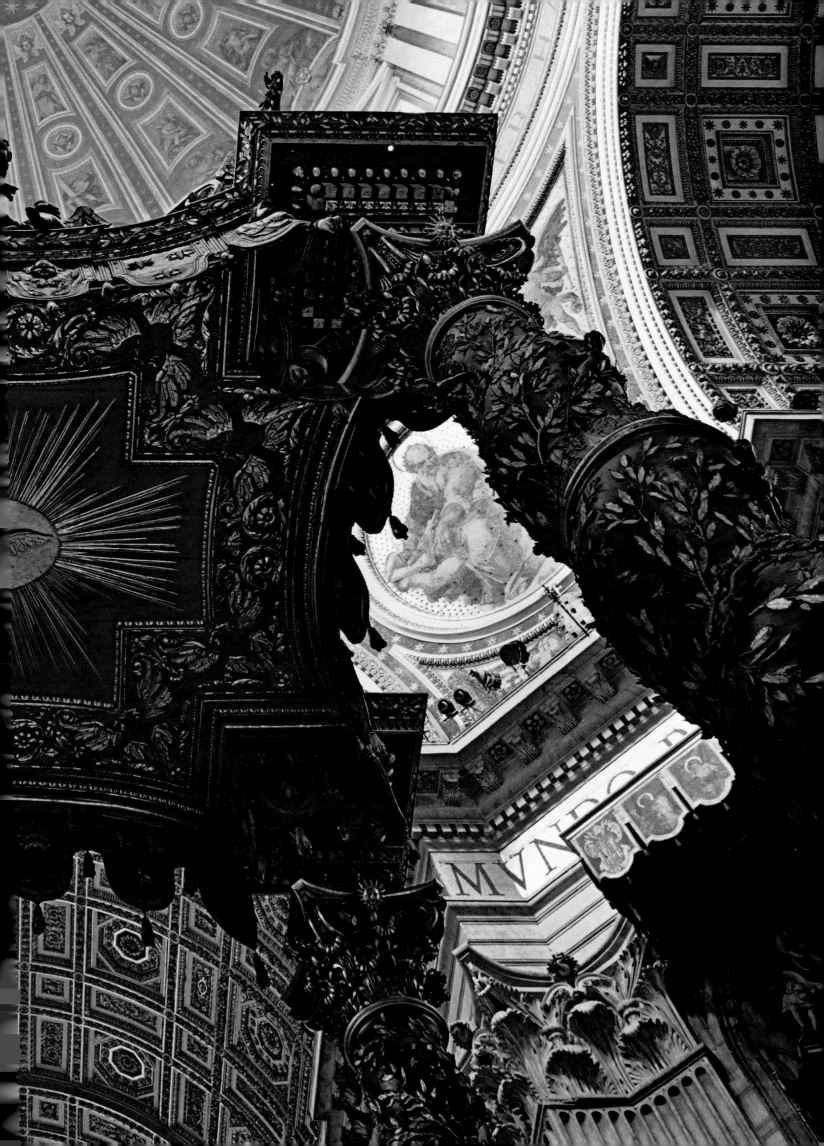

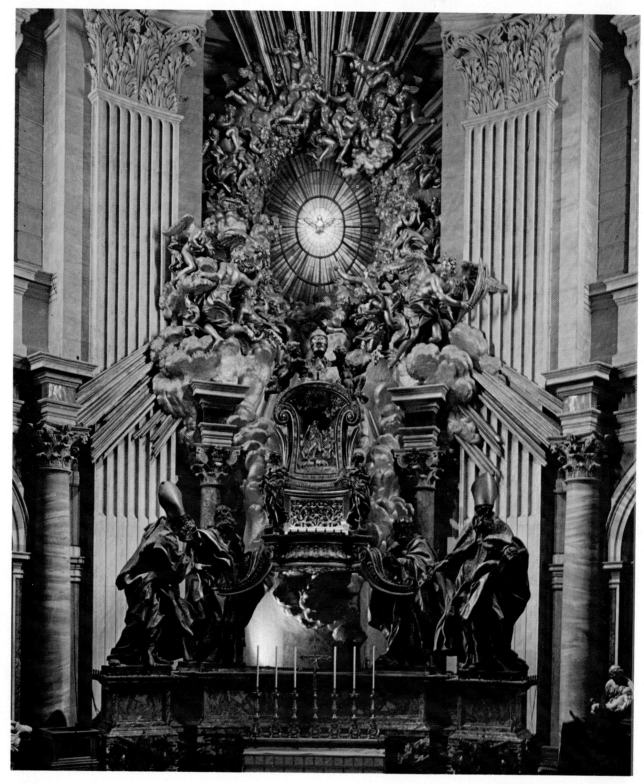

Cathedra Petri, 1657-1666

Every St. Peter's visitor is irresistibly drawn to the *Cathedra Petri*—the Chair of Peter—which beckons like a softly glowing beacon in the apse at the far end of the church. Planned primarily as a reliquary for what was believed to be the first pope's wooden chair, the *Cathedra* was transformed by Bernini into a glorious symbol of the papal link between Christ and the Catholic Church. Peter's Chair, enclosed within a bronze-and-gold throne, floats above the statues of four great sainted teachers of early Christianity: Ambrose, Athanasius, Chrysostom and Augustine. Above and behind the Chair, angels and cherubim bask in golden light from the dove of the Holy Spirit *(right)* painted on a window that Bernini ingeniously incorporated into his design.

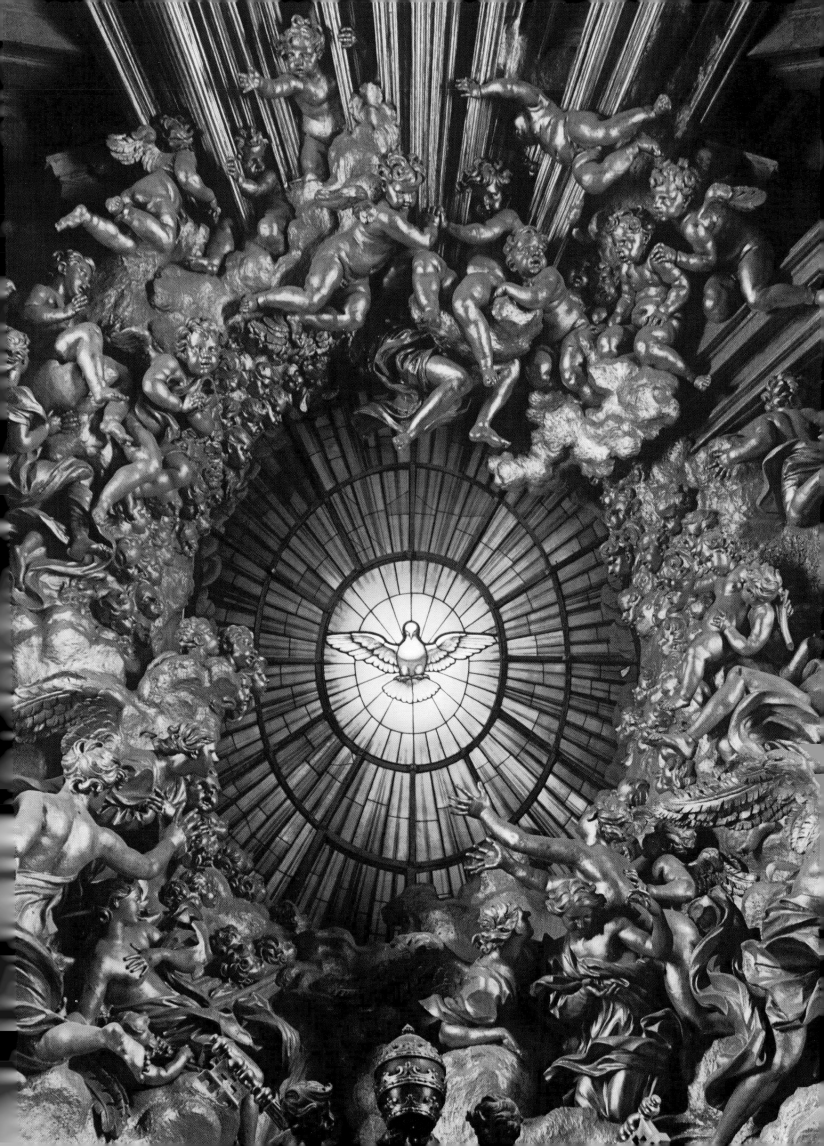

Altar, Cappella del Santissimo Sacramento, 1673-1674

The altar for the Cappella del Santissimo Sacramento—Chapel of the Blessed Sacrament —was the last major work executed by Bernini for St. Peter's, and is a striking example of a new concept of beauty that evolved in his later years. It was a concept based on the vivid use of color contrasts and richness of materials rather than the profusion of ornamentation that marked many of his earlier works. Bernini blended gilded bronze and rich blue lapis lazuli in the elegant temple-shaped tabernacle and added contrasting hues of multicolored marble in the handsome altar base. A close-up view of one of the gilded angels *(right)*, cast from Bernini's original model, shows the unusual emphasis on dramatic folds of cloth that also characterized Bernini's last sculptures.

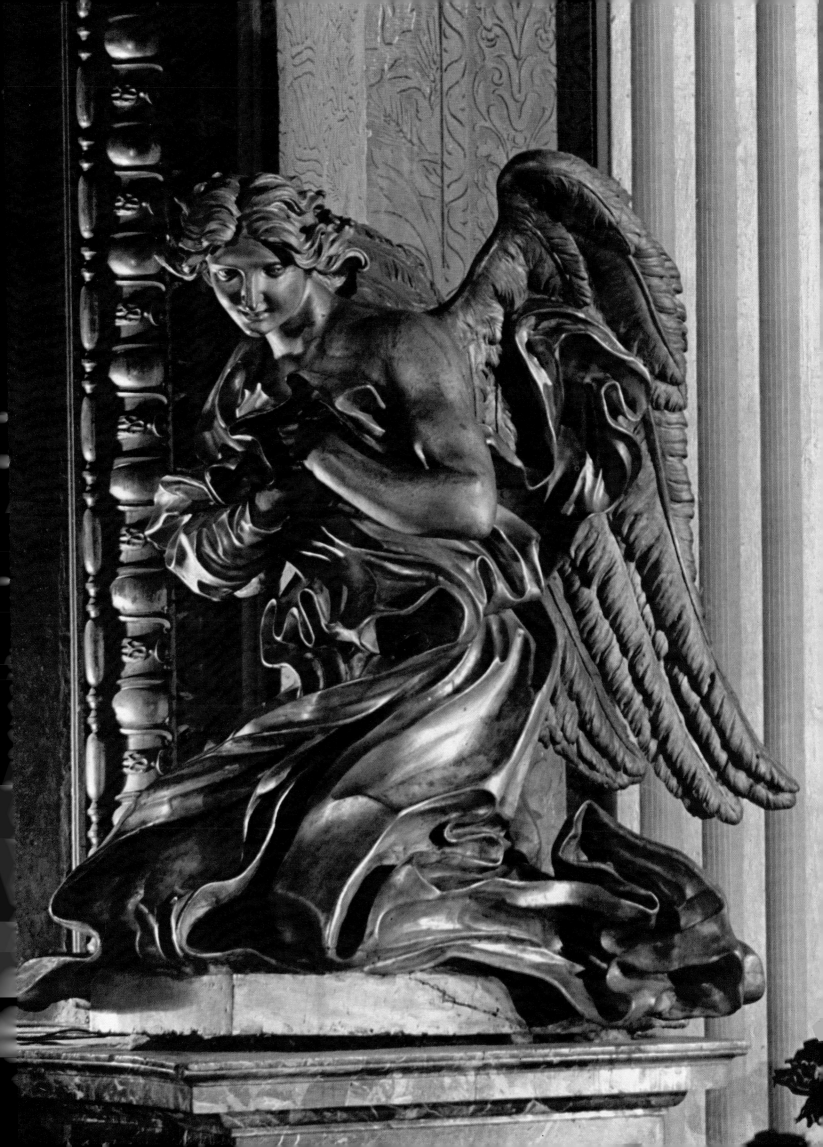

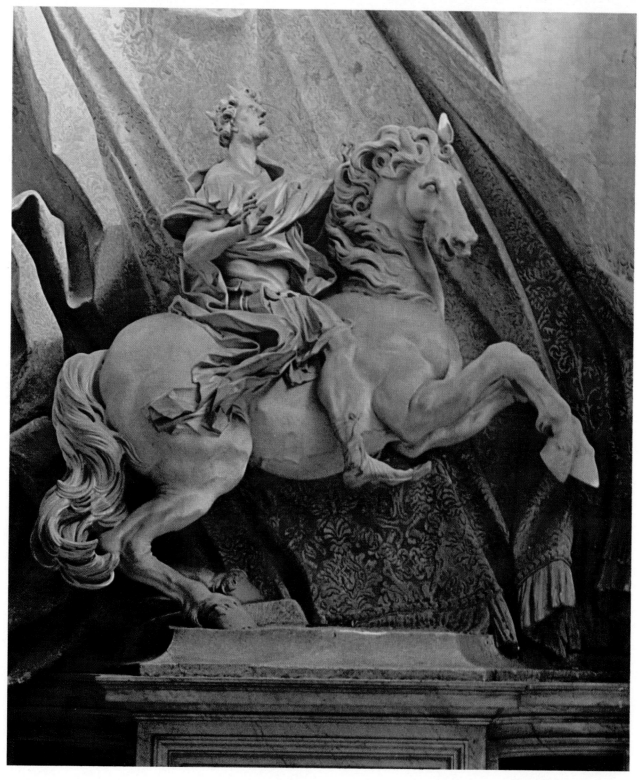

Constantine, 1654-1670

The Scala Regia, or Royal Staircase *(right)*, is Bernini's reconstruction of a steep and irregularly shaped staircase used by popes to descend from the Vatican Palace to the basilica. Bernini rebuilt the precarious steps and added a windowed landing to break up the steep flight. An artful illusion —created by rows of columns that are shorter and closer together at the top than at the bottom—gives the staircase an appearance of stately rhythm and uniformity. Near the foot of the stairs, facing the passageway into St. Peter's, is Bernini's grand equestrian statue of Constantine *(above)*, Rome's first Christian emperor. A few steps beyond, seen in a panoramic view on the following pages, is the piazza, Bernini's physical link between his two worlds: St. Peter's and the city of Rome.

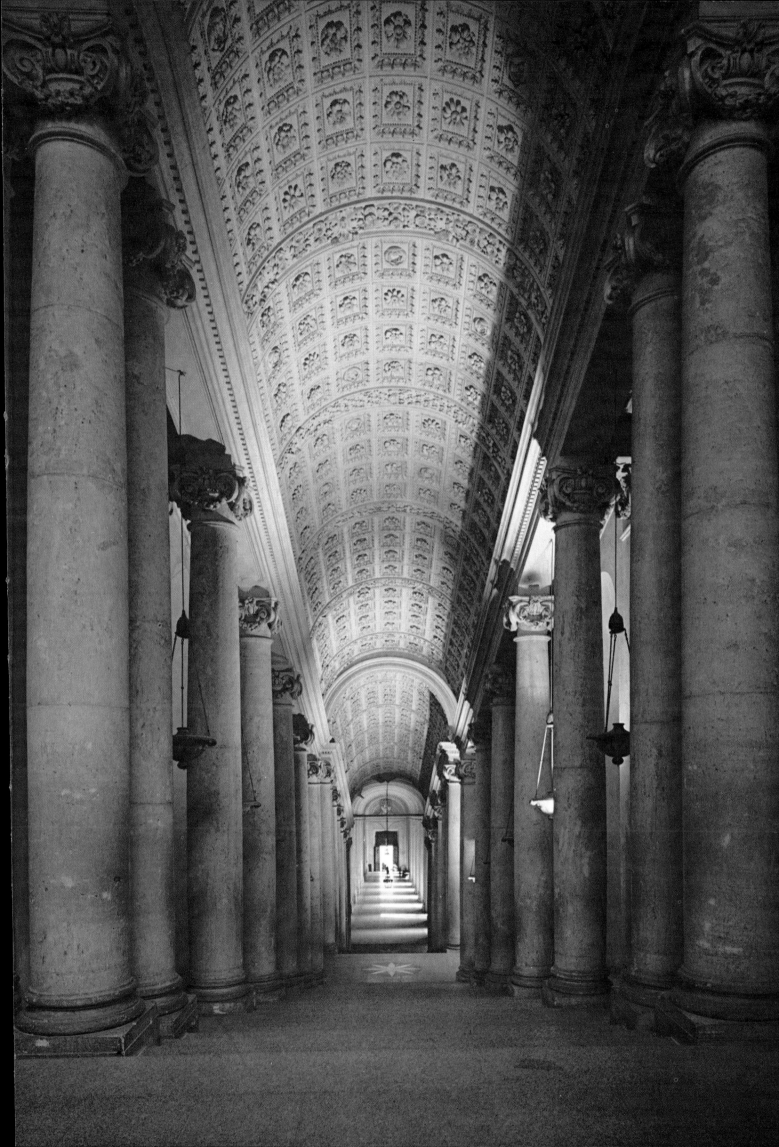

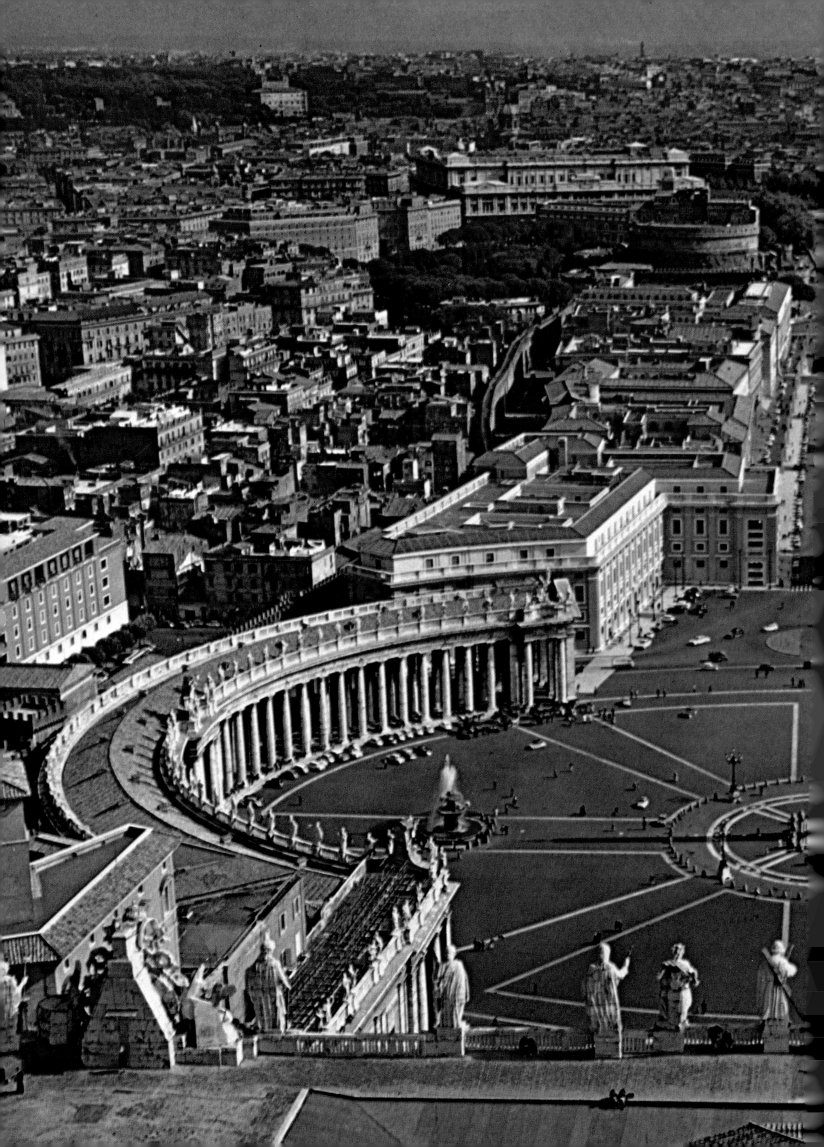

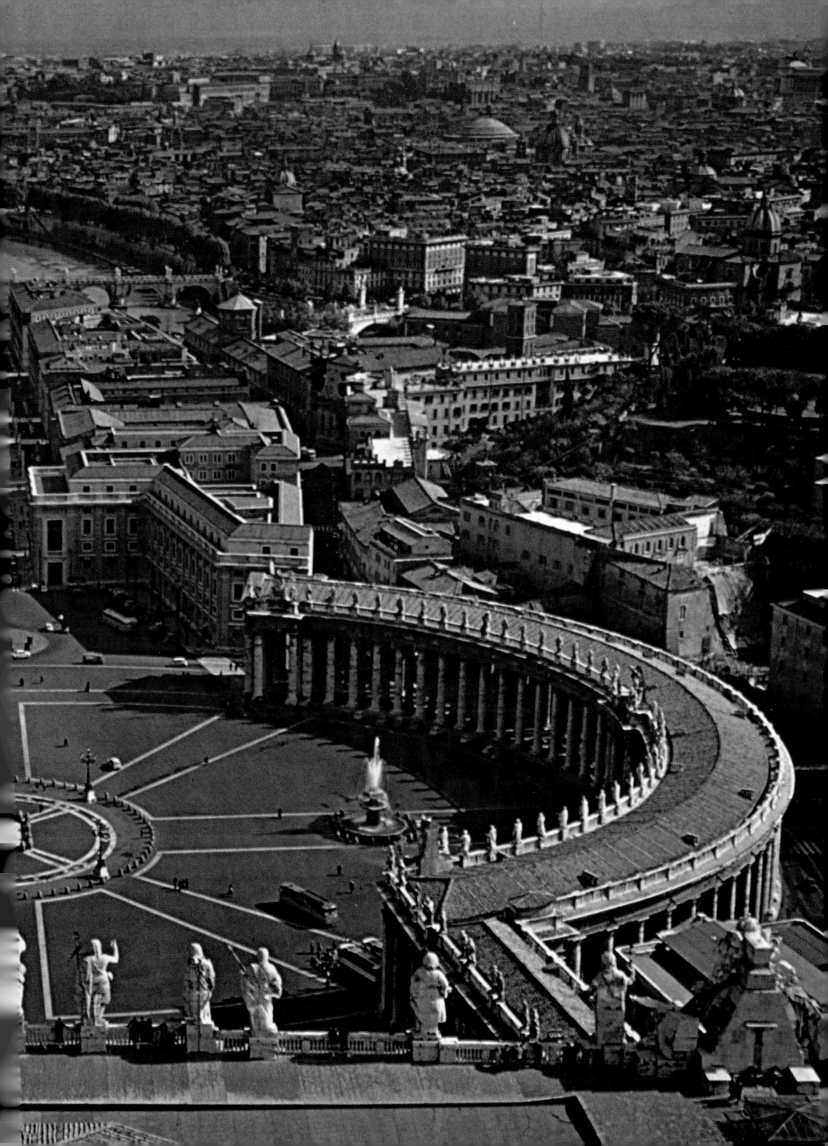